ELTON JOHN

BY TERRY O'NEILL

ELTON JOHN

BY TERRY O'NEILL

THE DEFINITIVE PORTRAIT, WITH UNSEEN IMAGES

CASSELL
ILLUSTRATED

An Hachette UK Company
www.hachette.co.uk

First published in Great Britain in 2019 by Cassell Illustrated, an imprint of
Octopus Publishing Group Ltd
Carmelite House
50 Victoria Embankment
London EC4Y 0DZ
www.octopusbooks.co.uk
www.octopusbooksusa.com

Distributed in the US by
Hachette Book Group
1290 Avenue of the Americas
4th and 5th Floors
New York, NY 10104

Distributed in Canada by
Canadian Manda Group
664 Annette St.
Toronto, Ontario, Canada M6S 2C8

ISBN 978-1-78840-148-7

A CIP catalogue record for this book is available from the British Library.

Printed and bound in China

10 9 8 7 6 5 4 3 2 1

Commissioning Editor Joe Cottington
Art Director Juliette Norsworthy
Senior Editor Alex Stetter
Designers Katie Johnston and Penny Stock
Photography processing for Iconic Images Adam Powell
Production Managers Gemma John and Nic Jones

Elton John and Terry O'Neill first worked together in 1972, and O'Neill went on to take in excess of 5,000 photographs of the artist over the following decades.

The photographs in this book represent the very best of this archive, with many of the images being shown here for the first time.

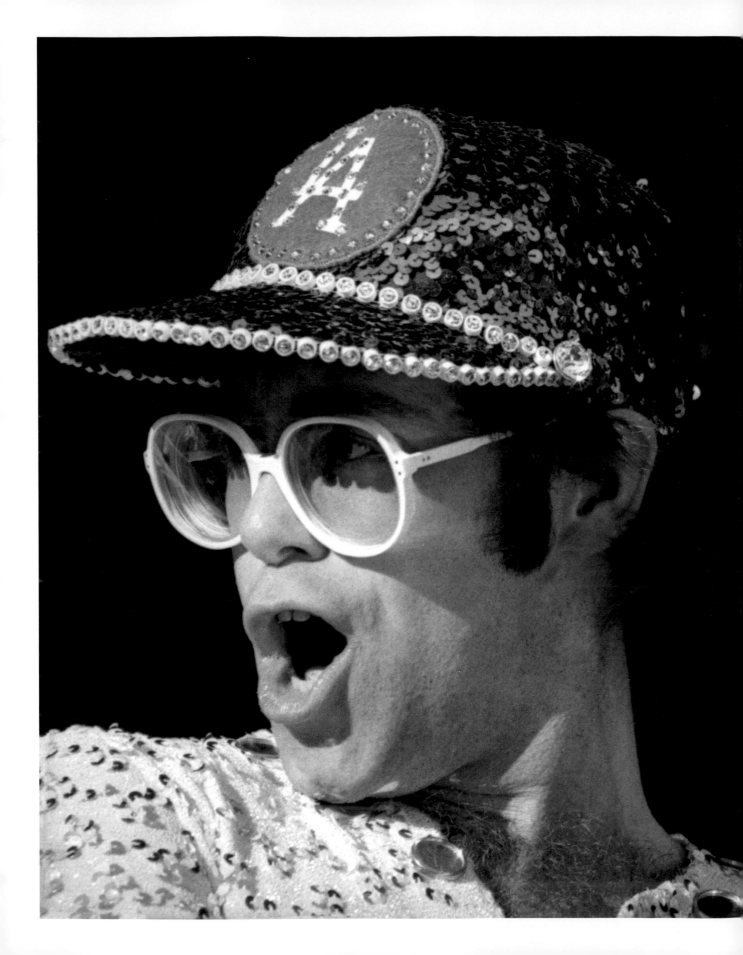

INTRODUCTION

"When it comes to photographic legends there can be few more prolific or revered than Terry O'Neill, the man who shot the greats."

VOGUE

When I started out as a photographer, I would take my cameras and run, quite literally, from job to job. It was the boxer Henry Cooper one minute, and Winston Churchill leaving hospital the next. Then back to the newspapers to deliver the rolls of film. Before they could start developing them, I was off again. One day, I got lucky. "There's a band recording over at Abbey Road Studios," said an editor. "We'd like you to go over and take their picture."

That band, The Beatles, would end up being one of the most important bands of the 20th century. And, in many ways, that assignment changed the course of my career. Those early images of The Beatles at Abbey Road, taken in 1963, ran the next day and the papers sold out. Pop was hot! And I was not only around the same age as these musicians, but I was also a would-be jazz drummer. My editors knew this, so I kept getting job after job, taking photos of new, emerging musicians, then actors, models, designers – individuals that would define, as Michael Caine recently called it, my generation.

After working with The Beatles, I had a call from Andrew Loog Oldham, the manager of The Rolling Stones. "Terry, I have a new band I am managing, and I'd like you to take their pictures." I told Andrew that I was too busy to travel to them, but if this new band was willing to visit Soho, then I'd meet them and see what I could do. My initial idea was to make them look like a travelling blues band, so I asked the boys to bring suitcases. Keith Richards told me, years later, that the suitcase he used for the shoot was the first one he ever owned; it still had the tissue paper inside.

Those two relationships with The Beatles and The Rolling Stones led to a career that, when I look back on it now, just makes me smile. How lucky I was. And what a time the Swinging Sixties were, with Michael Caine, Terence Stamp, Jean Shrimpton, Twiggy and Vidal Sassoon, not to mention Frank Sinatra, Audrey Hepburn, Raquel Welch, Brigitte Bardot, and Sean Connery as Bond. We bore witness to a decade that would change everything, with hopeful youth defying the austerity of post-war Britain and setting the country on a new course.

But in the span of about 12 months, from 1969 to 1970, horrible things happened. I witnessed first-hand what excessive drinking and drugs could do to people. The death of Brian Jones was a tragedy, as were the deaths of Jimi Hendrix and Janis Joplin, who I worked with when she recorded Tom Jones's television show. And if that wasn't enough, there was the horrific murder of Sharon Tate, a close friend. Those events left many of us lost.

In the early 1970s, pop music was floundering. The acts that had dominated the previous decade were just not around. The Beatles had officially broken up. Newspapers were on high alert for the next big thing – and they'd ring me frequently to ask if I had heard of any new acts that I thought might have talent, might be the singers that would break the next decade in the same way The Beatles or Stones had; the individual or group with the skill to balance on the shoulders of giants and retake the world of pop music.

I was in America when I first heard Elton John sing. I turned on the radio one day and 'Take Me to the Pilot' (1970) was playing. I thought, "Who is this new American singer?" He was special, had a great voice, and I knew right away that he was going to be a big star.

After making a few calls to different managers and PR people, I quickly learned that Elton wasn't American but English. Born Reginald Dwight in a town close to Watford, just outside London, he was actually living in a flat near London's Edgware Road. When I was back in the city, I asked his manager if I could come by and take some

Opposite: "I liked Elton straight away. I knew he was talented – that's why I contacted him in the first place – but we connected immediately. He had a nice little flat, complete with a piano, and we had a quick session together for some portraits."

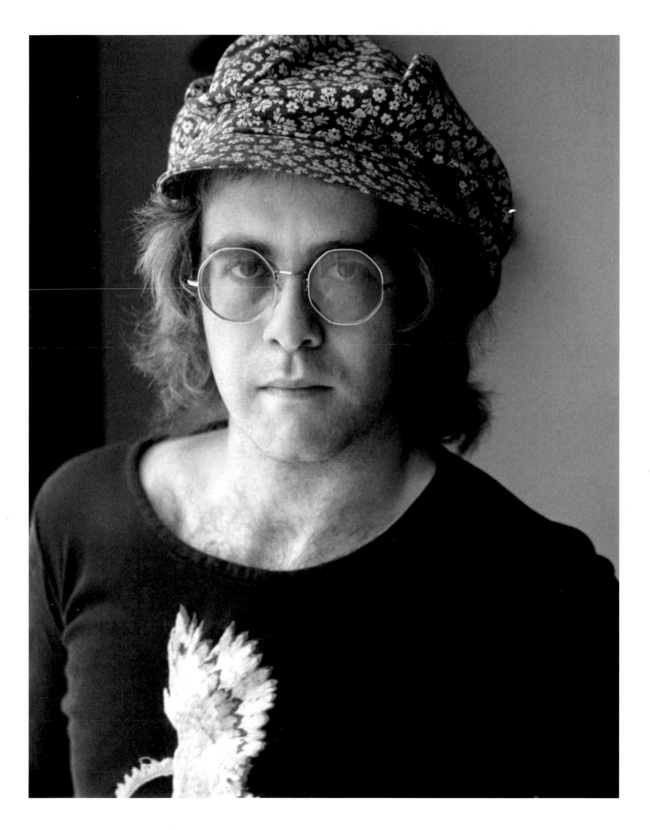

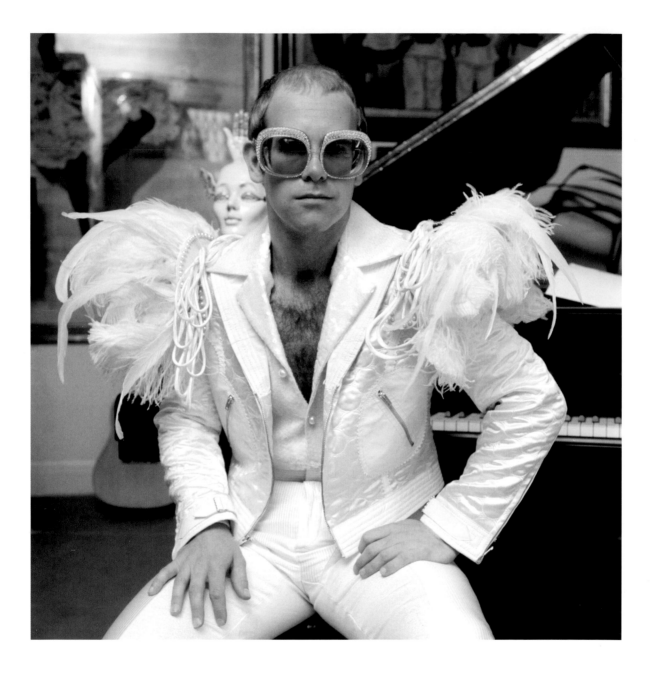

Above: "People ask me all the time what my favourite Elton John picture is. And I can never really answer that, because Elton graciously gave me so many opportunities to take a great picture. But this one, in colour – thankfully – stands out. It's his confidence that he developed over time when in front of the camera, my camera – and the outfit."

informal photos – I thought the newspapers and magazines might want to know about this guy, and if he had a record coming out, the photos would definitely run. I had a lot of good editorial connections, and pictures always help with publicity and getting the word out about a new act.

A date and time were arranged for me to take some photographs, and I made my way over to see him. I didn't know what to expect, but I found an absolutely charming young man wearing rock-star glasses. He was a bit shy, though. I could tell that he wasn't necessarily all that comfortable with me taking some straightforward shots, so we went to a rehearsal studio nearby, where he changed into a stage outfit and started to play the piano. And, I mean, he was not only playing, but also doing his best Jerry Lee Lewis jumping-handstand leap. On my way out, he gave me a cassette tape of what he was working on. It was labelled '17-11-70' and it was sensational. He was going to be the guy who resuscitated pop music, for sure.

I had a hard time placing those first photos but, finally, *Vogue* ran them. Elton kept plugging away, then, suddenly, boom! Everyone wanted to know him. And I started to get the calls: "Can you get us more pictures of Elton John?"

I'm lucky I followed my instincts that first time I heard Elton play. Those early portrait photos led to a working relationship that has spanned more than 45 years. I was allowed into Elton's life and captured not only great images of him onstage and backstage, but also memorable and sometimes personal moments of the man behind the star: for instance, working in his office, cheering on his favourite football team, even with his mother and grandmother. In 1988 Elton auctioned off nearly 2,000 items from his personal memorabilia collection at Sotheby's. The auction was so large that four catalogues were needed, and he asked me to take photos of him surrounded by some of the items he'd be selling: jewellery, art deco and art nouveau furniture, and stage costumes. Just looking at the shots of those costumes – and Elton is known for his extraordinary stage visuals – brings back fond memories of those times. I still consider him a friend and I've admired his ability to stay at the top of his game for all these years.

In the 1970s, at the start of Elton's career, I was a working photographer and had a good reputation for getting pictures and knowing how to place them. By this time, besides The Beatles and The Rolling Stones, I worked with numerous musicians and actors, and was one of the first photographers a manager or publicist would call when they needed a job done. The photo agencies all knew my work, too, and I think a lot of the celebrities I worked with appreciated the fact that I was quick with the camera. Relationships are everything in business, and by working with, and producing good images of, celebrities, I counted a few stars as friends.

A few years before I was introduced to Elton, I met Frank Sinatra and began a working relationship that would last until the great singer's death in 1998. Like Elton, Sinatra was a one-of-a-kind superstar and media celebrity who understood the value of having a photographer like me around to record the moments. Sinatra taught me valuable lessons about taking photos – mainly the art of being invisible. And so, once I got past my own nervousness, he allowed me to follow him everywhere. I replicated this technique with Elton years later.

The early 1970s also gave me the opportunity to work with another young rising British star. The first call I got to work with David Bowie came in 1973, around the same time I started to work with Elton. As with Elton, I ended up working with Bowie for decades, shooting portraits as well as recording studio, stage and behind-the-scenes moments. While different musically, there are some similarities between these three icons, with each one being a musical genius happy to allow me rare access to his personal and professional life.

When the calls came to photograph Elton, it would usually be for a specific assignment. After the release of his first few albums, he was at the top of the charts, and the papers and magazines wanted more. On occasion, I'd go and simply hang out with him wherever he happened to be. But after a while, I could tell he wasn't comfortable with straight-ahead portrait or candid photography. Unlike Bowie or Sinatra, it was difficult for Elton to pretend that I wasn't there, lurking around with my camera. Bowie and Sinatra could block me out entirely or use my camera to their advantage. Elton was different, but over time he got more used to it.

In the beginning, I needed to understand how best to work with the star and make him comfortable enough so we could get the photos we needed. I figured out quickly that the trick was to create a shot list of what I thought we'd be able to do and then just walk him through it as quickly as possible. Sometimes, we'd just get lost in his house. It's often true that the bigger the star, the bigger the collection, and Elton was a bit of a shopaholic. He had collected thousands of records, and his closets were bursting with shoes, scarves and outfits – all the accessories a flamboyant star could wish for. And while some of the clothes were perhaps not my style, anyone could immediately see that he had great taste – in everything. When I asked him to pull out a record from his collection that was special to him – maybe because it was valuable or had particular meaning – without hesitation, he reached for John Lennon's *A Guitar's All Right John But You'll Never Earn A Living By It* (1975).

Favourite records aside, as soon as the big money started to roll in, Elton began purchasing art, sculpture and rare photographs. In 2016, Tate Modern in London showed his priceless collection of mid-century photography in its exhibition *The Radical Eye*. He owned one of the first cars with a working television in the back. I remember, too, that

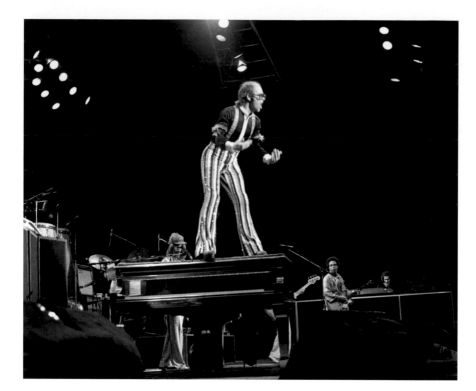

the private jets he'd charter for touring – and which I was fortunate enough to take a spin in – usually came with a baby grand piano on board. Even his office had a glass Allen Jones table. I have no idea what he might have paid for it in the mid-1970s, but I know that a similar piece sold at Christie's recently for more than £700,000.

As well as taking candid shots, Elton and I had hundreds of traditional portrait sessions together. Whether in colour or black and white, they are among my favourite images. The "white feathers" session, sitting outside the Café Les Deux Magots in Paris with his longtime writing collaborator Bernie Taupin, or even the denim jumpsuit series that I did for *Playboy* magazine produced great images of the artist. I believe he was more comfortable this way, when he was able to dress the part of his stage persona. He wasn't just a mate showing me around his house; he was a rock star, in every sense of the word.

Occasionally, I'd get the call to do an album cover. In the space of about four years, I worked on three of Elton's bestselling records. The first was in 1974, a "best of" collection that would introduce some of his earlier music to the millions of people who were just now tuning in to his songs. Following the smash success of *Honky Château* (1972) and *Caribou* (1974), *Greatest Hits* was set to cover the first four years in Elton's career. Back then, a recording artist at his level of popularity would be expected to release an album a year at the very least. Remember, there were

no downloads or streaming back then. You had to buy the singles or the albums if you wanted to hear your favourite music over and over. Record sales, at that time, were in the millions. Releasing a greatest hits album so early in a career was not unusual. We decided to go classical and dress him up in a clean, classic white suit with a cane, then sit him in front of a beautiful black baby grand. The back of the album featured a photo from the same session but in portrait.

In 1975, I was called in to join Elton and his band at the famed Caribou Ranch recording studio in Colorado, where they were putting the finishing touches to *Rock of the Westies* (1975). This was only the third album recorded at the relatively new recording studio. We decided to be much more informal this time, so I shot a relaxed Elton, smiling and sitting outside the studio. I also took portraits of the three key members of Elton's team: guitarist Davey Johnstone, drummer Ray Cooper and lyricist Bernie Taupin. At the ranch, Elton seemed upbeat and focused. Little did we know what a difficult year he was having. He was the number-one bestselling artist in the world, yet behind the scenes he was struggling with depression and exhaustion.

A few years later, Elton and I met again to shoot the cover of *A Single Man* (1978), photographed on the Long Walk in Windsor Great Park, Berkshire. We decided to go back to the classic style, with Elton wearing a black coat and top hat. The back of the album was simple: the same shot but from behind.

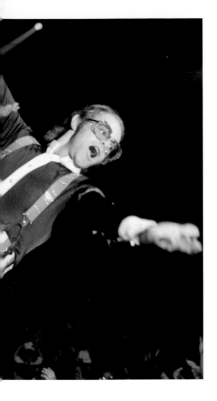

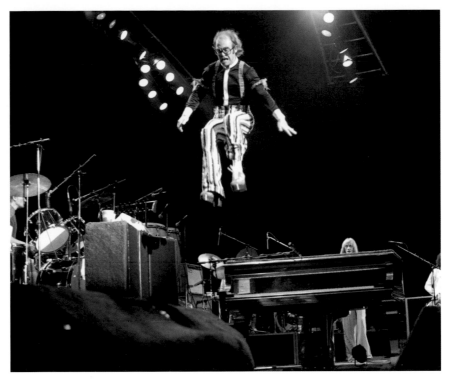

In the early 1960s I also had the opportunity to work with interesting people on film and television sets. Bands were starting to appear on variety shows – The Rolling Stones on *Thank Your Lucky Stars* in 1963, for example. These types of programmes were incredibly important to a star's exposure, with one appearance getting you in front of millions of would-be listeners or ticket buyers.

Television brought me a wide variety of subjects, from Tom Jones and Cher to Janis Joplin and Carol Channing. I was on the set for at least two Elton appearances: the *Parkinson* show in 1976, on which he appeared with my old friend Michael Caine, and *The Muppet Show* in 1977. I had never worked with The Muppets before, but the show was hugely popular and, to be fair, great fun. I also happened to be present at the first Rock Music Awards, held in Los Angeles in 1975, which were set to rival the Grammys but only lasted three years. For that first year, though, the organizers pulled out all the stops, and there was Elton with the great Ella Fitzgerald.

I was also there for the filming of the movie version of the rock opera *Tommy* (1975), based on The Who's 1969 album of the same name. The Pinball Wizard sequence, in which Elton played the lead, was shot at the Kings Theatre in Southsea, with Elton backed by The Who (Roger Daltrey, Pete Townshend, John Entwistle and Keith Moon). Someone once told me that Elton had only agreed to the role on the condition that he could keep the giant boots he famously wore.

The 1970s started to get busy. Besides working with Elton John on so many seminal occasions, I was booked for countless other studio portrait sessions with the new acts of the day. My work with David Bowie led me to the set of *The Man Who Fell to Earth* (1976), and when I was back in Los Angeles, I arranged a meeting between Bowie and Elizabeth Taylor at film director George Cukor's home. This resulted in a series of terrific photographs, one of which is part of the permanent collection at the National Portrait Gallery, London. I even ran into Bruce Springsteen on Sunset Strip when I was heading into Tower Records as he was leaving. Those chance photos landed on the cover of *Melody Maker* at a time when his album *Born to Run* (1975) was rising in the charts.

Reflecting on all my work with Elton, it's 1975 that stands out. It felt like a whirlwind to me, so I can't even imagine what it felt like for him. In those 12 months he probably worked the hardest that any musician has ever worked: international tours, the release of the cult rock opera *Tommy*, concerts in clubs and stadiums, television appearances, recording and releasing two albums, on top of everything else that was happening behind the scenes.

While the tours must have been physically draining for Elton, 1975 provided many memorable live performances. The ones I caught were, I believe, his best. The first took place on Elton's home turf at Wembley Stadium.

Working live shows presents a whole new set of problems and opportunities for a photographer. And, sure, I had

worked with Frank Sinatra on several occasions, but his stage movements were a bit different from, say, those of Elton and other 1970s giants such as Led Zeppelin. Lucky for me, I'd had some recent experience shooting rock stars playing live. At the end of 1974 I was in Los Angeles on tour with David Bowie in support of his *Diamond Dogs* (1974) record. I remember I was shooting in colour and black and white, which was unusual for me. The shots turned out nicely, so I was up for a new challenge. Elton was going to play a big show at Wembley the following year and I was asked to document the day, which included rehearsals and time backstage.

The concert on 21 June was promoted as MidSummer Music, with Elton John joined by several of his favourite American acts: The Beach Boys, the Eagles and Rufus with Chaka Khan. The television commercial that ran to promote the show portrayed Elton playing football with Chaka Khan! And tickets were £3.50.

Before the gates were opened, Elton, his crew and I walked around the venue to capture the view that only a few ever experience: an empty stadium. Then he went into rehearsal and a sound check.

When the first acts went on in front of a crowd that topped 70,000, most headliners would have been in the back, resting before it was their turn to shine. But not Elton. He was right in the front, dancing away to The Beach Boys.

When it was Elton's turn to take the stage, he did it with gusto. The first set was a mix of his best-loved songs. And the crowd was with him every step of the way. For the second act, however, he decided to perform all the tracks on his newest album, *Captain Fantastic and the Brown Dirt Cowboy* (1975), released only a month earlier. Although the members of the audience weren't as familiar with all the tracks, they were not disappointed, by any means.

After the show, there was a host of names to greet and congratulate the star backstage. I found Paul and Linda McCartney mingling with Harry Nilsson. Billie Jean King was also there, weeks away from winning her sixth Wimbledon singles title, along with an emerging tennis star, the relatively unknown Martina Navratilova. It wasn't unusual to see Billie Jean King with Elton – they were great friends. Elton was also a tennis fan, and the pair would play in charity matches and often attended tournaments together as spectators.

At the start of the year, Elton had released the song 'Philadelphia Freedom' (1975), which was inspired by Billie Jean, and it became an instant number-one success. Their friendship remains strong to this day. In 1992 he founded the Elton John AIDS Foundation in the USA, with Billie Jean King as the Honorary Lifetime President. The UK chapter opened a year later. As one of the biggest charities in the world, the Foundation has raised more than £400 million to help people to get treatment and doctors to find a cure.

Most superstars would consider a monumental Wembley concert enough for one year, but by the time October rolled around, and with two number-one albums behind him, Elton

took on America. The venue was the world-famous Dodger Stadium in Los Angeles, and two days, 25 and 26 October, were booked for the concerts. A jet was chartered to fly Elton from Heathrow to LAX, along with his family and friends who were to witness the event, all of which was recorded for a television special with chat-show host Russell Harty.

A few days before, Elton received a star at the Hollywood Walk of Fame. Whole blocks of Hollywood Boulevard were closed to accommodate the thousands of fans who turned out to catch a glimpse of the rock star. The event kicked off what was officially celebrated as "Elton John Week". He would also receive a gold disc for the album *Rock of the Westies*, which debuted at number one in the charts not long before the show.

Before the concert kick-off, there was the rehearsal and sound check to do. At a venue as large as the Dodger Stadium, a crowd of more than 55,000 was expected to attend each night, so making sure everything sounded good was a priority for Elton. That was when I began to appreciate the size of the venue. It was massive. And the sound, even without 55,000 people screaming and singing along, was fantastic.

The gig was scheduled to start at just after 1pm with the opening acts: Emmylou Harris, followed by the James Gang, with Joe Walsh, who would soon join the Eagles. Unlike at the Wembley gig, where Elton danced along to The Beach Boys, here he stayed mainly backstage. All the major stars in Los Angeles were gathered, including film legend Cary Grant. Davey Johnstone, Elton's guitarist, told me recently that when Grant appeared backstage, a few of his friends thought he was Gary Cooper. Elton was in a great mood messing around with security and the backup singers, and when his friend Billie Jean arrived, he really lit up.

When it was Elton's turn to take centre stage, a few hours after the concert had started, the crowd was at fever pitch. At one point, I found my way – I don't know how I did it – to the very back of Dodger Stadium, and was able to capture the immensity of the crowd he was facing.

Elton was giving 150 per cent and all I had to do was keep up. For some shots, I stood in front of Ray Cooper, the drummer, so I could see what the audience looked like from Elton's point of view. Those pictures of Elton, facing the crowd in his Bill Mackie-designed, sequined LA Dodger uniform with "Elton 1" on the back, baseball hat and bat in hand, are among the most iconic and requested photos in my archive. They've been used and viewed the world over.

One of my favourite moments was when Billie Jean ran onto the stage. Elton was playing 'Philadelphia Freedom', and here was the number-one female tennis player in the world onstage at the biggest rock concert of the year, performing with the backup singers.

Bernie Taupin joined Elton onstage when he started to play 'Don't Let the Sun Go Down on Me' (1974). Aptly timed to coincide with the famous California sunset, it was the

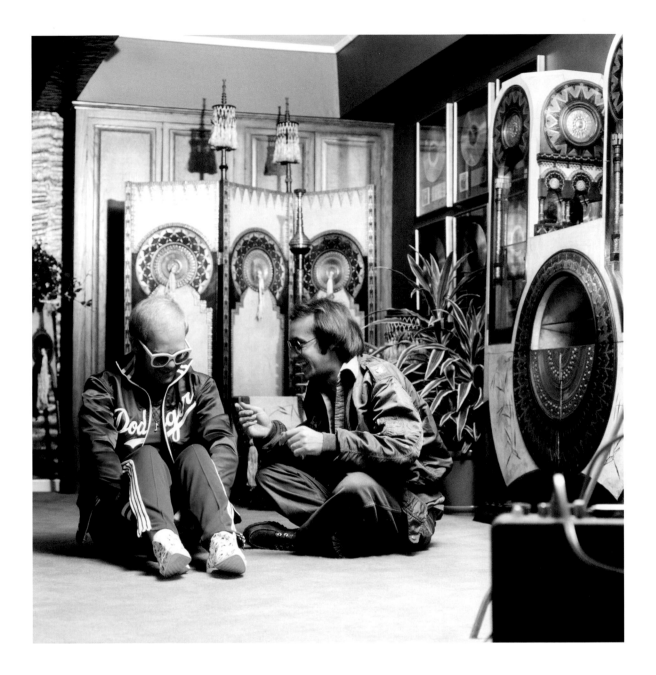

**Above: Elton John and Bernie Taupin,
his longtime collaborator.**

beginning of the end of a perfect day. After more than 30 songs in a three-hour, high-octane performance, Elton closed with 'Pinball Wizard', a song that was not only one of the bestselling hits of that year, but also one that has become a true modern classic.

I must have used more than 50 rolls of film, colour and black and white, over those two days, and spent most of the time over the following weeks getting them developed and doing photo edits for all the papers and magazines that wanted to run stories about this triumphal two-day concert.

A few weeks after the show, the television special was broadcast, complete with Russell Harty interviewing Elton at his LA home, the former residence of screen icon Greta Garbo. I have a few blink-and-you'll-miss-me cameos in the documentary. In one blink, you'll catch me next to the backup singers with two or three cameras around my neck. I laughed when I saw that. I never expect to see images of myself – I stay behind the camera for a reason. Watching the special, I really wanted to relive the moment when the biggest star in the world played to more than 110,000 people over the course of two days.

After that week Elton was wiped out. It was only years later that he revealed publicly what he had been going through privately. The pressures of fame and the troubles they caused were taking a serious toll on the man. Apparently, he took a large handful of pills and jumped into his swimming pool, in the hope that everything would end. It's hard for me to believe, but, then again, I saw first-hand what that level of fame can do to a person. I don't think I've ever witnessed anyone work so hard in my life and be so dedicated to putting on a show that the crowd would remember for the rest of their lives. I'm thankful and relieved that Elton was strong enough to beat his personal demons and have the courage and strength to carry on.

Elton worked hard on his public persona, but behind the glamour and glitz, I think there's a quiet soul. He's an immensely gifted musician, classically trained, and no one comes close to his piano playing. He's actually very down to earth and always great fun. His mother and grandmother were very special to him, I know. I met and photographed them both. And, of course, as a good Englishman, he loved his football. During the rehearsal and sound check before the Dodger Stadium tour, someone brought out a football and a few of us had a quick game on the field. Elton loved football so much, he became club chairman of his beloved Watford FC in 1976. He grew up watching his local team from the terraces, and when he reached superstardom level, he was able to invest in the club and join the board of directors. Elton was Watford's biggest and most famous fan. When he attended games, it was an event, but I think that deep down he just wanted to be there as an ordinary fan. I went with him on occasion to matches and could follow him around the back offices and locker rooms, meeting his team then cheering them on from the stands. Elton really cared about his team, Watford, and he brought in the right people to manage the team and take them to a new level of play. He also was a leading figure in making football more "family friendly", if you know what I mean. He wanted football to be open to all – for everyone to enjoy this great game.

I think that's why our photos work. I call them "our photos" because they are as much about the subject as they are about the photographer.

I was allowed unprecedented access to Elton's life and work from the very beginning – in the recording studio, portrait studio, at home and at play, onstage and off. My relationship with him for more than 45 years now has been one of the most rewarding friendships in my life, and he has always been kind to me. I must have thousands of photos of the man in my archive, and when you start looking at them, it's like witnessing the visual evolution of a superstar.

Although it has been nearly 45 years since that night at Wembley, and those two nights in Los Angeles, one of my fondest memories is the split second I stood in his shoes. Elton was mid-performance at Dodger Stadium and I was onstage, working hard. I tried to stay out of the way, moving as quickly as I could so as not to distract the musicians. Then I heard Elton announce gleefully into the microphone, "In case you are wondering who this photographer is, it's Terry O'Neill!" The crowd cheered riotously for a man who was supposed to be invisible.

And it's for such moments that you can't help but love Elton. He's a genius, an enigma, a star and one of the kindest, most compassionate people – both in public and in private. I had the pleasure of working with Elton John for all these decades. I'm proud to share with you just some of the images I captured. His music has become part of the soundtrack to our lives, but behind all the music is an incredible person that I've had the privilege to know. I can promise you this, there will never be anyone quite like him again.

Terry O'Neill.

Opposite: Elton John in concert at London's Wembley Stadium, June 1975.

Following pages: "Elton was great to work with, and a great subject. We quickly figured out how to work together in those early days. But I went out of my way to work with him because of his talent. And the fact that he's still out there – giving it his absolute all on stage – that's astonishing."

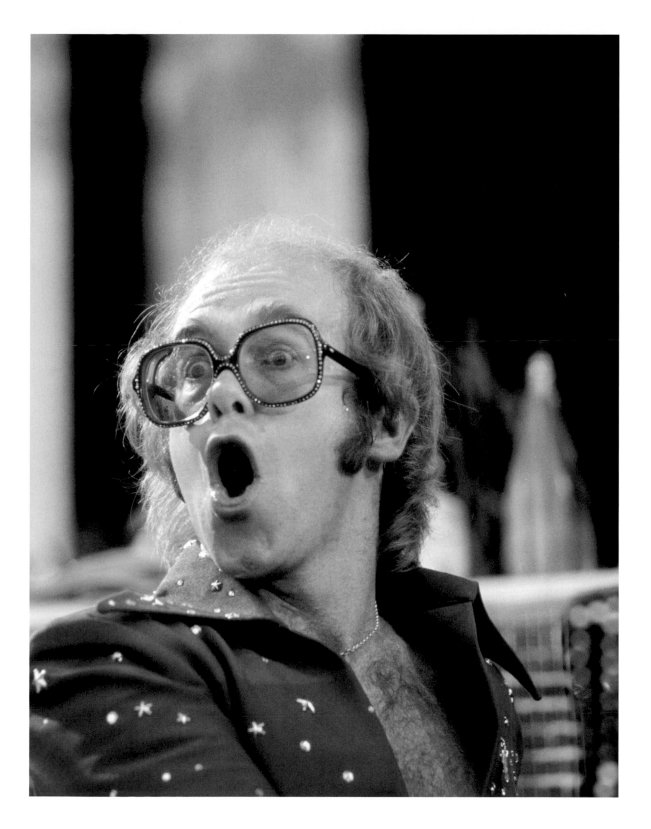

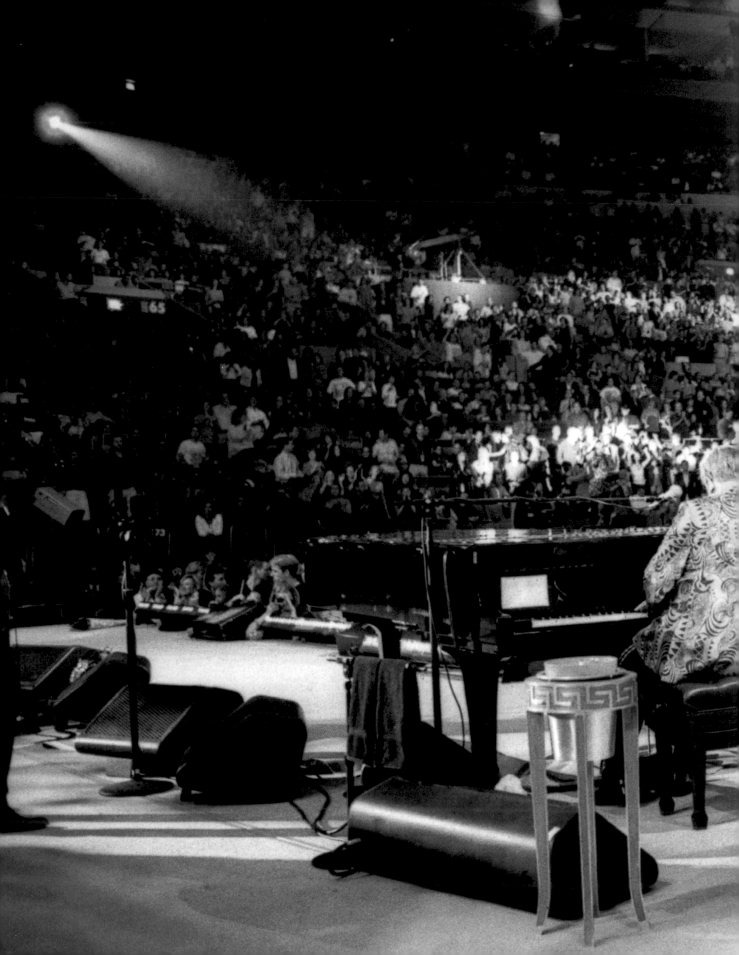

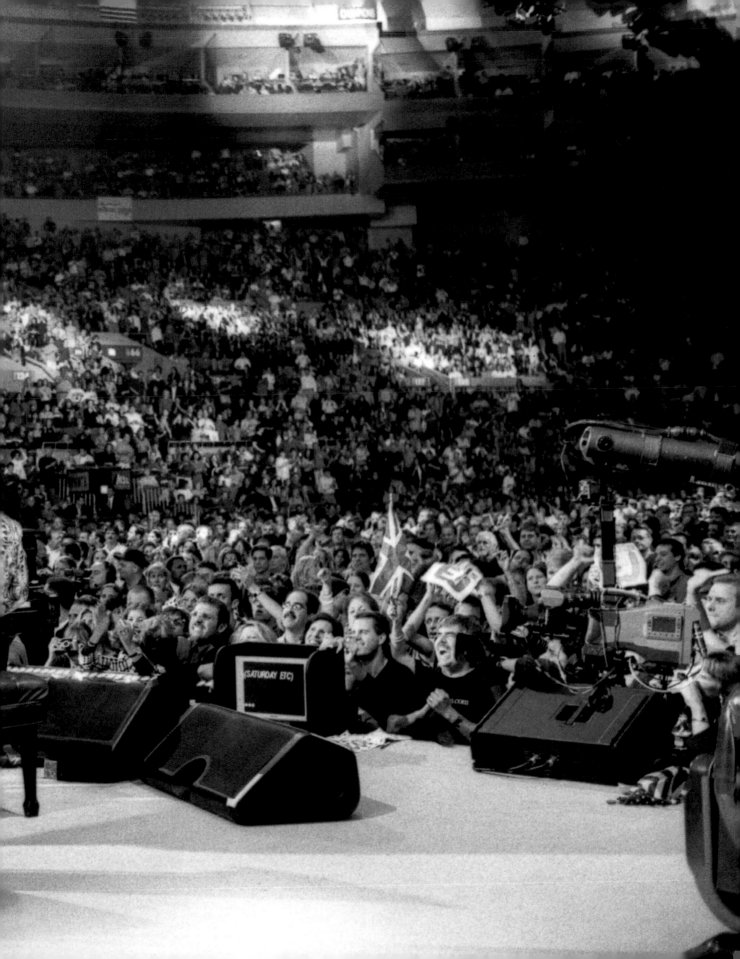

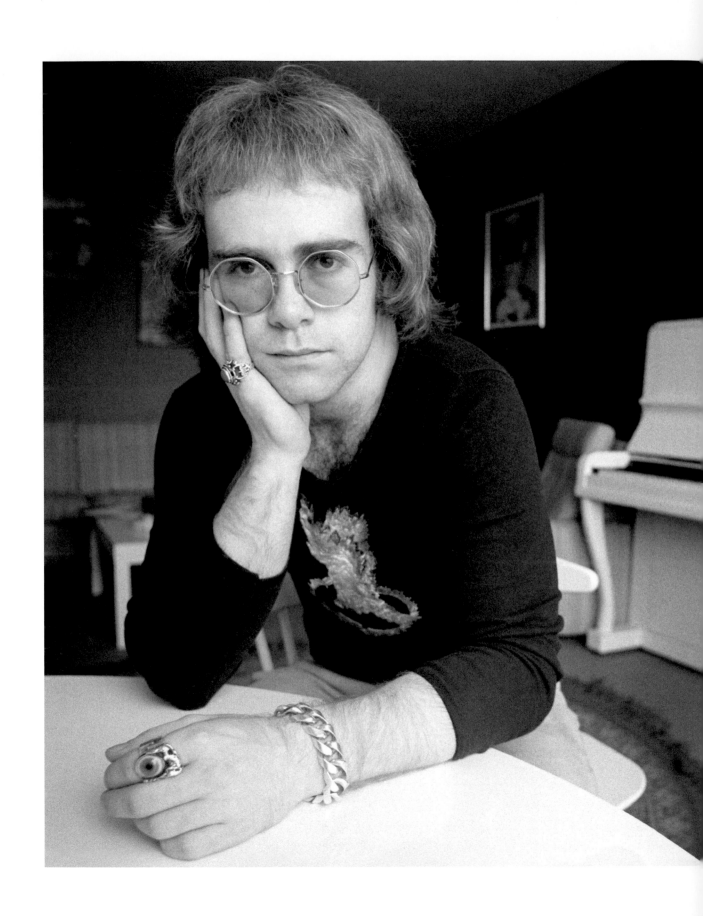

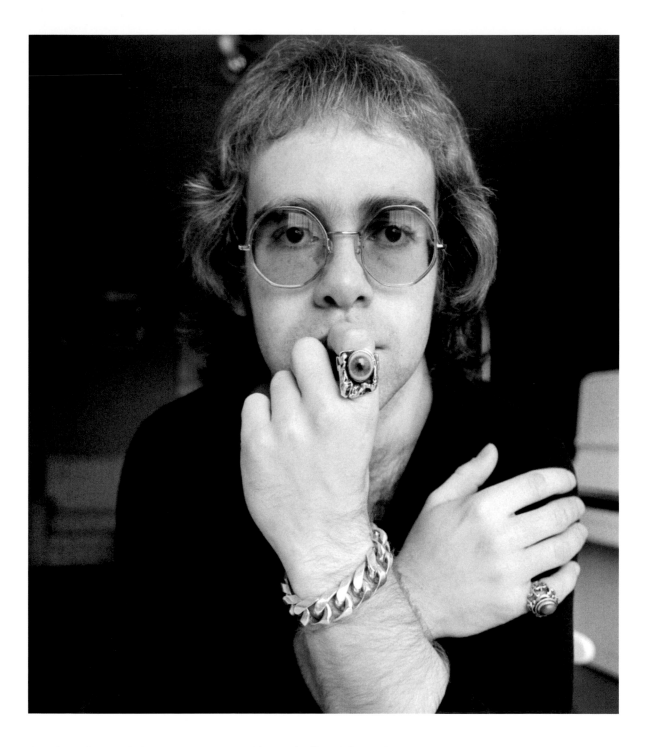

Opposite and above: The first
photoshoot at Elton John's home
off London's Edgware Road, 1972. "I had
a hard time selling these early images.

British *Vogue* finally took them and they
ran the image above. A few months
later, all the magazines and newspapers
were calling me, looking for Elton."

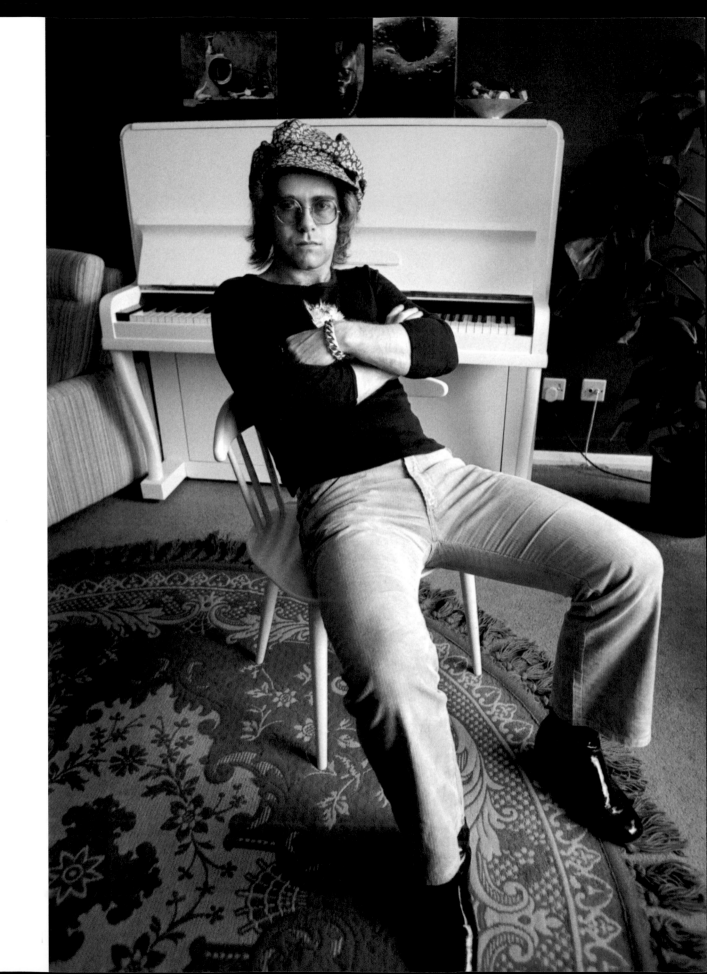

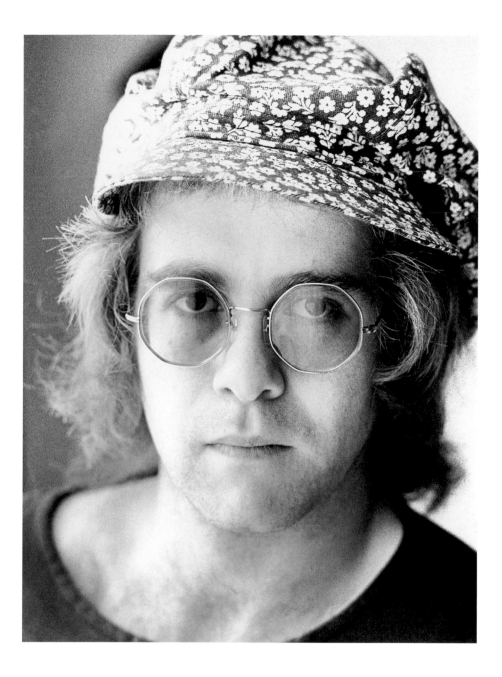

Opposite and above: "As I left Elton's flat, he gave me a cassette. When I went home to have a listen, well, it was extraordinary. He was going to be a big star – there was no doubt in my mind."

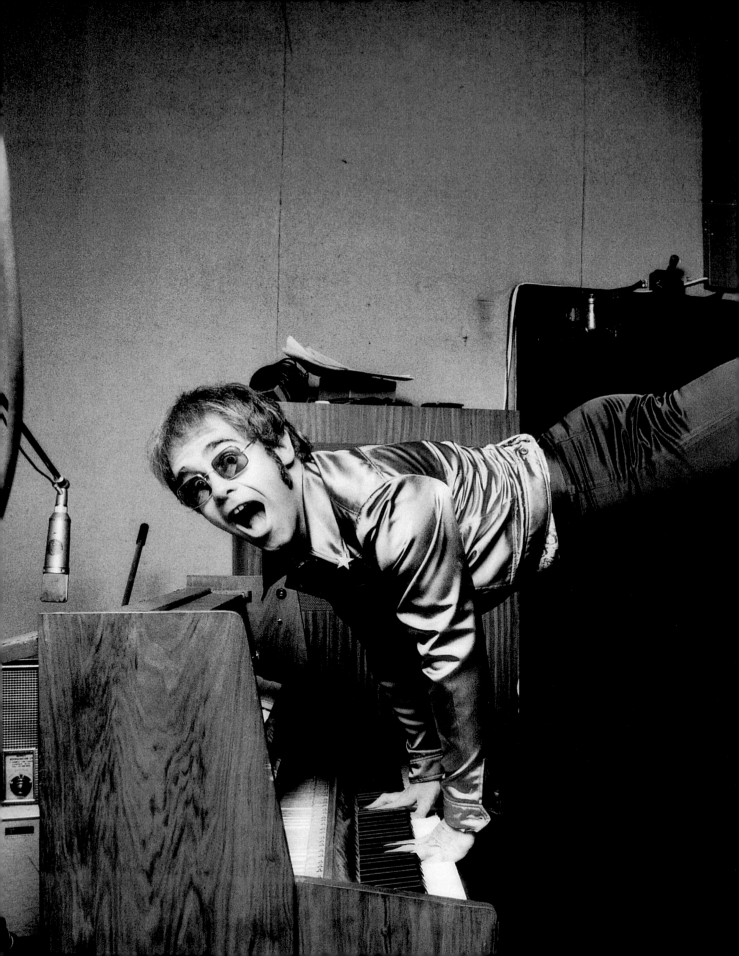

Left: "The famous jump – he used to do this on stage! This was his trademark move, no wires needed."

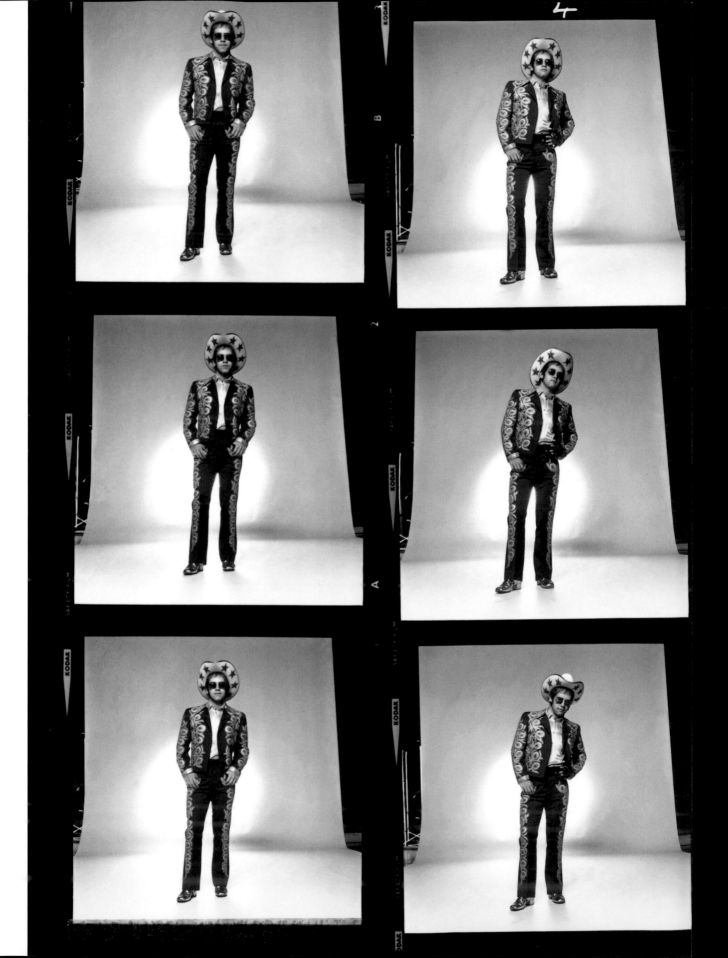

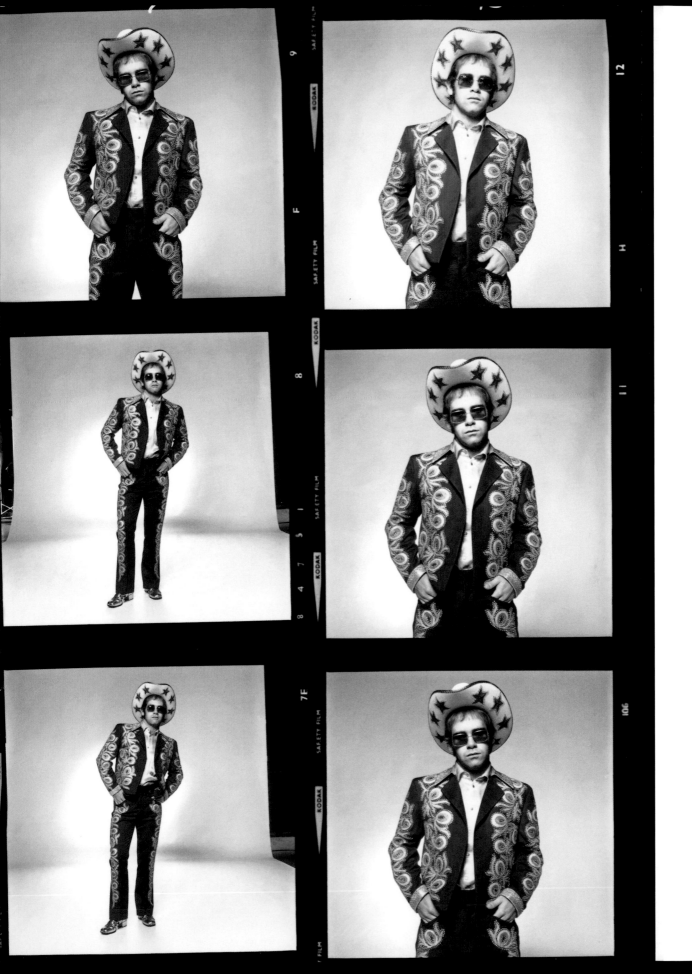

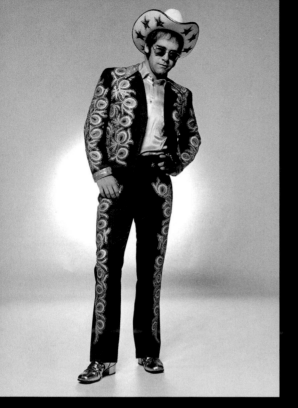

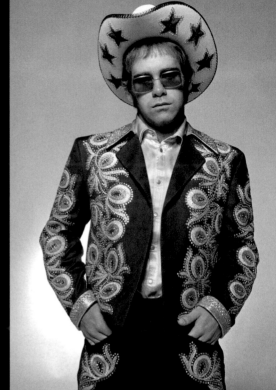

Previous pages, above, opposite and overleaf: Promotional images for the album *Honkey Chateau*, used for in-store display as well as the cover of the single 'Rocket Man' (1972). "These must be the first, real promotional shots I did.

You never really know what the use will be; they don't tell you, 'Oh, this will be for a record cover', or anything like that. But they did end up using quite a lot of these, and it was great to see them on the cover of such a successful single."

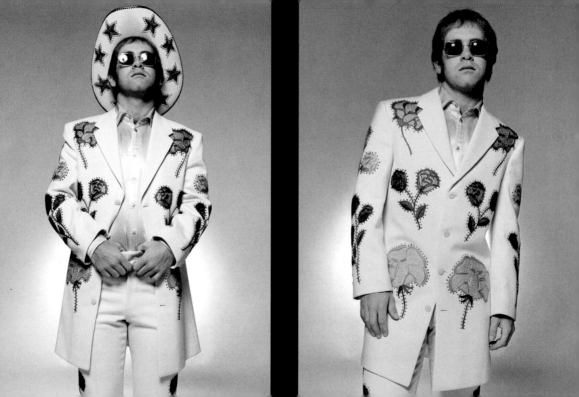

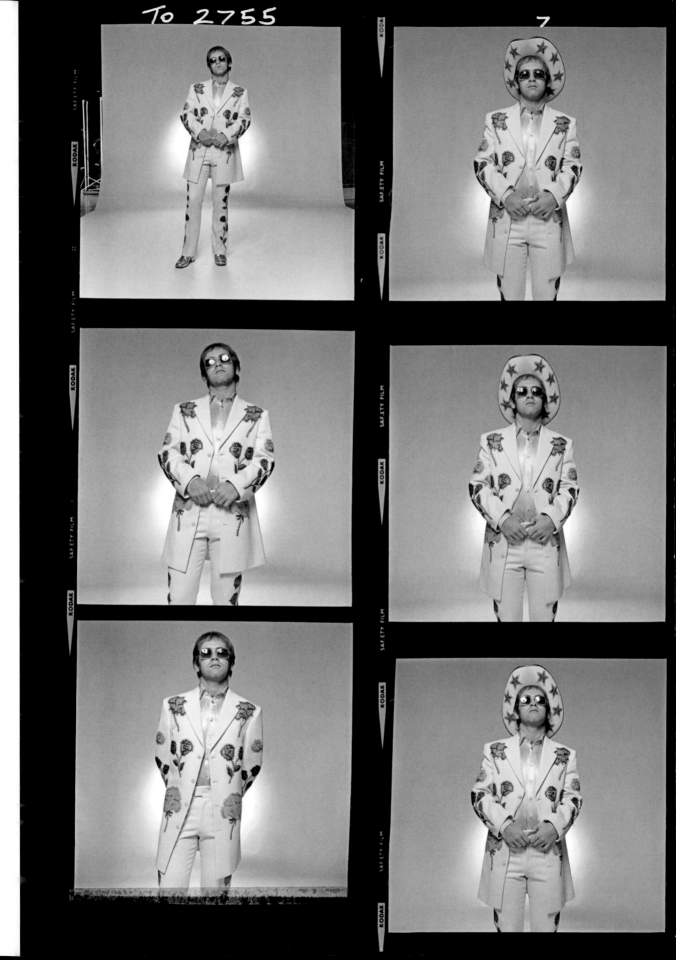

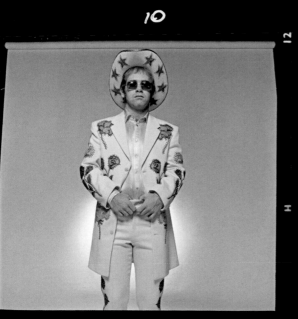

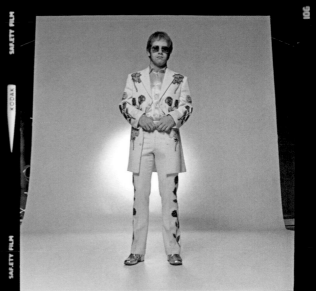

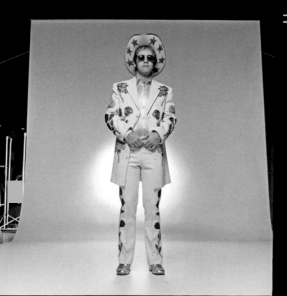

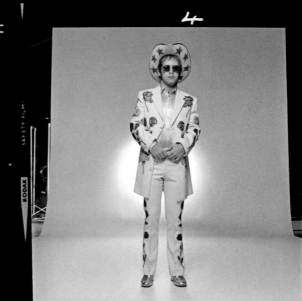

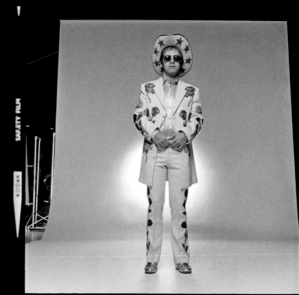

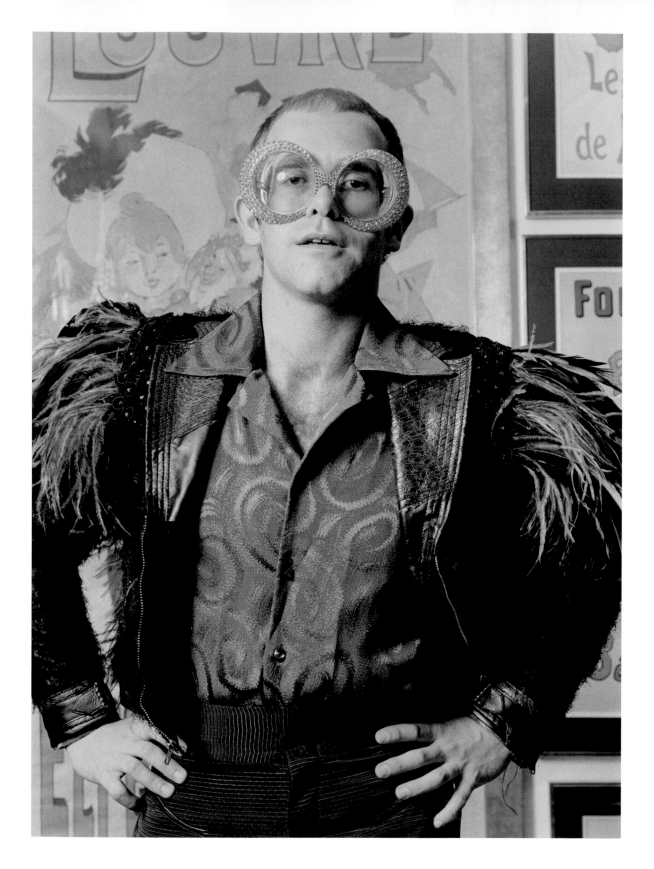

Opposite: "He loved the costumes, that was pretty evident. But no one had better eye-glasses than Elton John."

Below: "Bob Mackie, Tommy Nutter – Elton's closet was filled with all the designer labels of the day."

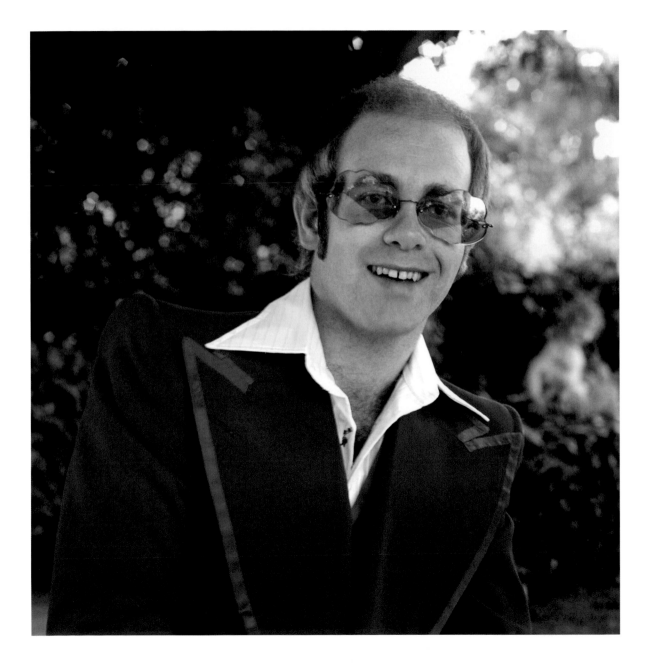

Below: Elton John and his band for the promotion of 'Philadelphia Freedom', 1975. Clockwise from top left: Dee Murray, Elton John, Ray Cooper, Nigel Olsson, Davey Johnstone.

Opposite: From the photo shoot for the 'Louder than Concord But Not Quite as Pretty' programme, 1976. "Standing in the back, that's James Newton Howard, Davey and Ray. Ray's great – a drummer! But I don't remember who the other guy is, with the sunglasses." Bottom row: Caleb Quaye, Elton John, Kenny Passarelli and Roger Pope.

Overleaf and following pages: Elton on stage at the Hammersmith Odeon, London, December 1974.

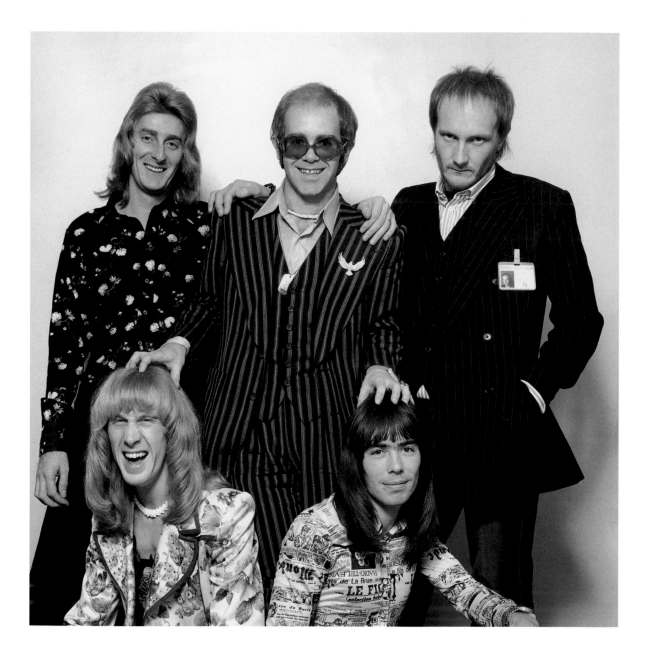

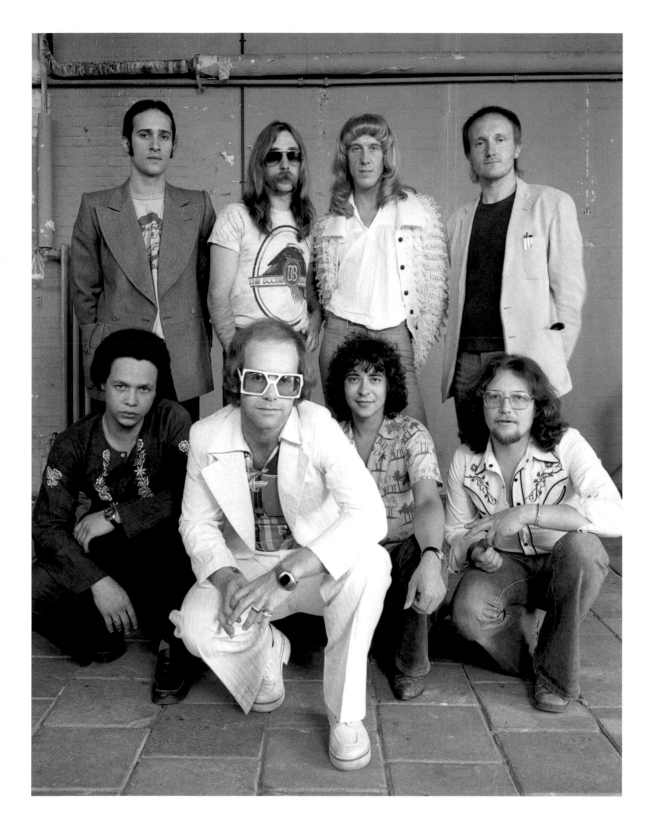

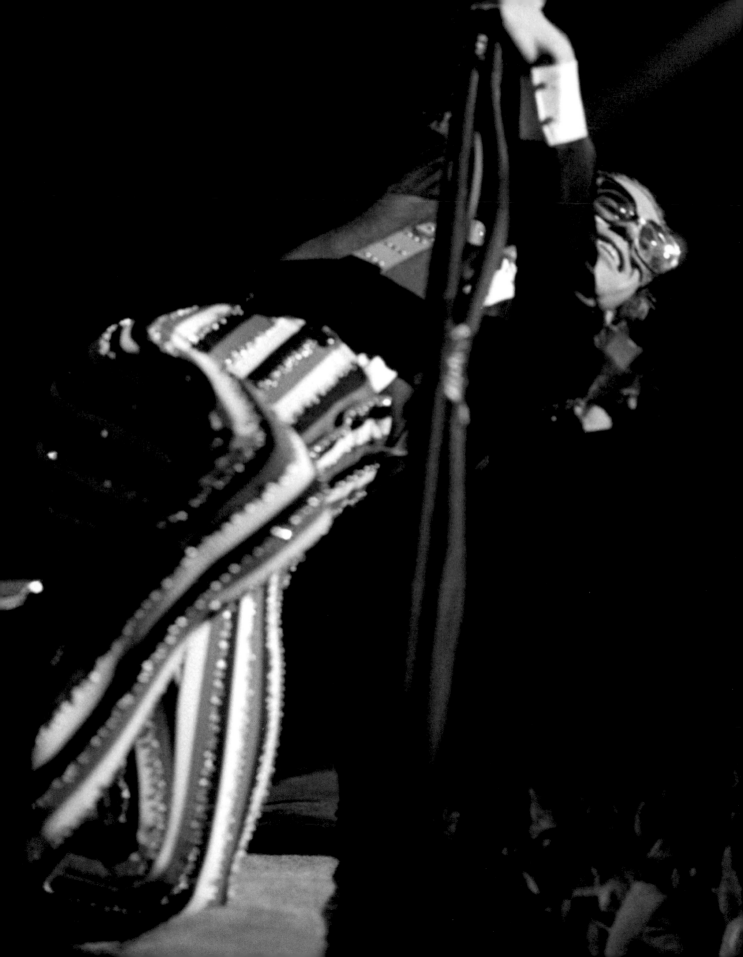

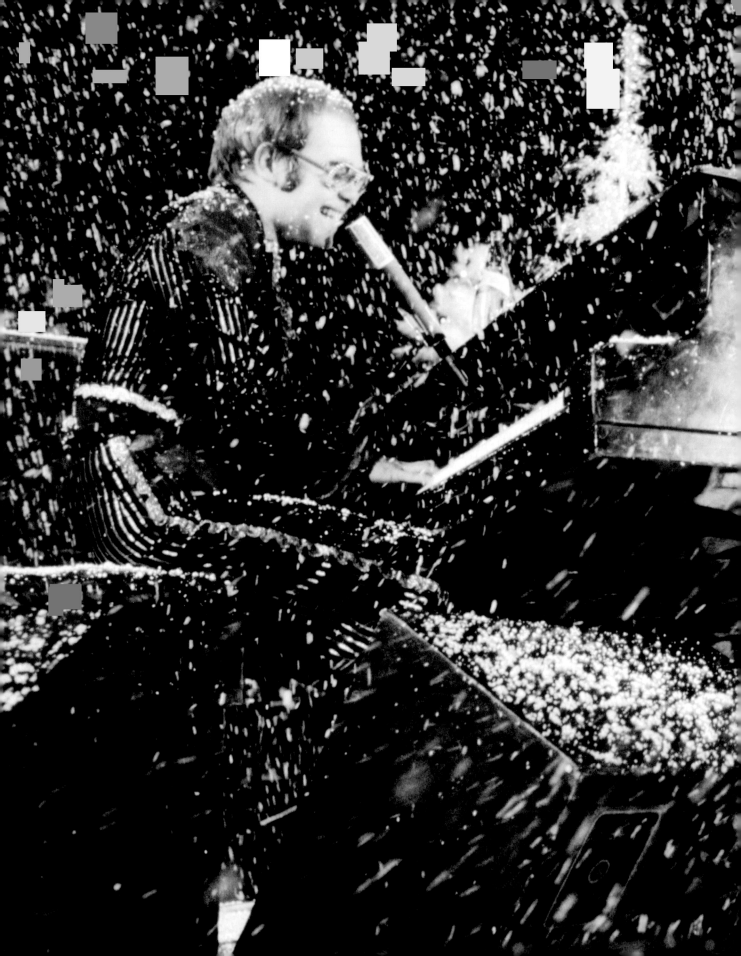

This page and opposite: "This was one of the first times I ever took photos of Elton performing for an audience, for the 1974 tour promoting *Goodbye Yellow Brick Road*. I wish I had more of my negatives from this night, because he decked out the piano in sequins that sparkled throughout the show."

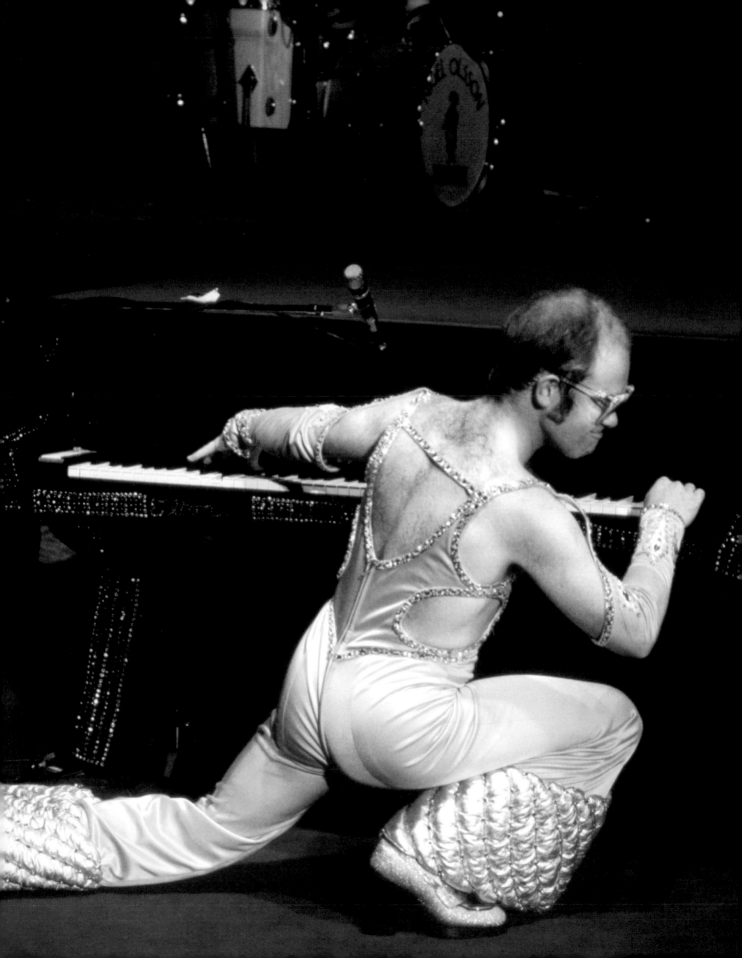

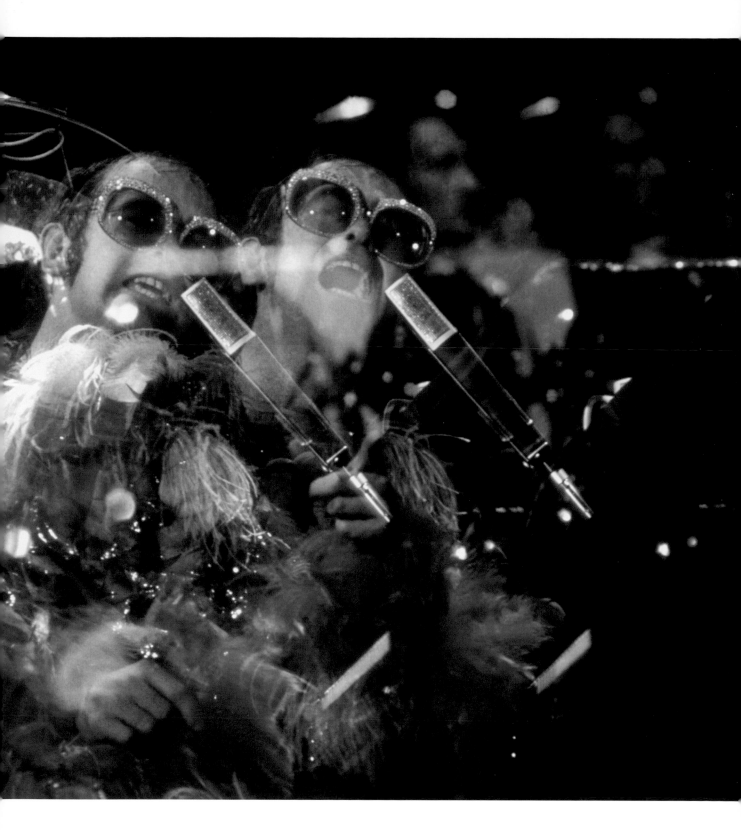

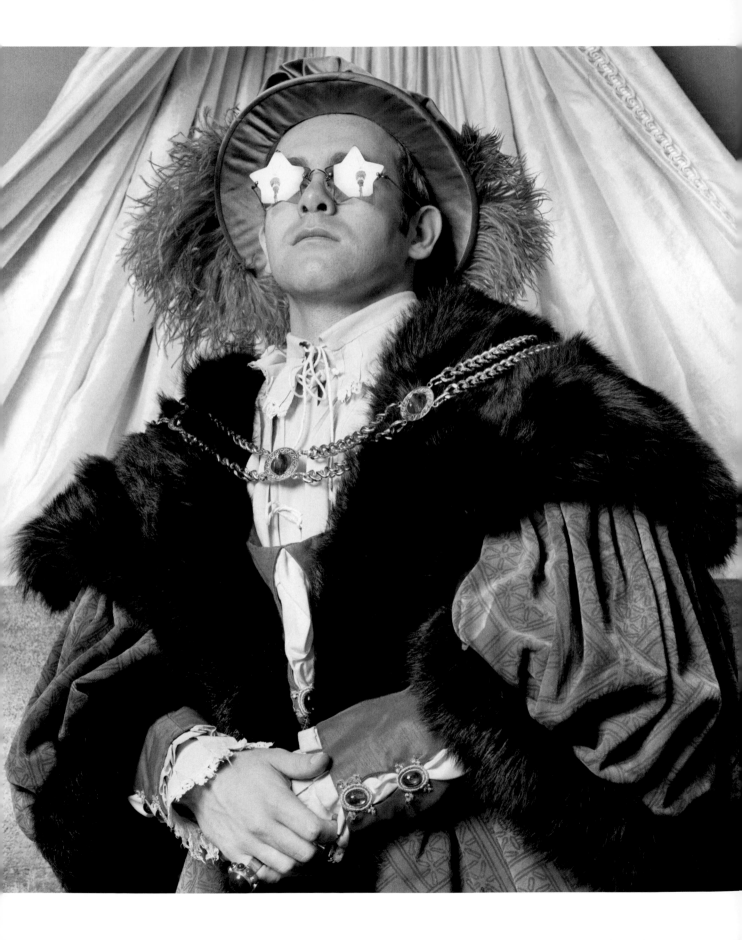

"I never really knew ahead of time what the outfit – or outfits – would be."

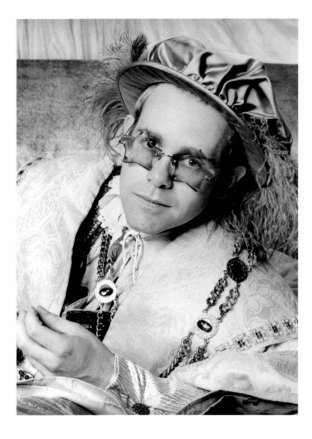

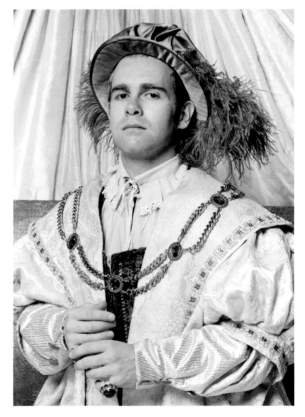

Opposite and above: "Elton was always up for putting something on, and I never really knew what would be next. He did love his glasses, though – he must have had hundreds of different frames. You could do a whole book just on Elton's eyewear."

Below and opposite: "Often there was not a specific assignment, just a need for general portraits that would be used for the press, mainly, to go along with interviews and articles. And at this time, around 1974, the press was running anything and everything Elton-related."

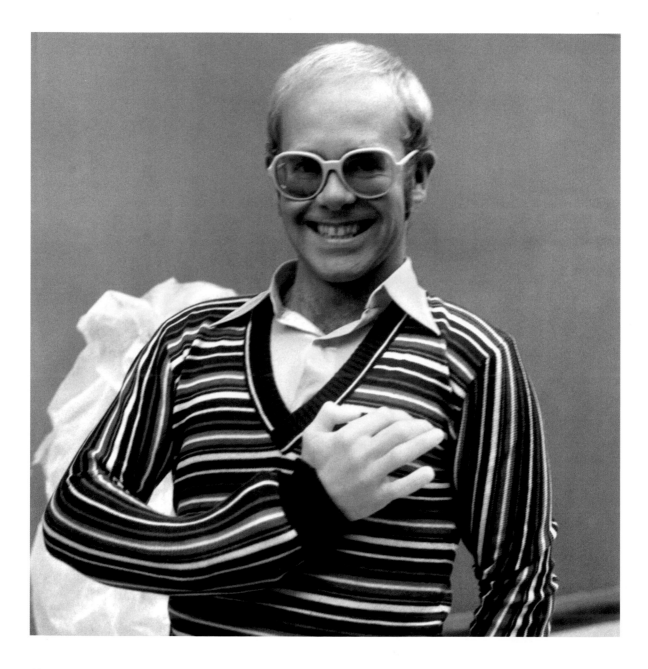

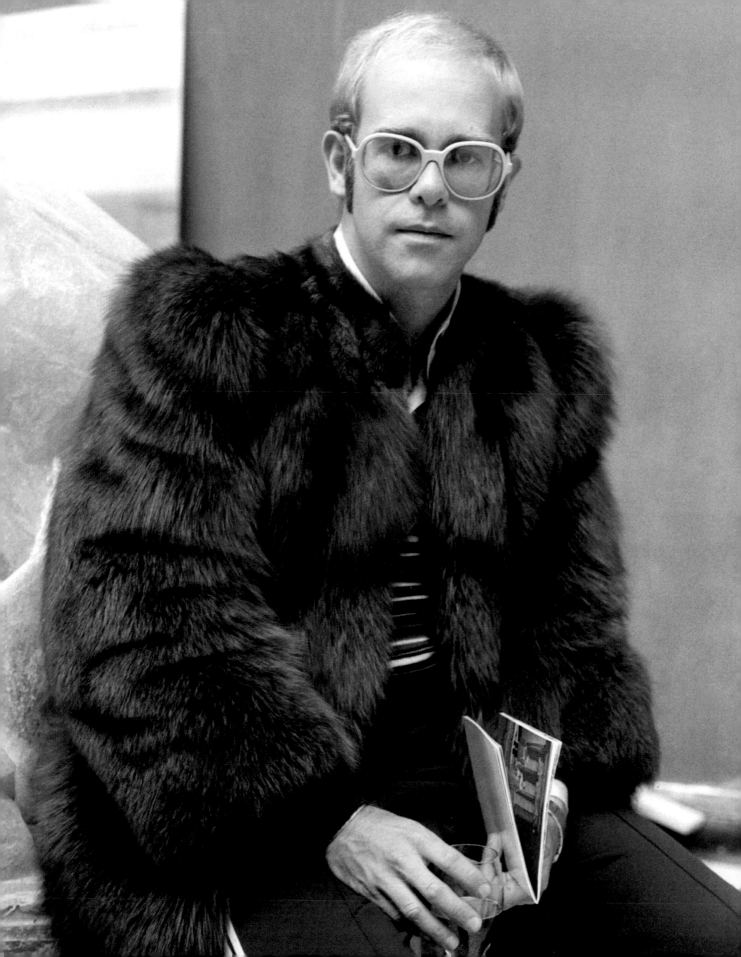

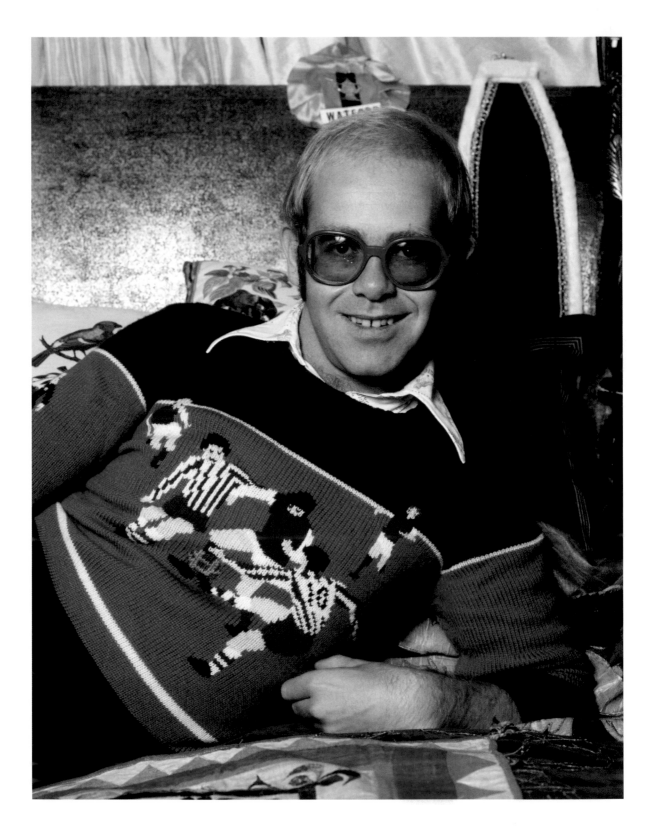

Opposite: Portrait used on the cover of *Rolling Stone* magazine, issue 223, 7 October 1976.

Below: "This might have been around the same time – or even the same session – as the shoot we did for the *Greatest Hits* (1974) cover. I love the pairing of the classic suit with the wild glasses."

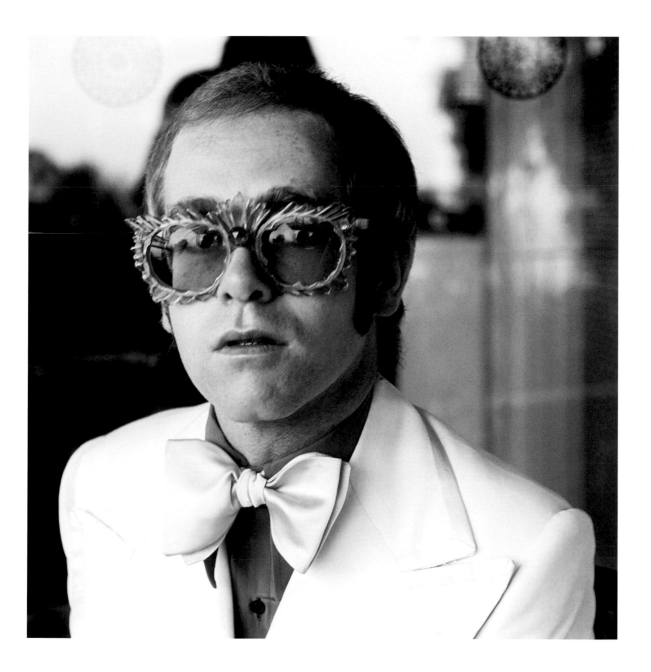

"After a while, I figured out the best way to work with Elton."

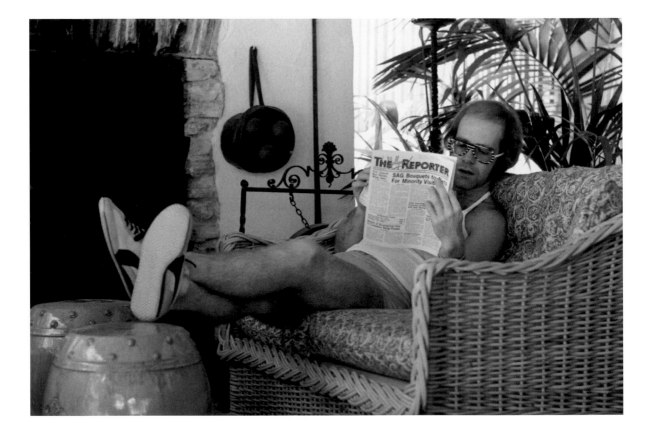

Above and opposite: "I would arrive at his house – or office – with a list of ideas and we'd simply work our way through them. On the couch, in the kitchen, in his office, looking at records – on one occasion, I noticed he had a stationary bicycle in his bathroom! So I thought, why not?"

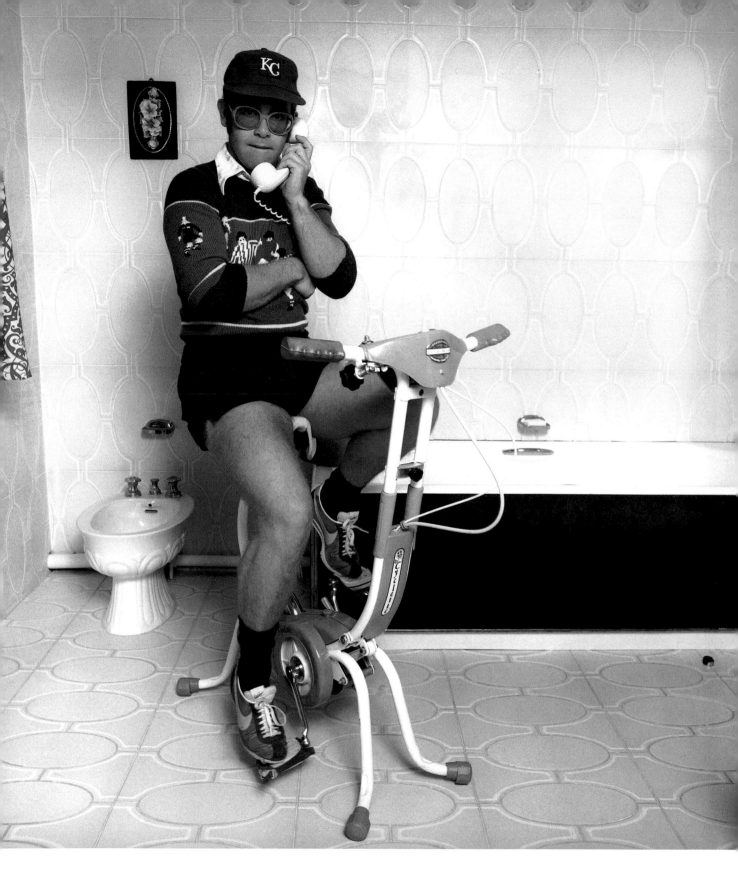

Right: "He came a long way from that humble flat. I could tell Elton was immensely proud of his house in Windsor. He bought it in 1974 and moved there in 1975 – and it's a home he still owns to this day."

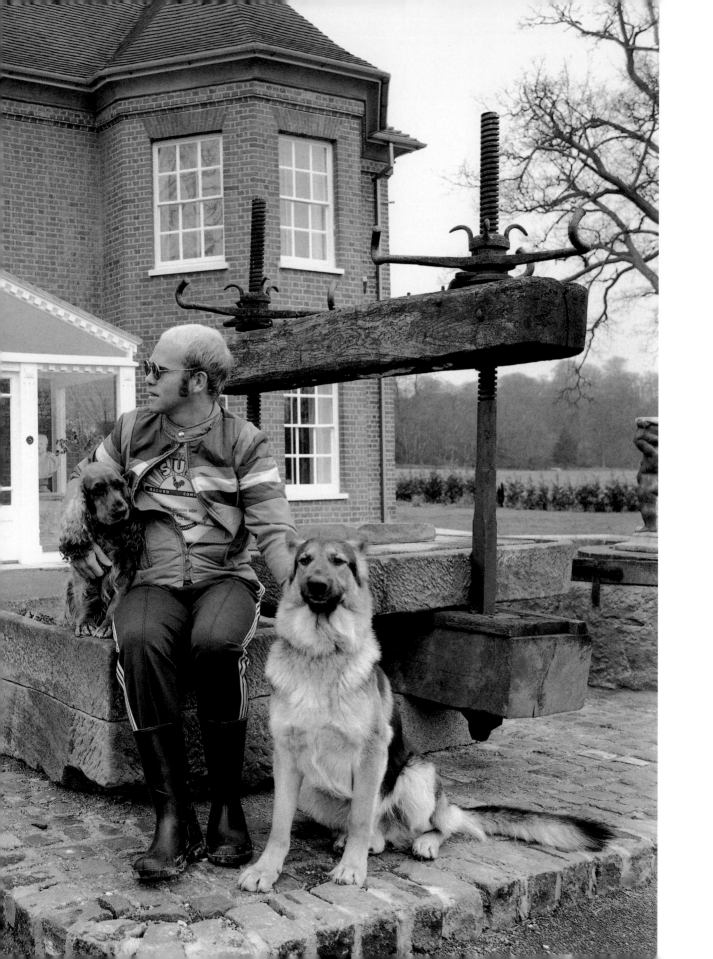

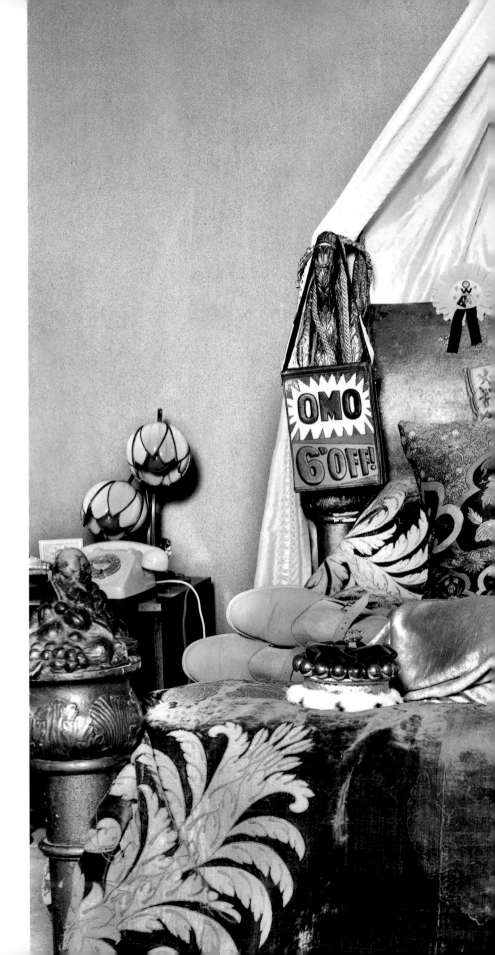

Right: "Elton in bed would be a reccurring theme with us – there was just something very witty and extravagant about it."

54

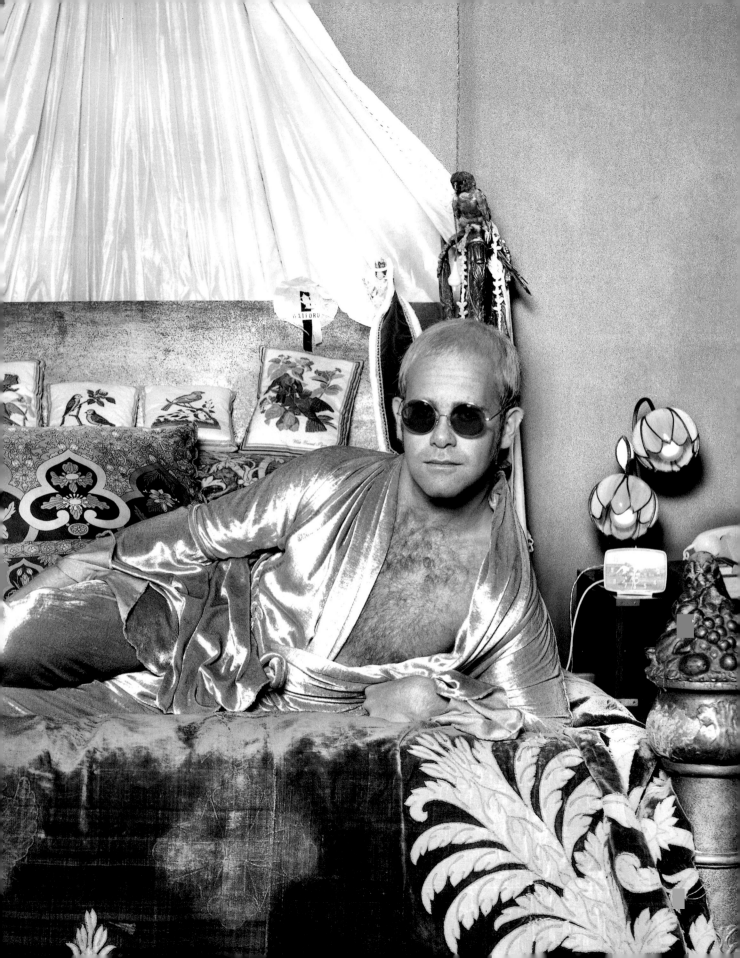

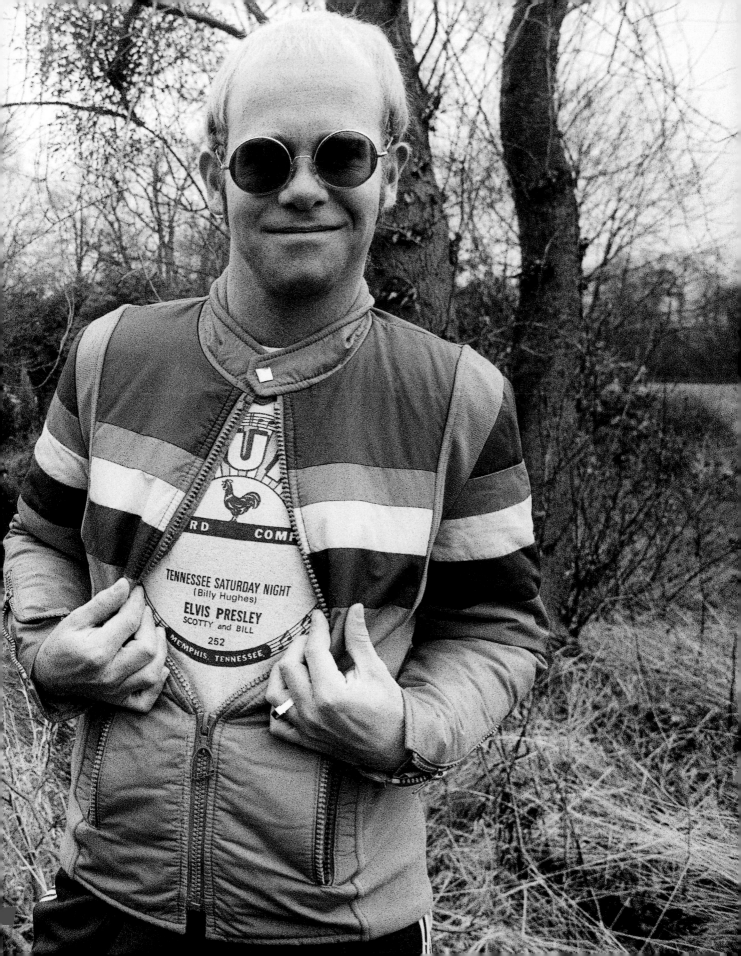

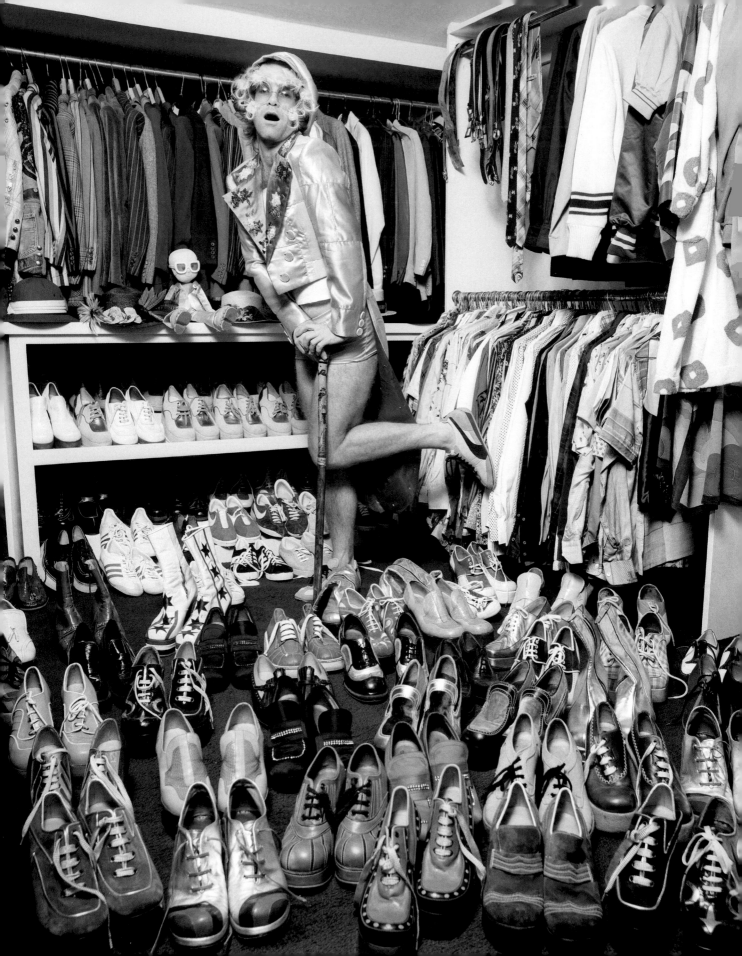

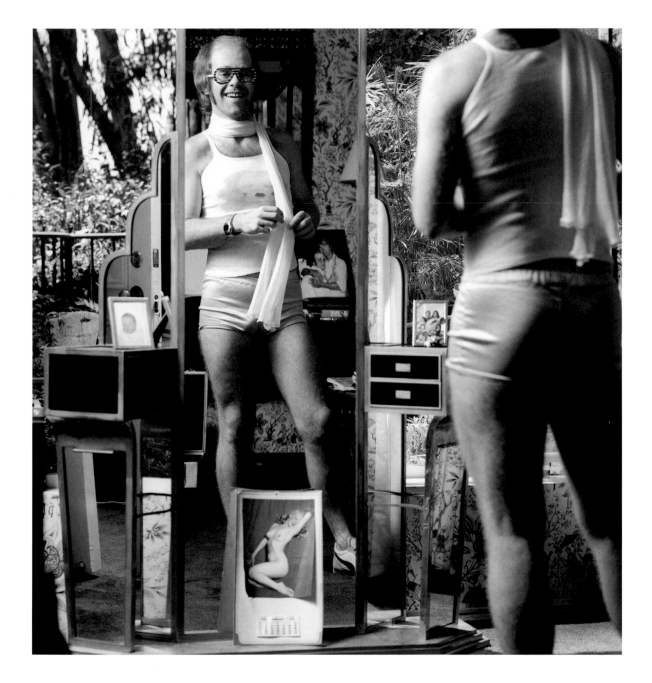

61

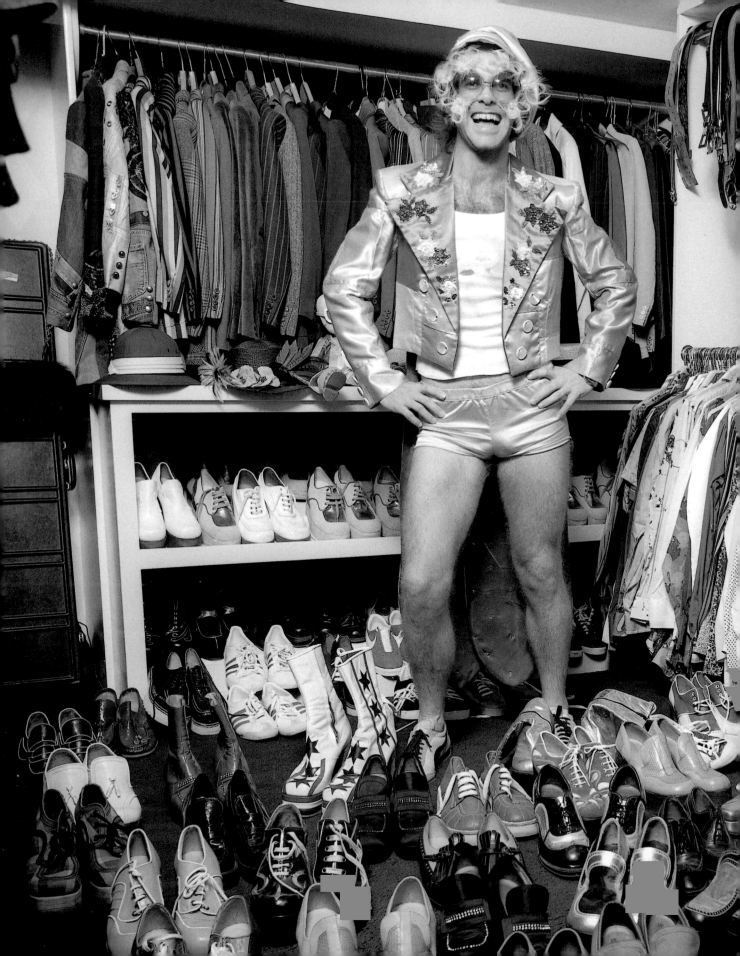

Left: "This all came about when I said,
'Why don't we go look at some of your
collection – maybe you could show me
some of your shoes?' Little did I know
what I was getting myself into."

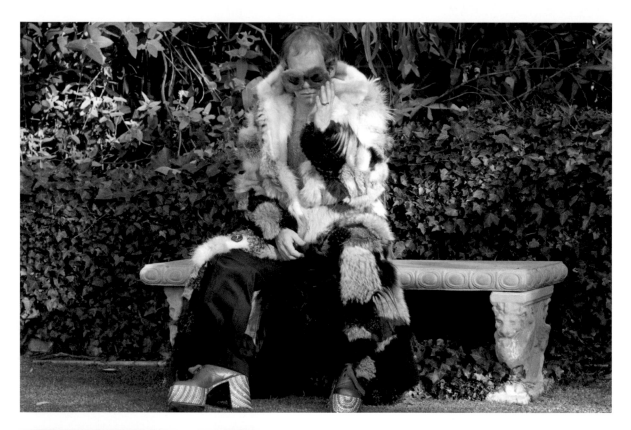

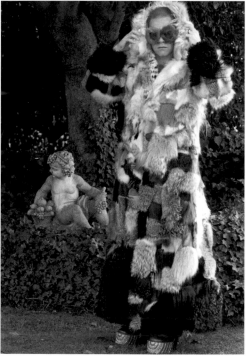

This page and opposite: "These were taken in Los Angeles. I never understood why he had quite so many fur coats in California."

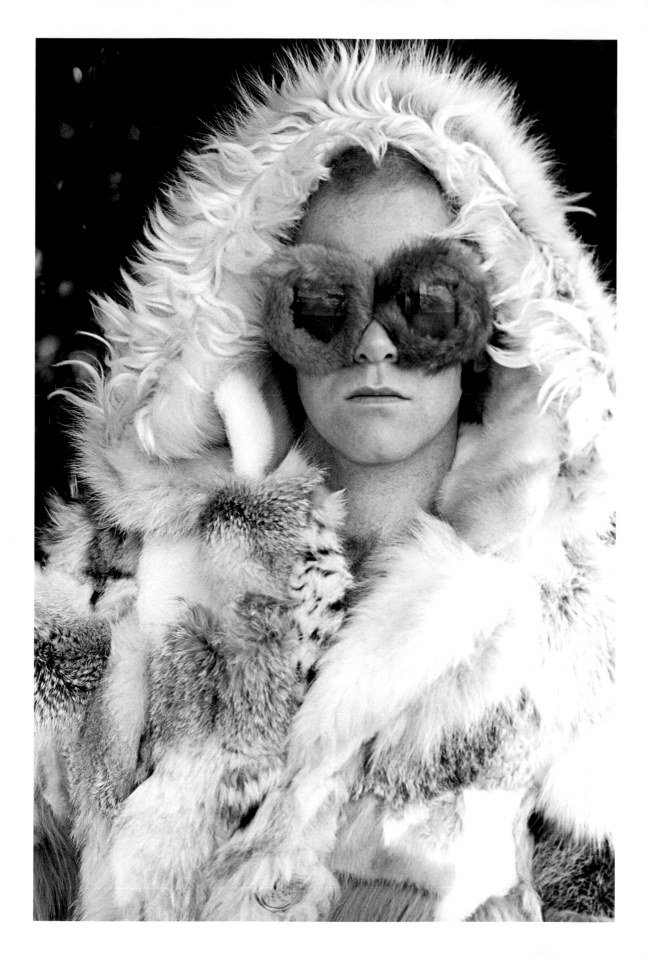

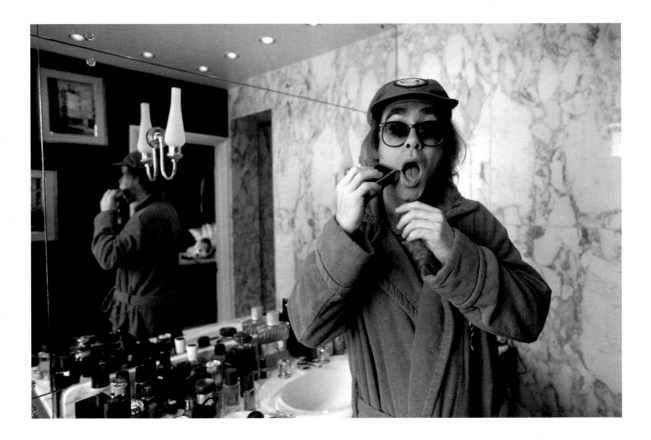

Opposite: "Before I looked through all
these images, I didn't realize how many
times we re-created the 'in-bed' pose!
Though I think this one is quite sweet –
notice the little Elton John doll."

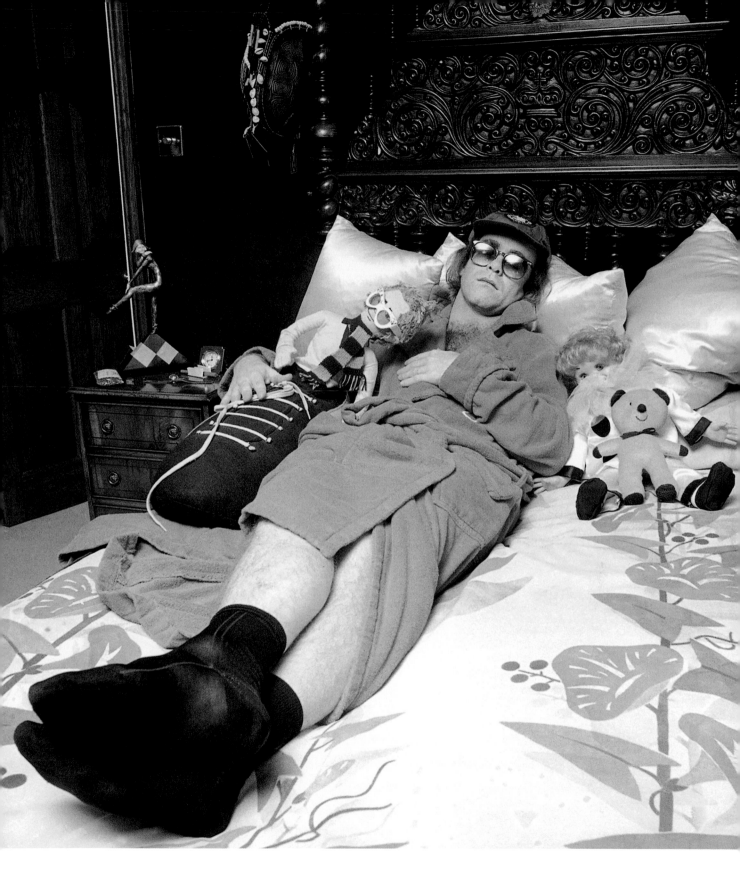

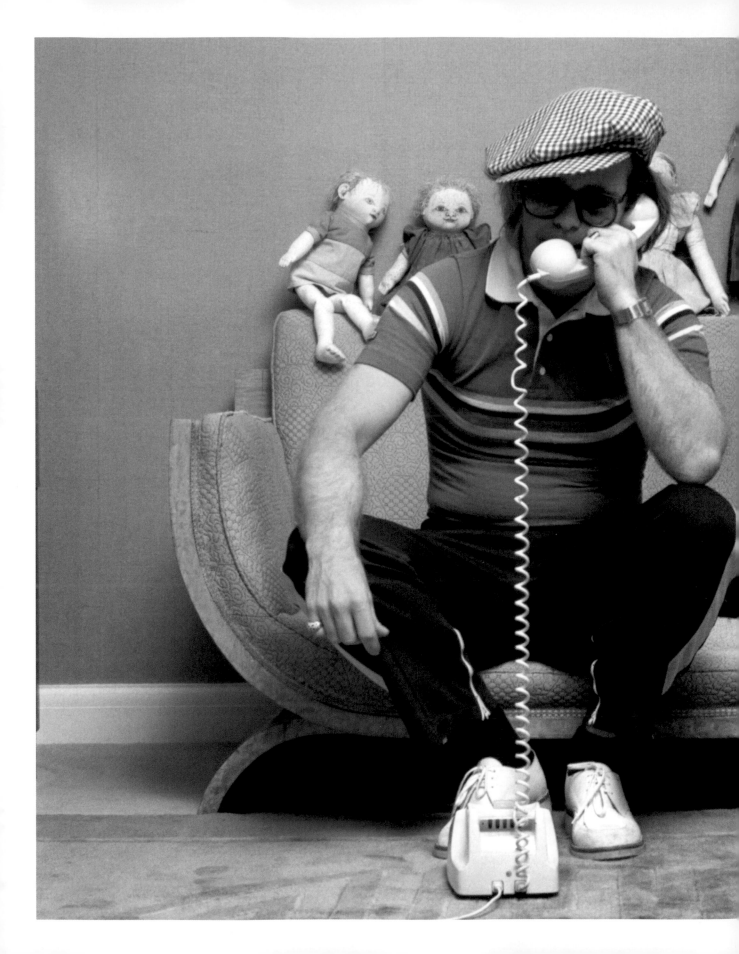

Opposite and overleaf: "These are likely in Elton's home or even at his office. In the picture overleaf, there are stacks of the new *Captain Fantastic and the Brown Dirt Cowboy* (1975) record about – he was autographing them while I took these snaps."

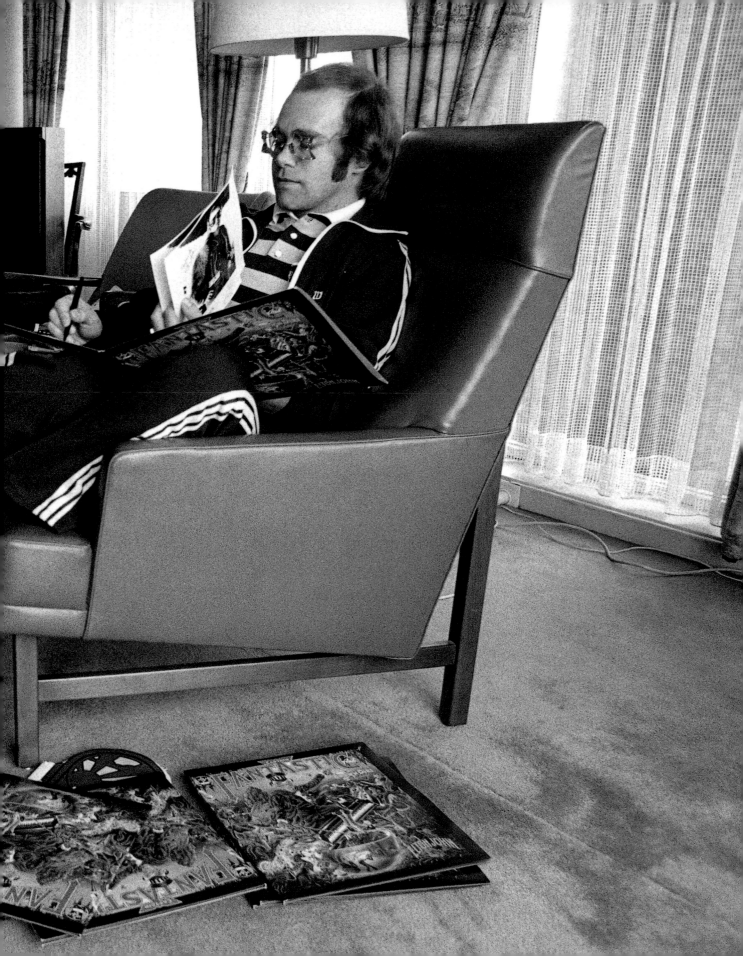

Below and opposite: "These photos were taken for an interview in *Playboy* in America, but I don't remember them running anywhere at the time. Elton's clothes often had a touch of humour, but the placement of the Rolling Stones logo might have been a step too far."

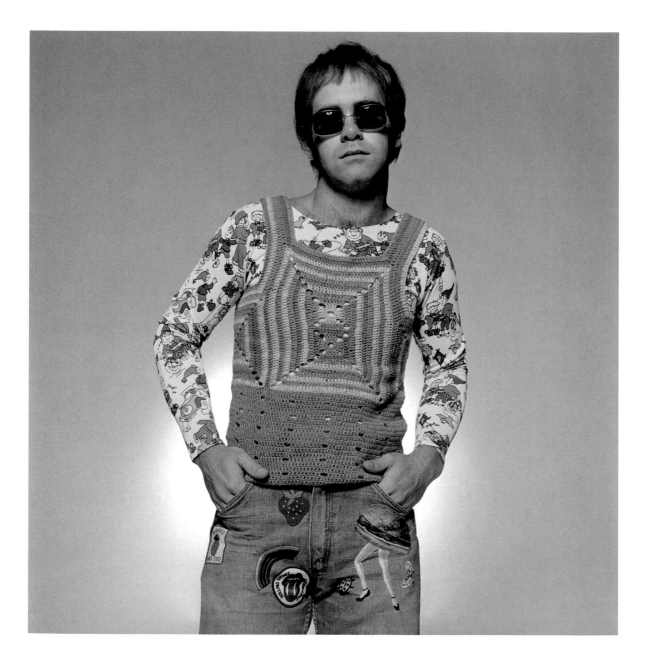

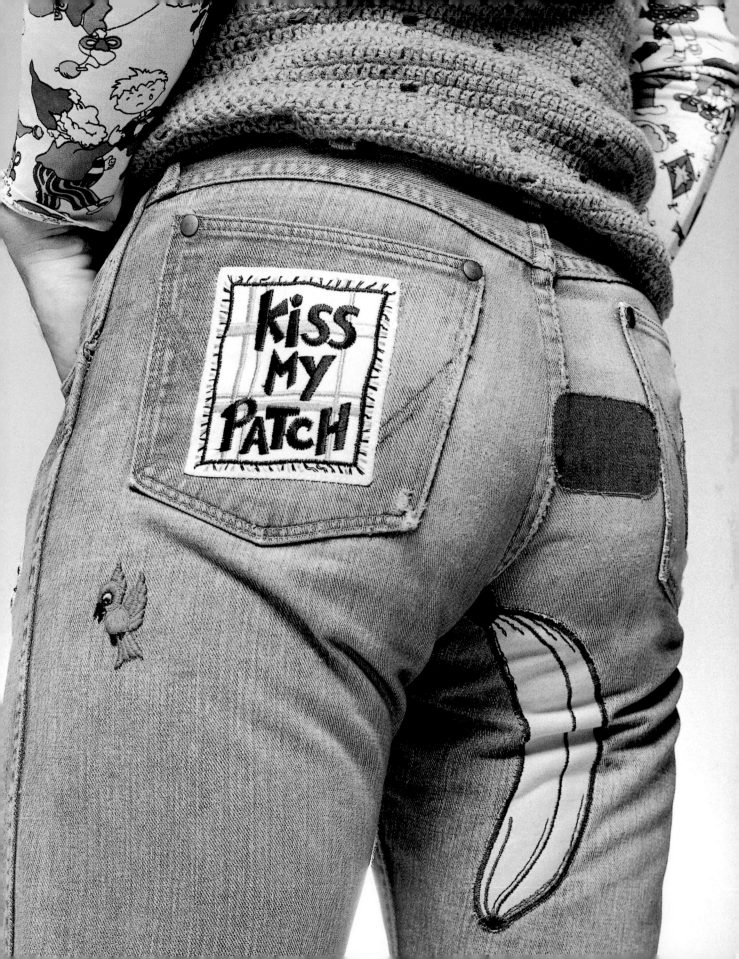

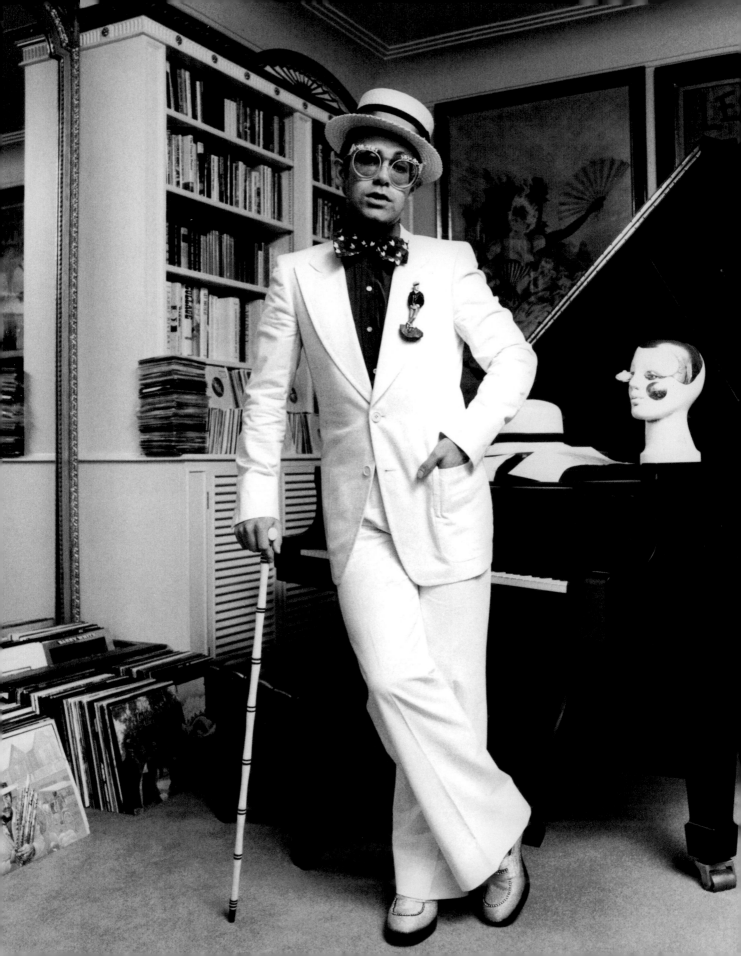

Opposite and below: "For the *Greatest Hits* album in 1974, Elton wanted to go classic. The album spent ten weeks at number one and really kick-started 1975, a year that would be so pivotal in his career. I was honoured to be asked to take this cover photo – he was the biggest star in the world."

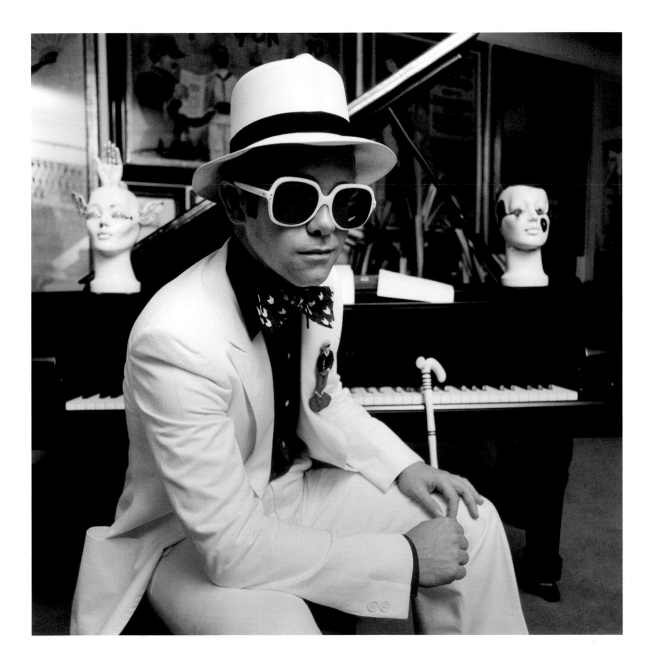

below and opposite: "It is funny, when
looking through all these photos,
to see how Elton's style evolved. When
first met him, it was T-shirts and jeans.

As he became more and more famous,
he started to buy, and wear, more
extravagant outfits. Maybe he
was more comfortable in front of

a camera when he had his stage
persona on? I'm not sure, but it
was great fun and made for some
great images."

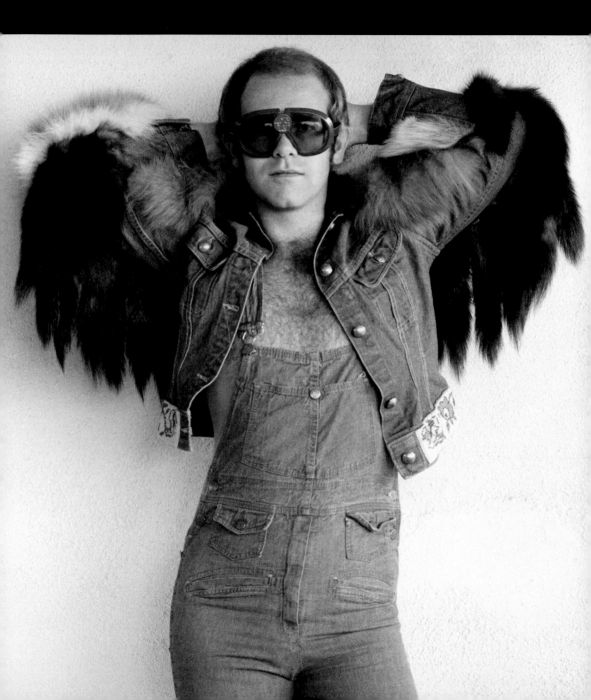

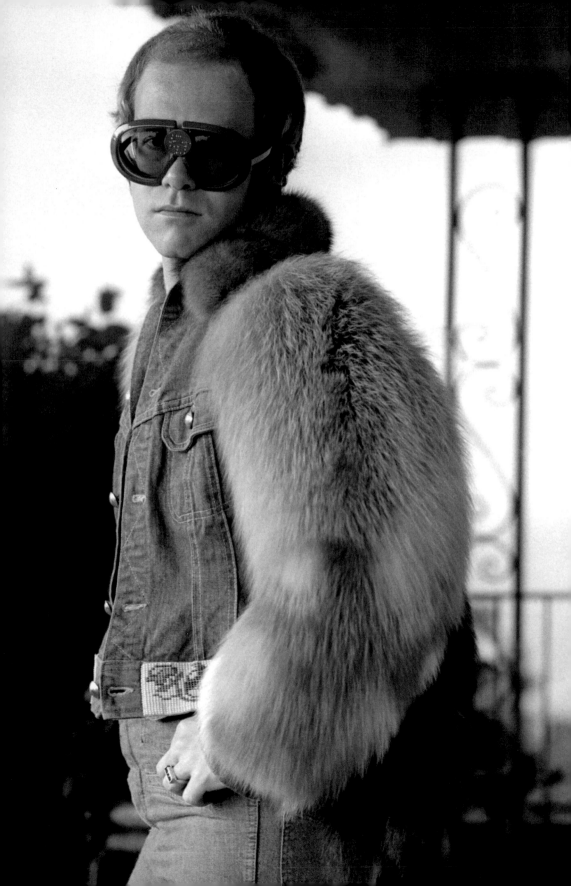

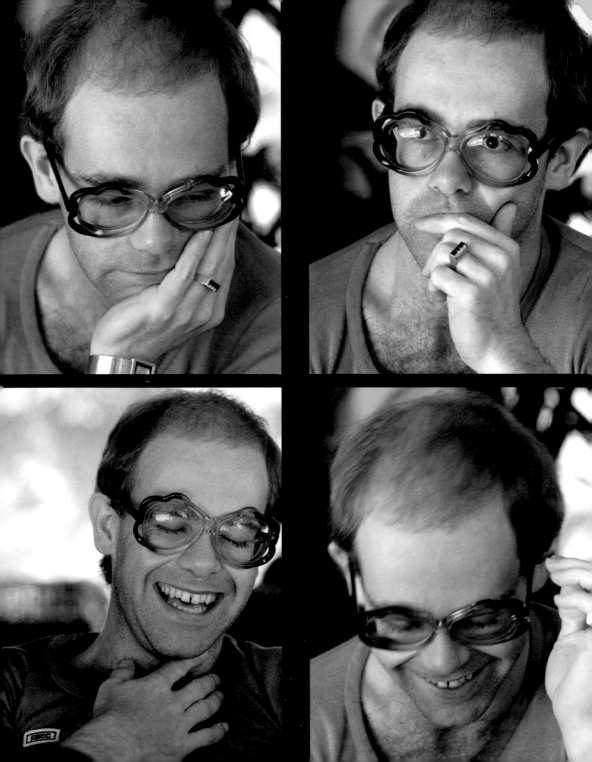

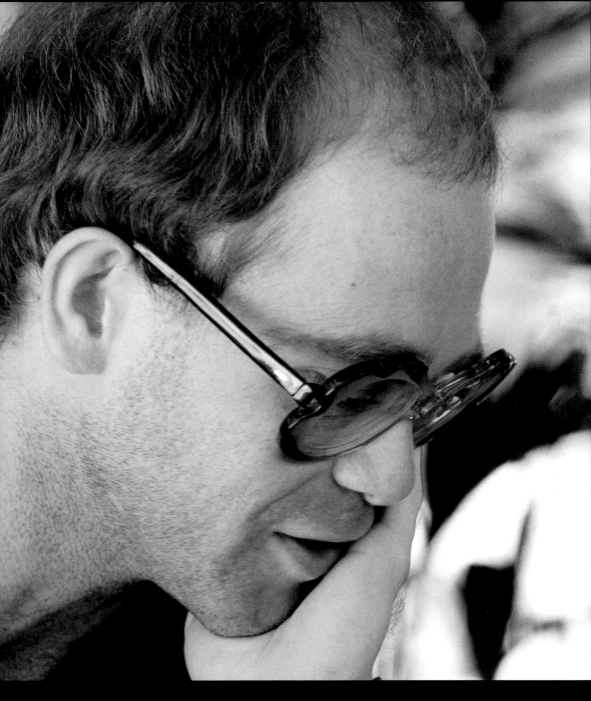

Opposite and above: "These were
taken at the end of 1975, probably in
Los Angeles. They were initially
used for the January 1976 issue of
Playboy magazine in America."

Right: "I was asked if I could travel to the Caribou Ranch recording studio in the town of Nederland, Colorado, to work with Elton for a few days. How could I turn that down?"

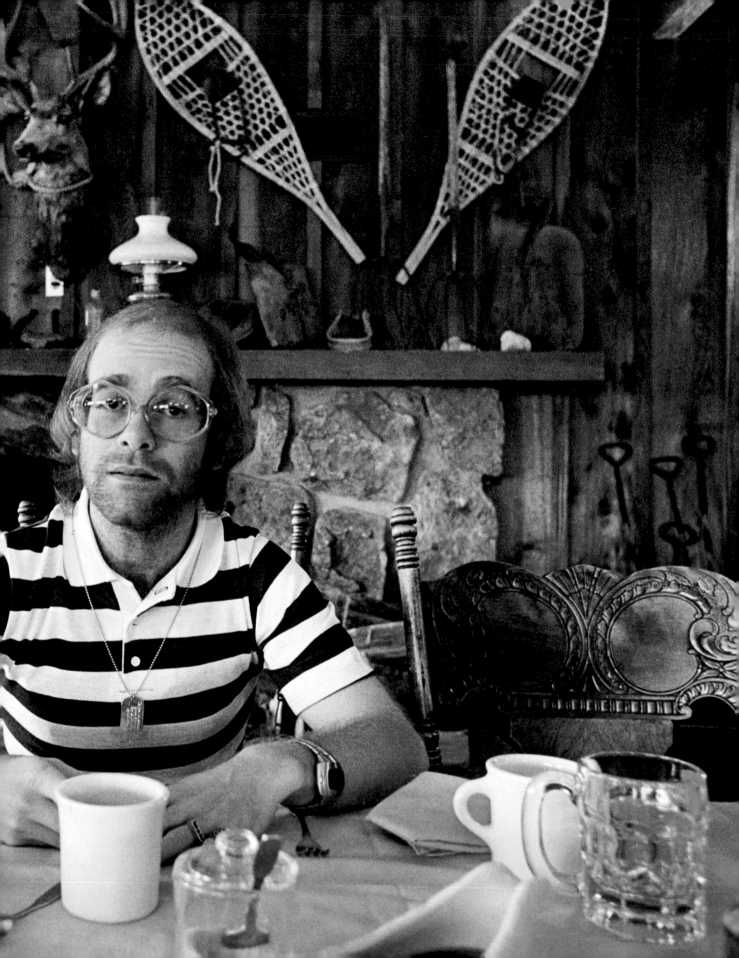

"We wanted something casual, much less formal than the *Greatest Hits* album cover. I decided to try the shots outside and use only natural lighting."

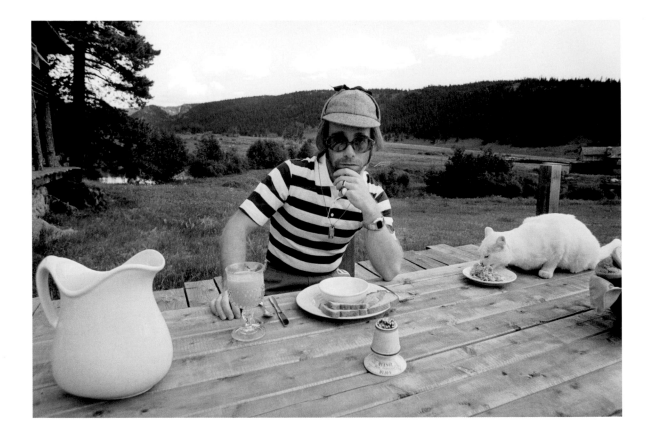

Above and opposite: Alternative shots for the cover of *Rock of the Westies*, the second album Elton John released in 1975, not long before the Dodger Stadium concert.

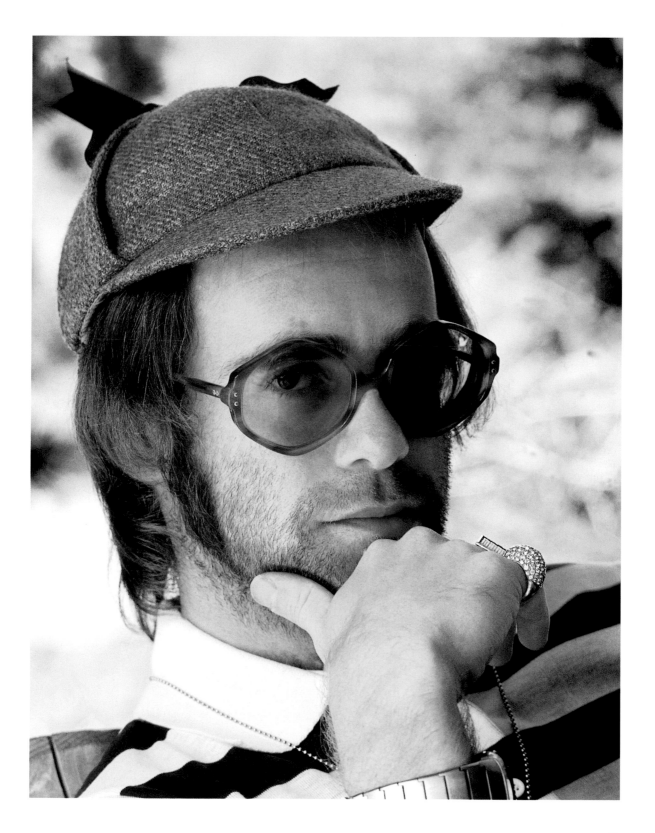

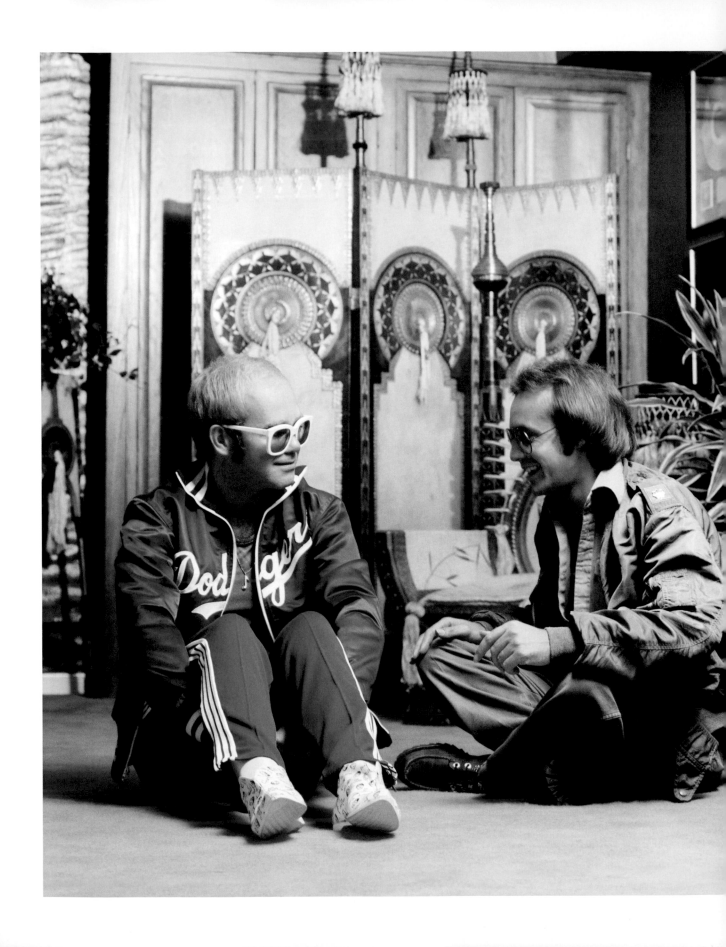

Left: Elton John with his longtime collaborator, Bernie Taupin. "This is likely at Elton's home in Los Angeles. Bernie's a great guy, and they've had an extraordinary partnership over the decades."

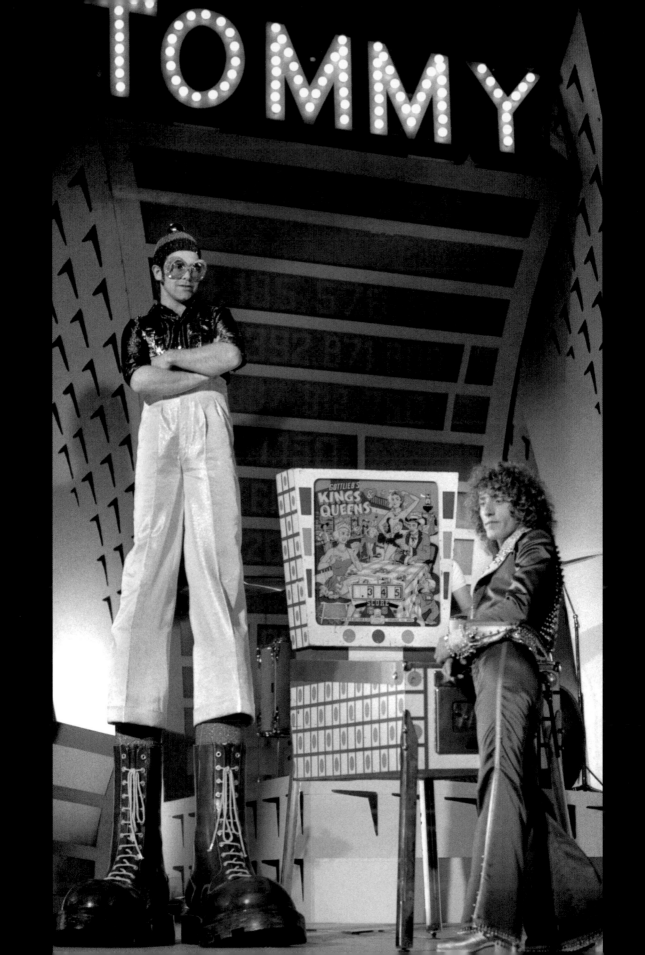

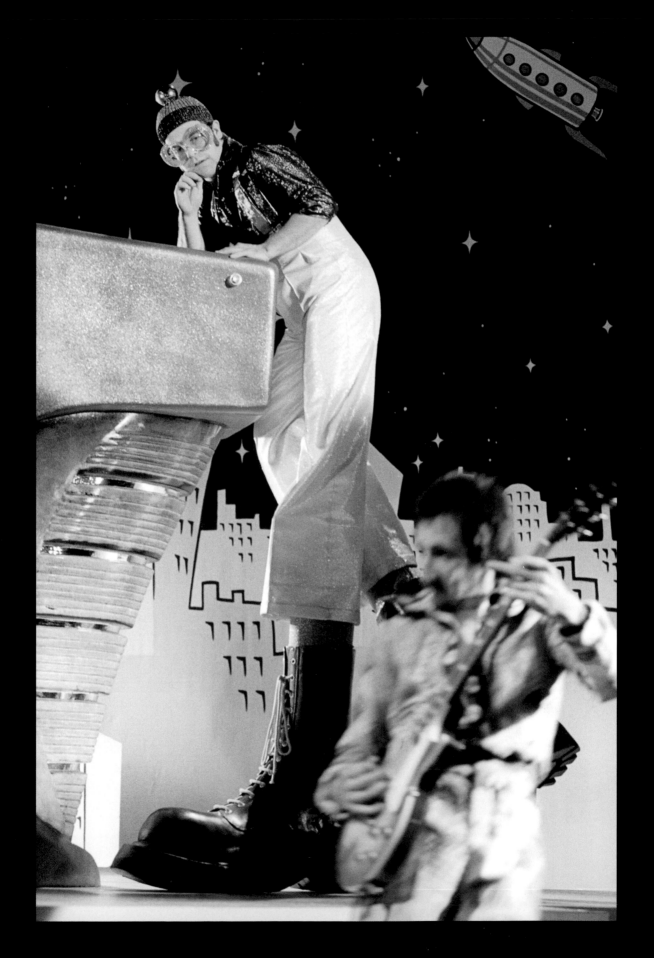

"I did hear that Elton only accepted the role on the condition that he could keep the boots."

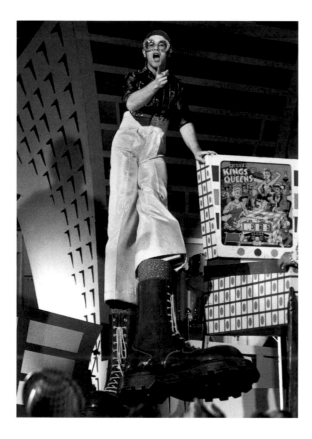

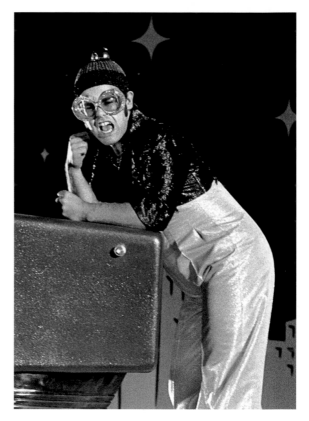

Previous pages, above and opposite: Elton John appears in the role of The Pinball Wizard for The Who's rock opera, *Tommy* (1975).

"The Pinball Wizard sequence, complete with The Who as the backing band, was shot at the Kings Theatre in Southsea in 1974. I would go on to work with The Who a few years later, to take a portrait that would appear on the cover of their album, *Who Are You* (1978)"

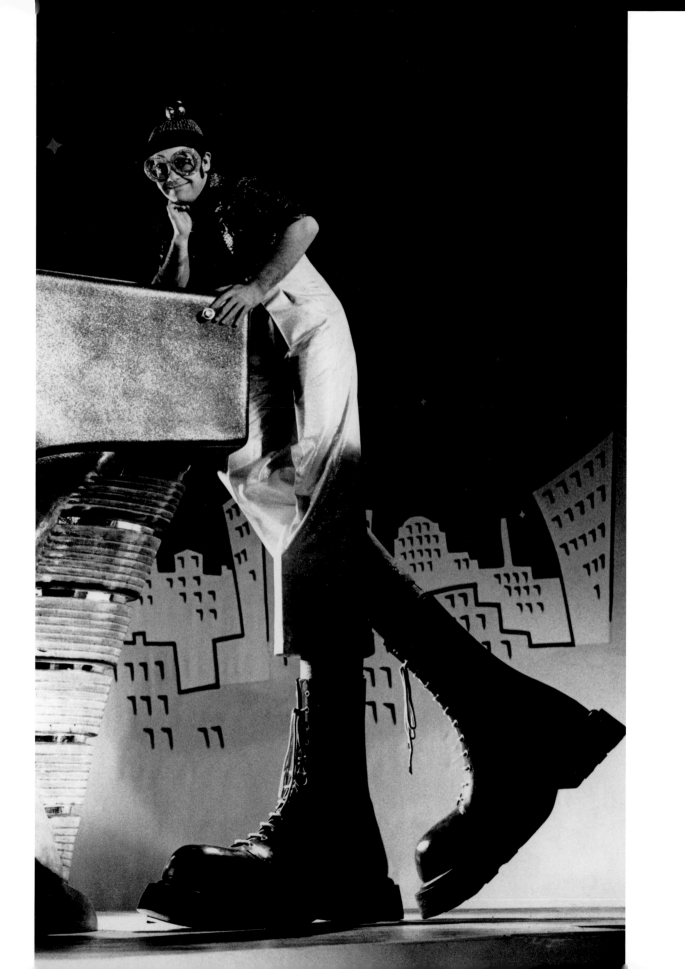

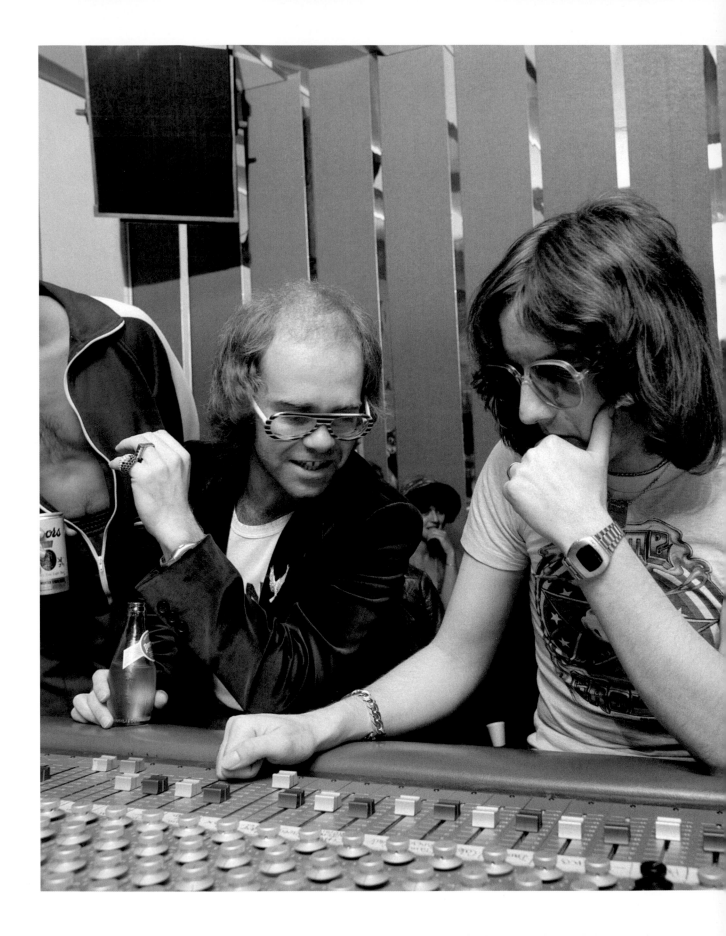

Left: Elton John with Angus Boyd
"Gus" Dudgeon, Caribou Ranch
Recording Studio, 1975.

This page: Elton John recorded several albums at the famed Caribou Ranch, including *Caribou* (1974), *Captain Fantastic and the Brown Dirt Cowboy* (1975) and *Rock of the Westies* (1975). Gus Dudgeon teamed up with Elton in 1970, after Gus produced David Bowie's 1969 single 'Space Oddity' and he worked with Elton, including co-founding The Rocket Record Company in 1973, throughout the 1970s.

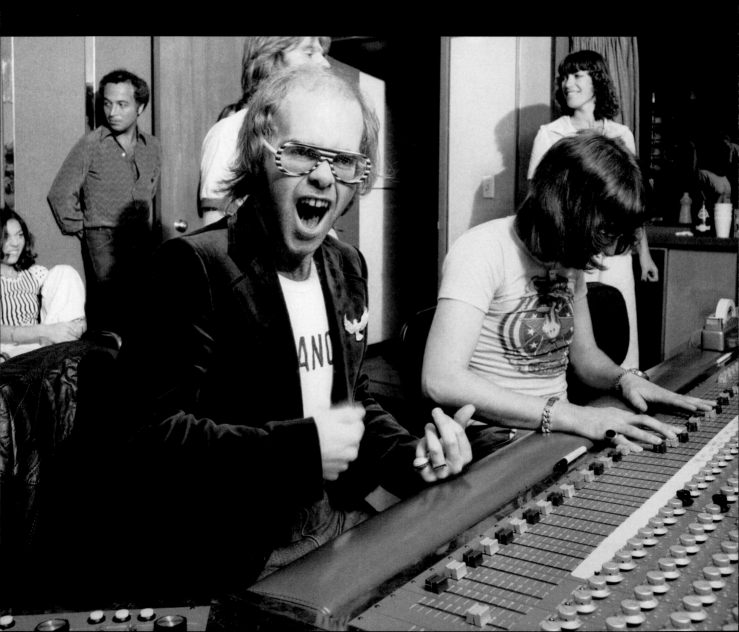

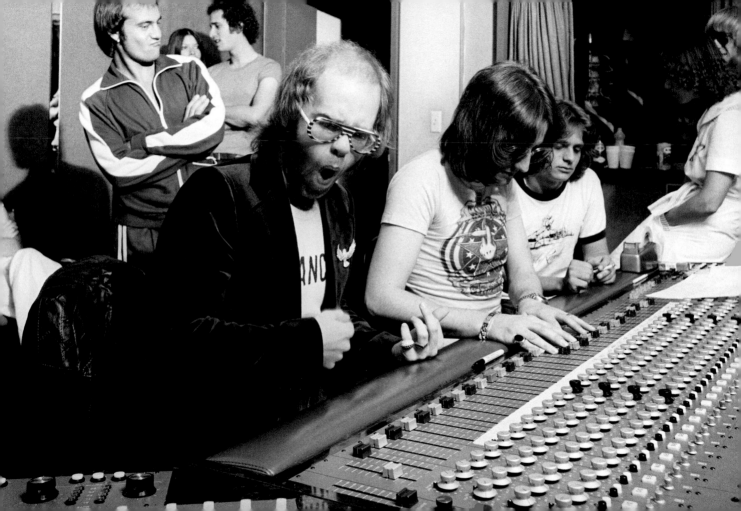

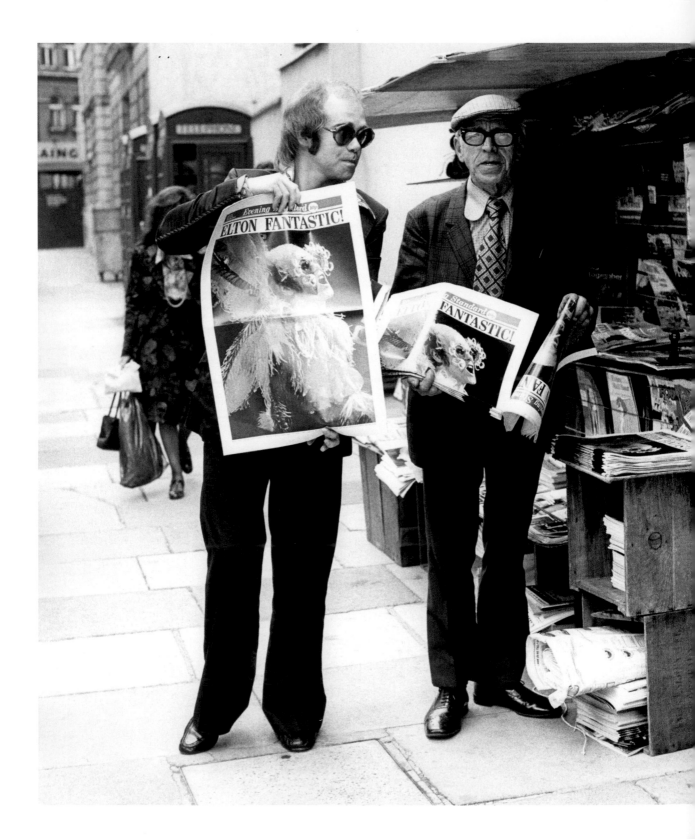

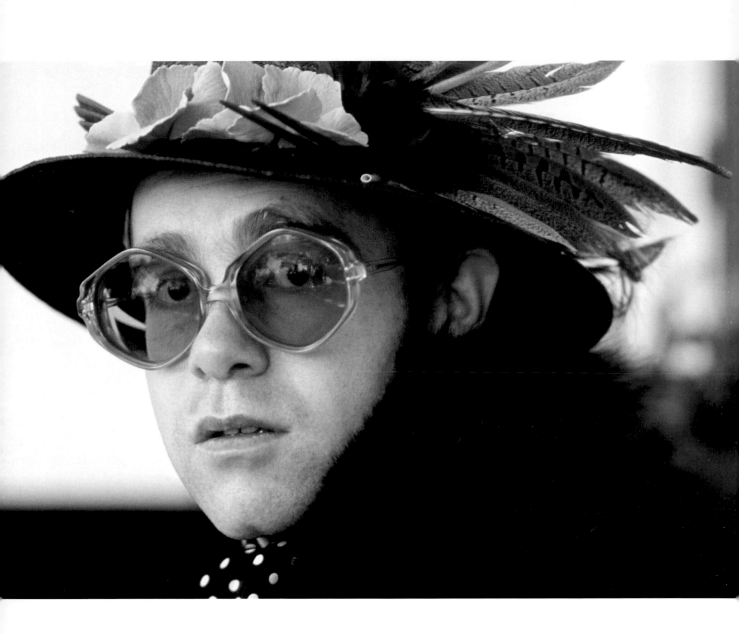

Opposite: "Right after the
Hammersmith show in December 1974,
the papers went wild. I'm not sure the
newsagent knew whom he was
selling all those papers to."

Above: "I think the more candid portraits
are the ones that best capture Elton.
Here, he is not as posed – but still
wearing his finest."

Right: On 21 June 1975 Elton John headlined an all-day concert at Wembley Stadium called "MidSummer Music". Opening acts included The Beach Boys and Rufus with Chaka Khan.

Following pages: "I'm glad I worked with Elton at Wembley Stadium – for me, it was almost like a test run before the Dodger Stadium concerts later that year."

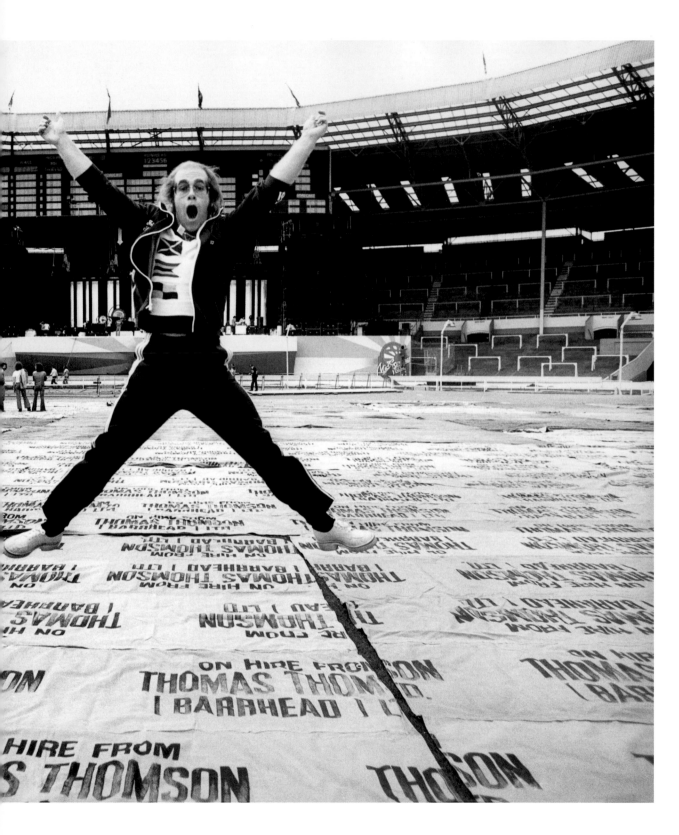

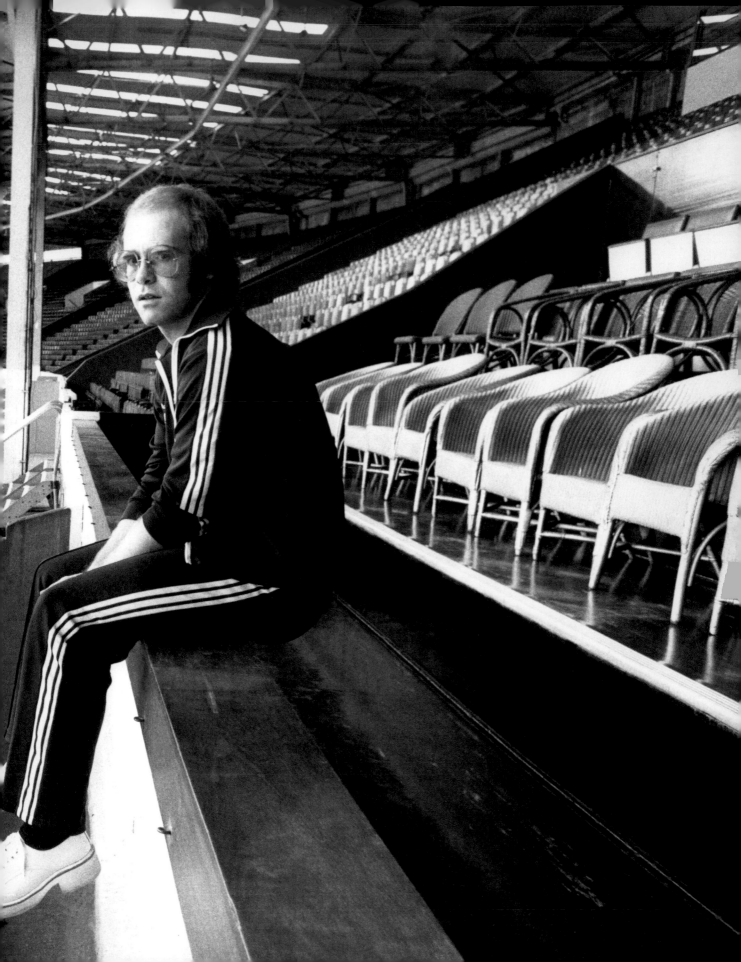

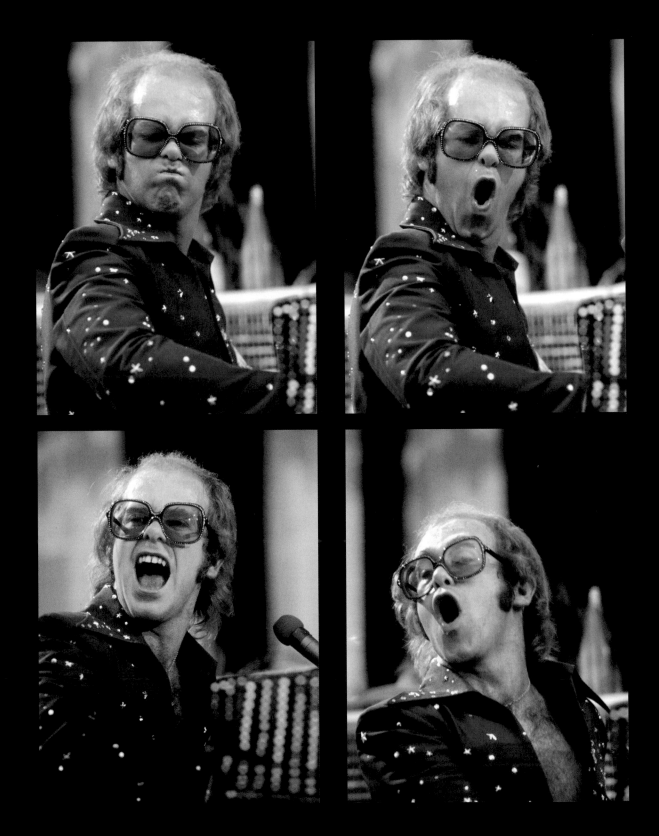

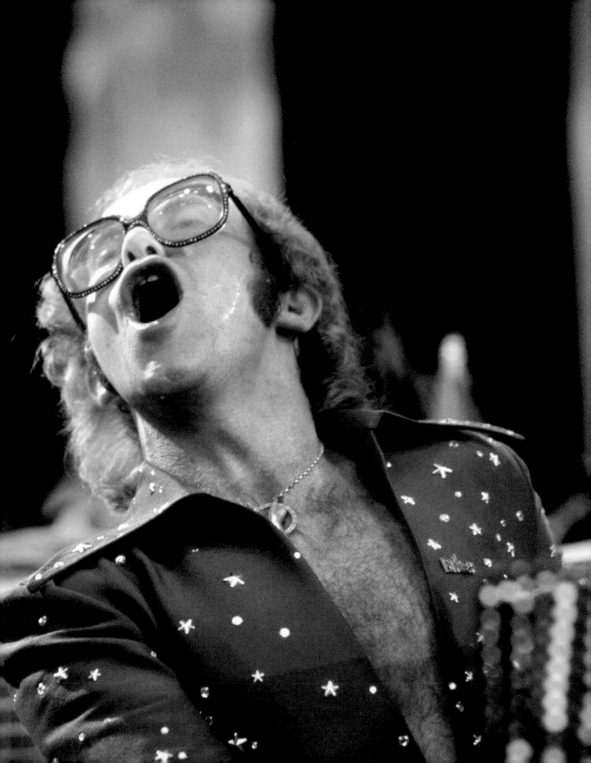

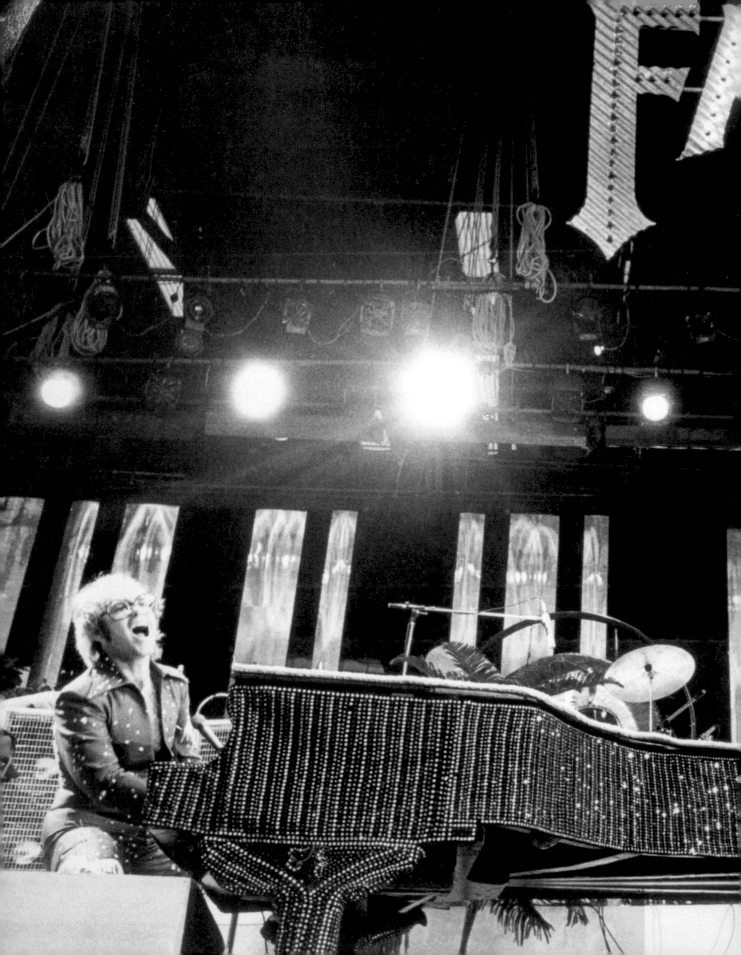

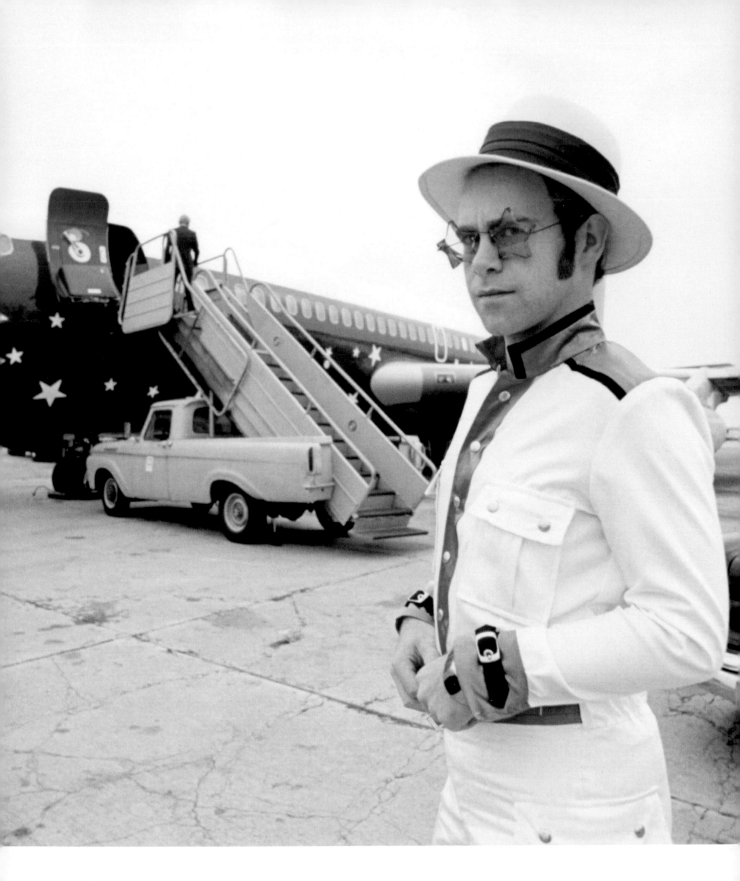

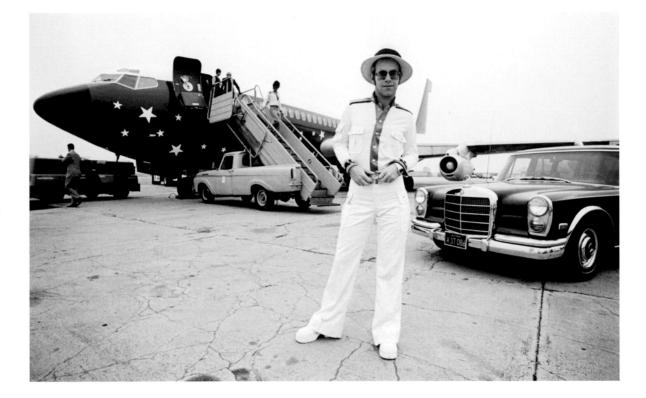

Opposite and above: For his American tour, Elton John chartered the Starship, a plane quite used to rock stars – it had previously been used by Led Zeppelin. The plane was fully equipped with a full bar, couches and, in Elton's case, a piano.

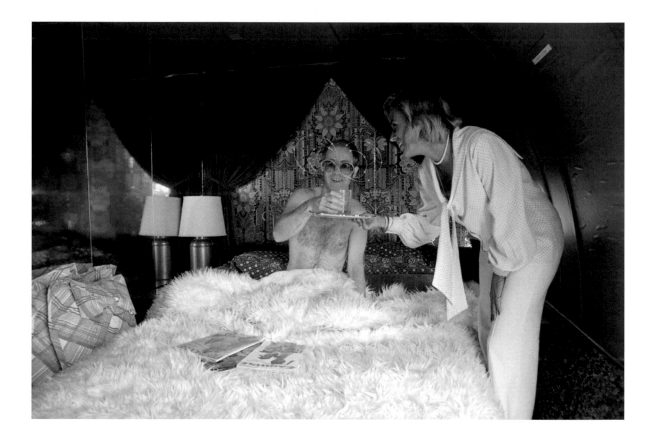

Above and opposite: "As soon as I saw the bed on the plane, I knew we had to get some photos. I didn't know he had those glasses with him, but the instant he put them on, I knew the shot would have that sense of Elton mischief."

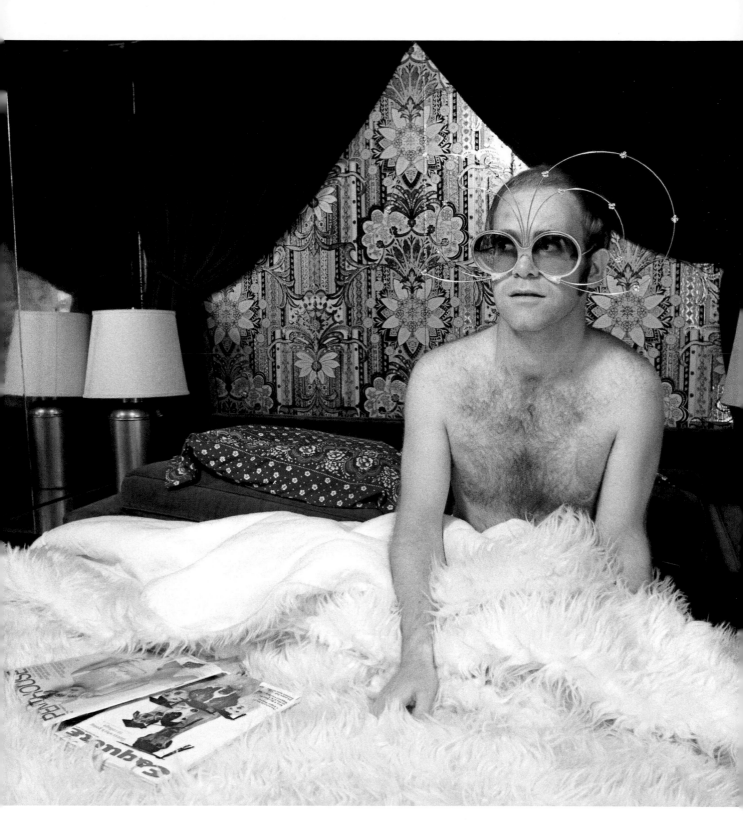

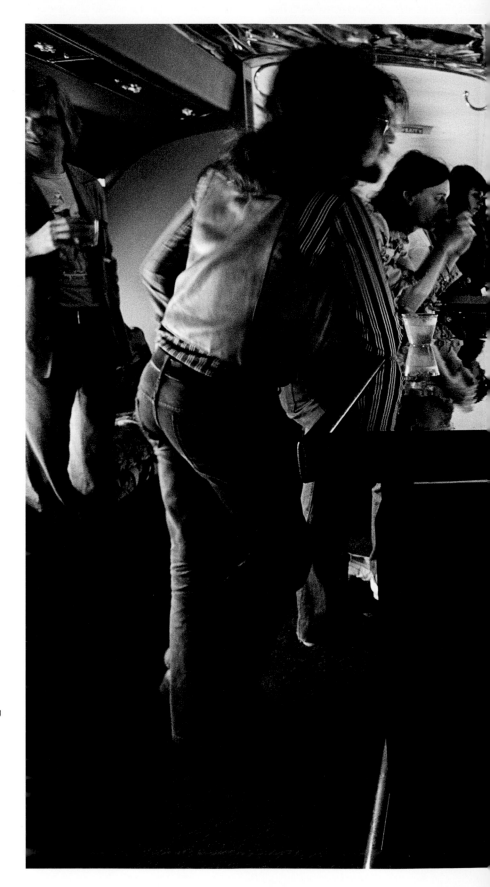

Right: "Here, I was trying to capture a bit of the fun on the plane – the band propped up at the bar and Elton playing away. Touring was big business in the 1970s, especially at Elton's level. This sort of luxury was affordable and made for some great images."

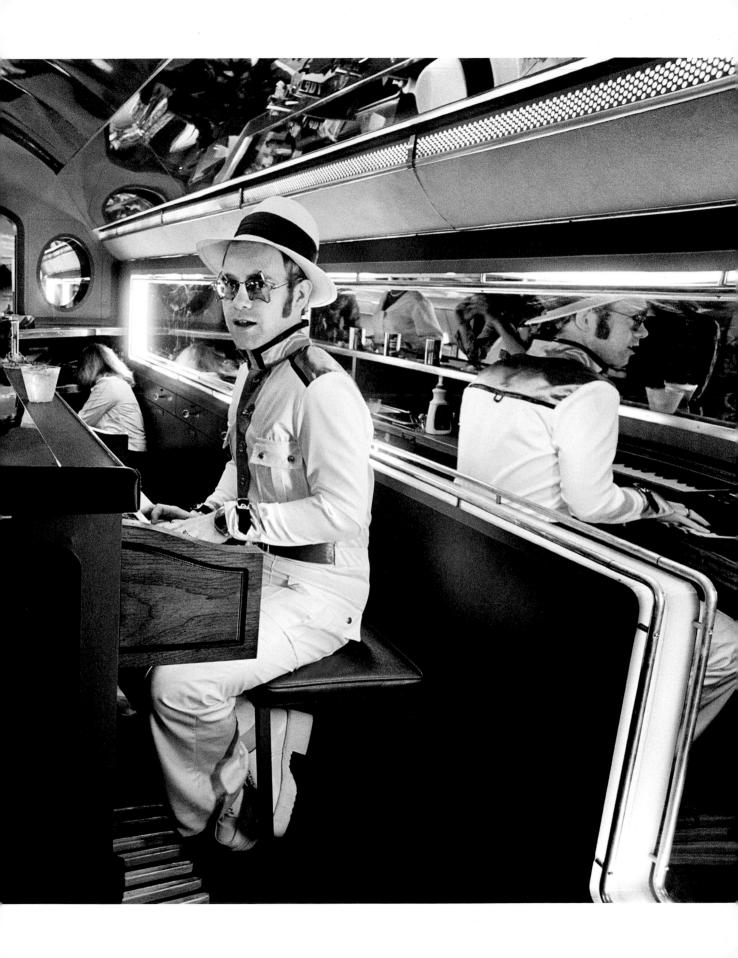

"The two days at the Dodger Stadium in Los Angeles truly did rock the world."

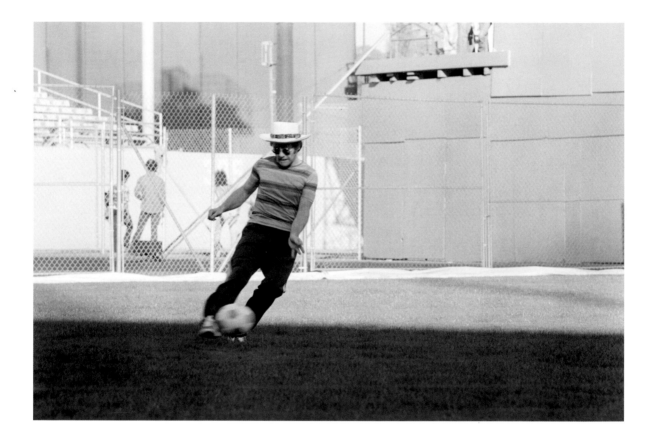

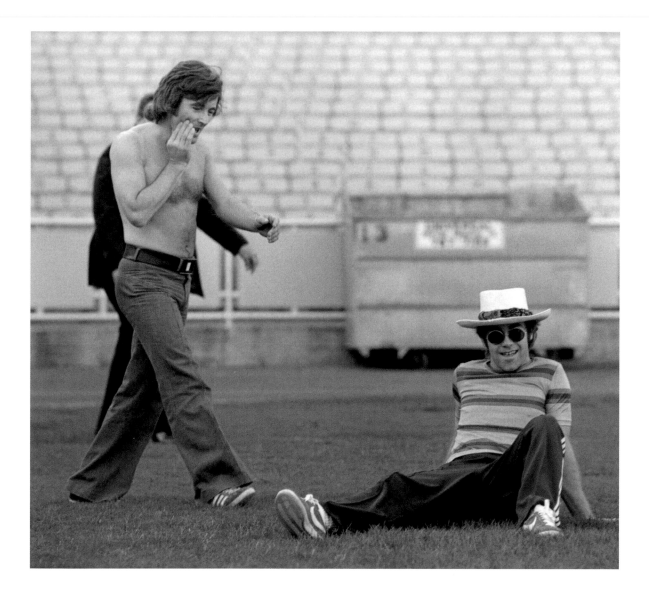

Opposite and above: During breaks in
rehearsals, the mainly English crew,
including O'Neill (above, front left),
went to the baseball field to play a little
(British) football.

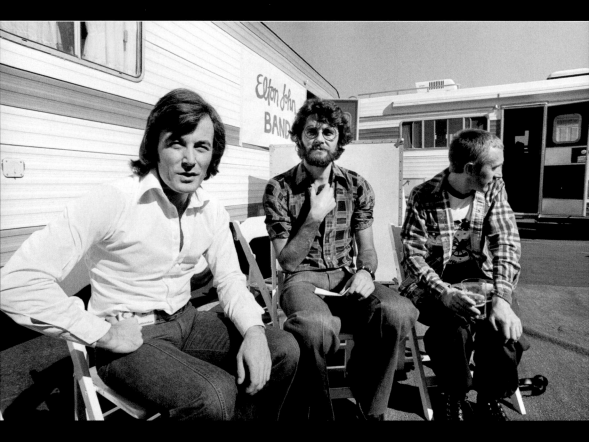

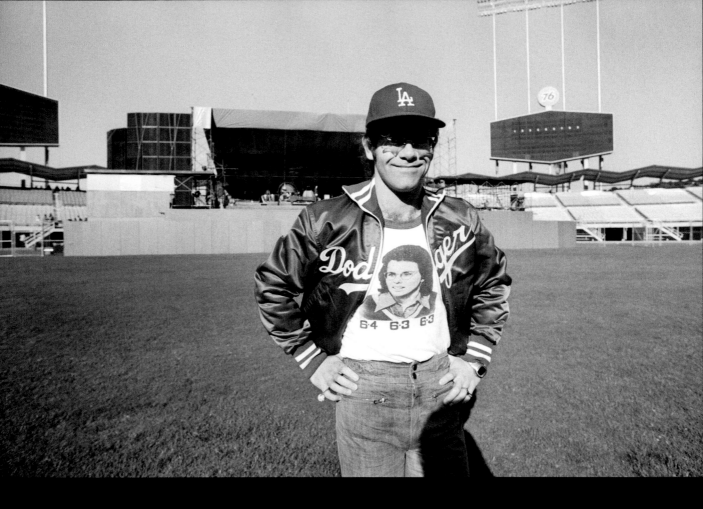

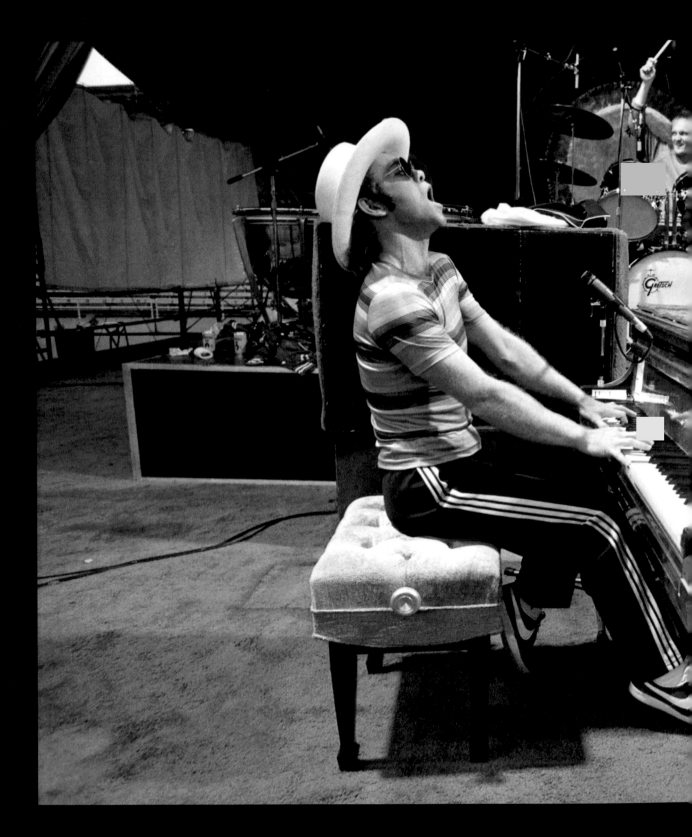

Left: "Even during rehearsal – to an empty stadium – Elton would give a performance."

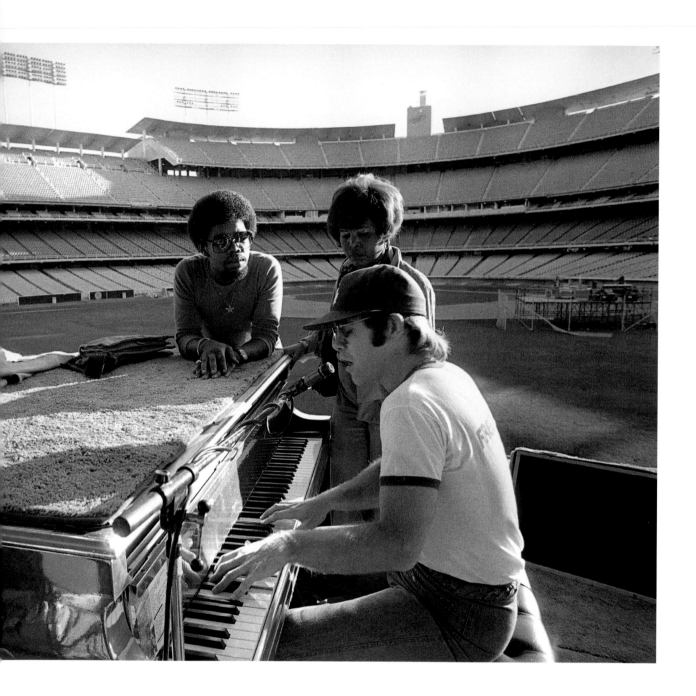

Opposite, above and overleaf: O'Neill
was allowed full access, even to the quiet
moments and during the sound checks.

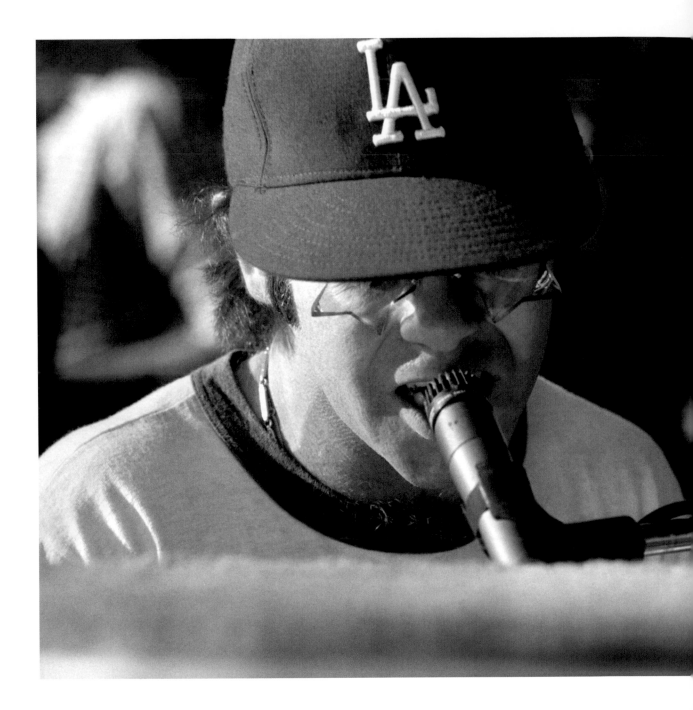

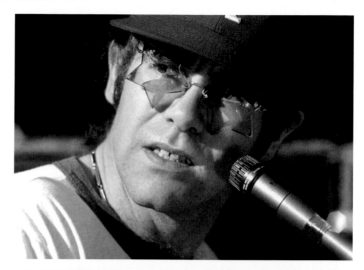

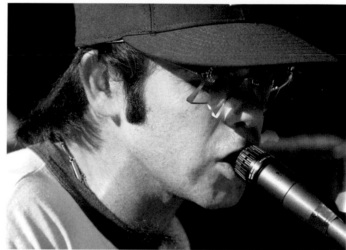

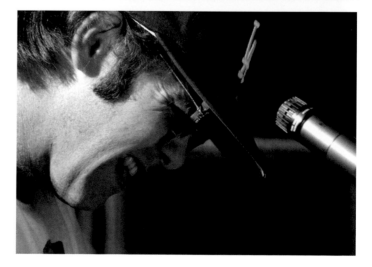

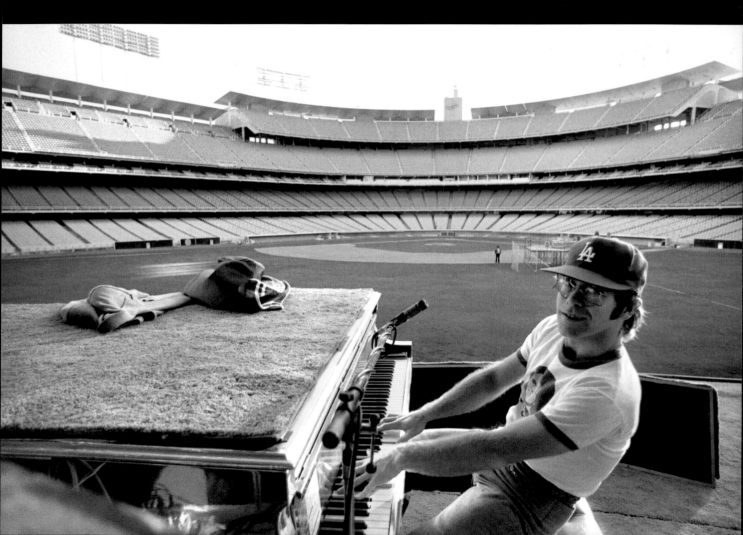

Below and opposite: "The artifical grass was kept on the piano during the rehearsal – likely for sound reasons, as Elton was always concerned about quality, especially at the giant stadiums he played. That's a sold-out crowd in the background, more than 55,000 people."

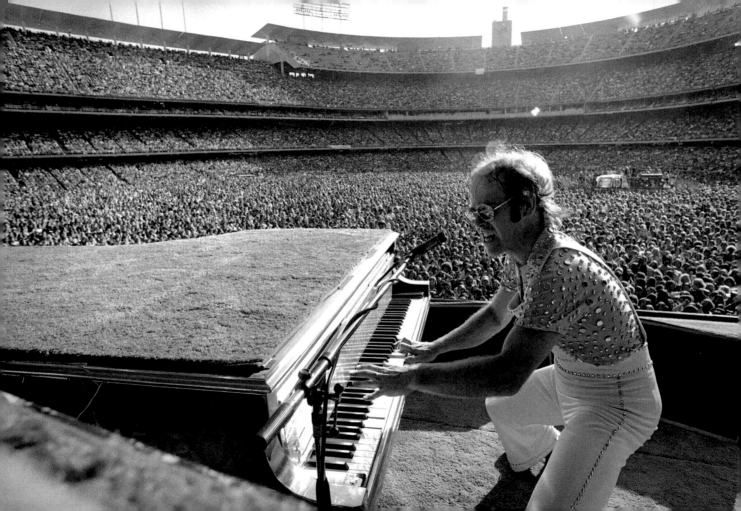

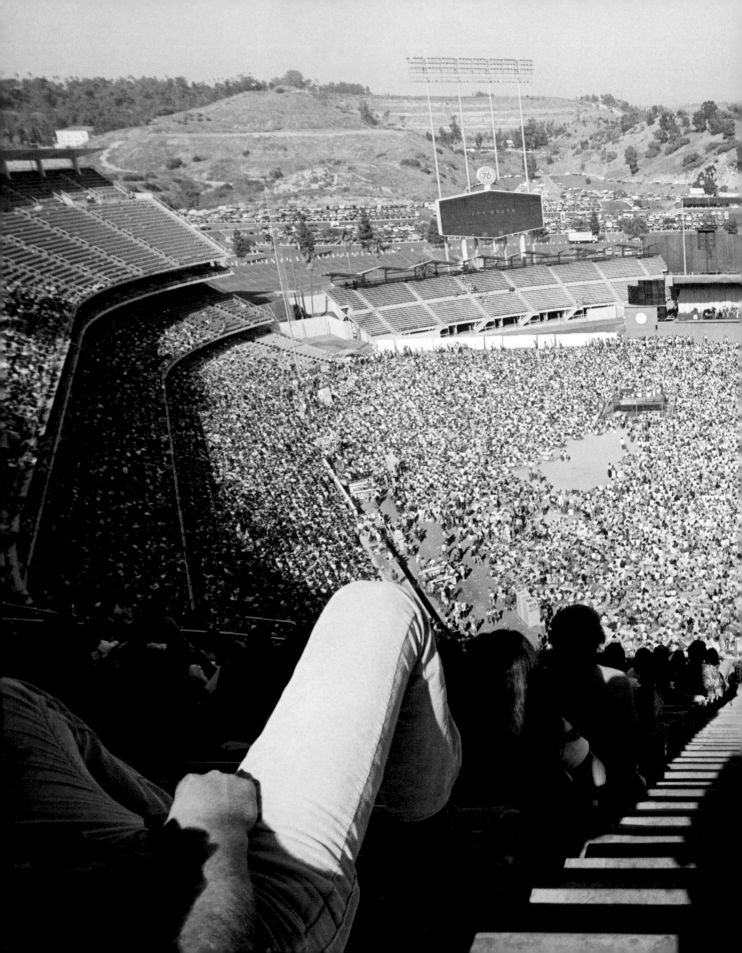

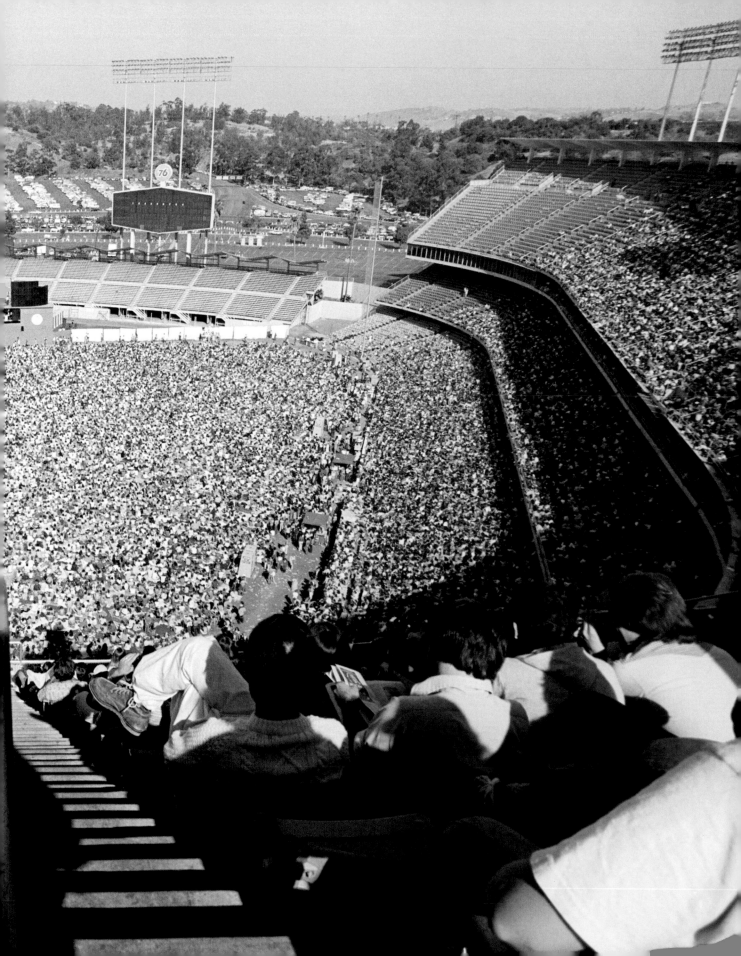

Previous pages: "After seeing what it looked like from the stage, I wanted to get a view of the stadium from the very opposite end. It took me a long time, but I finally made my way to the very last row at top of the stadium."

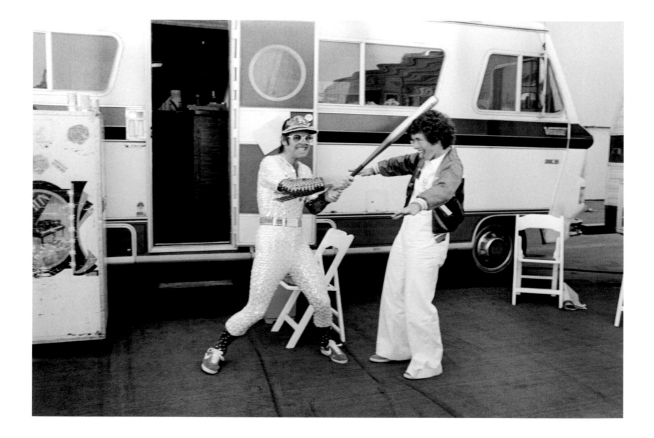

Above: "Billie Jean King was there. She even jumped onstage and joined the backing vocalists on 'Philadelphia Freedom' during the second set."

Opposite: British television presenter Russell Harty backstage. Harty was filming an interview with Elton John, which included footage of the Dodger Stadium concert.

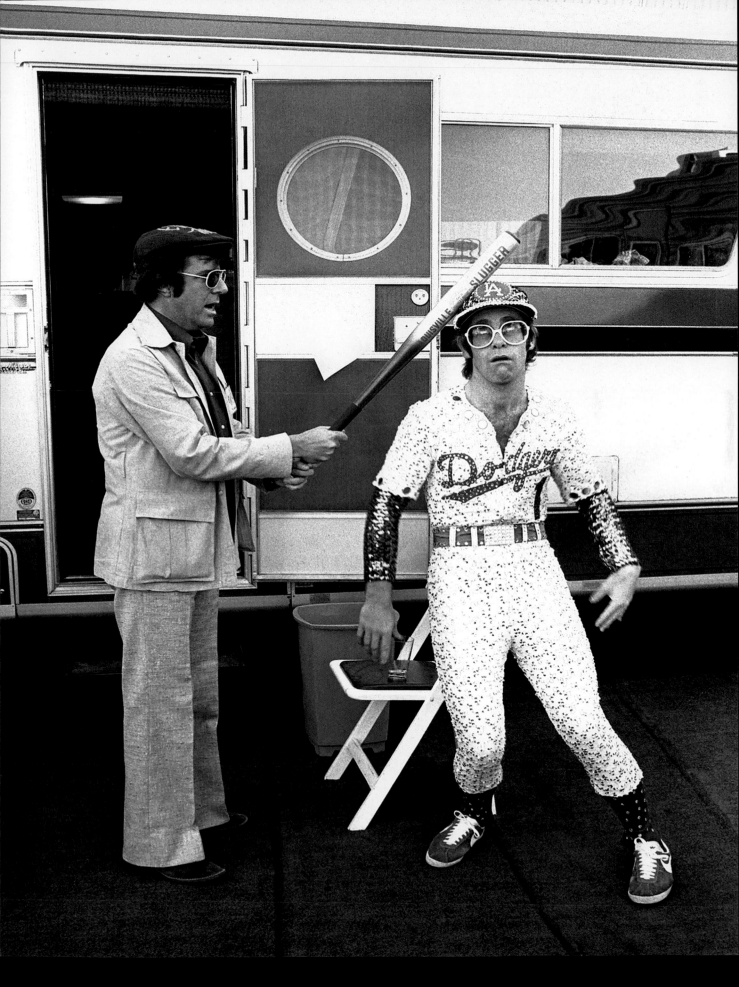

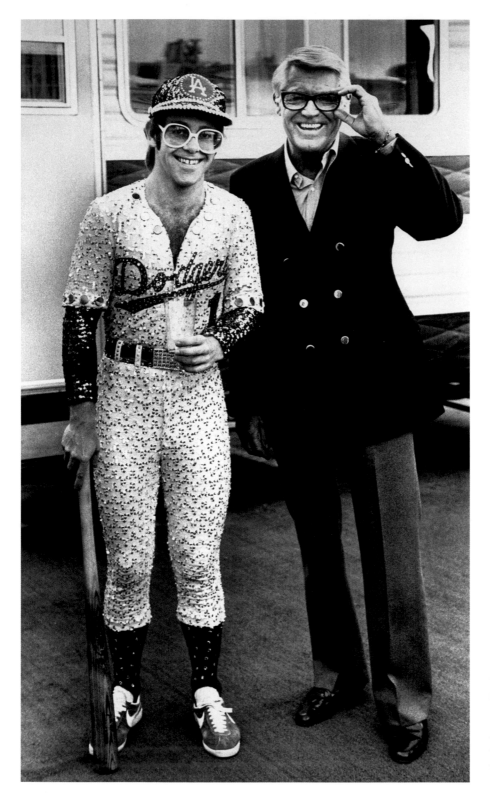

Left and opposite:
"There were a lot of
stars backstage, as one
might expect, especially in
Los Angeles. Cary
Grant was the highlight,
though. I think we were
all a bit starstruck when
he arrived."

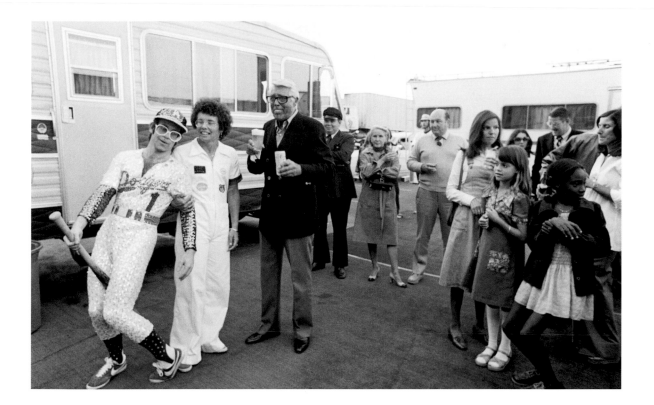

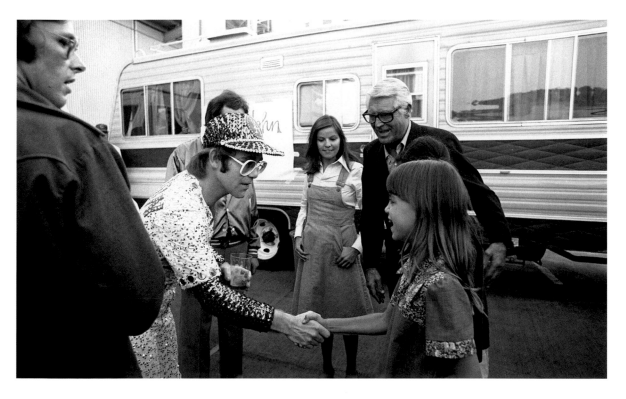

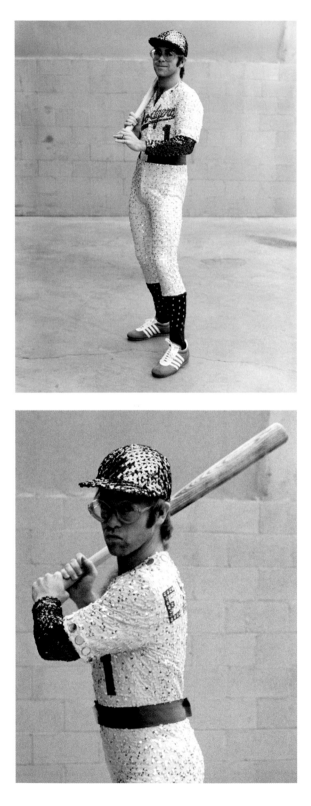

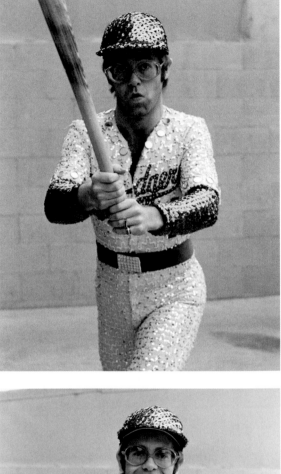

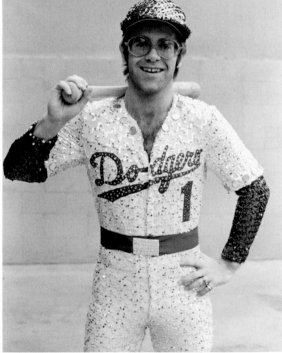

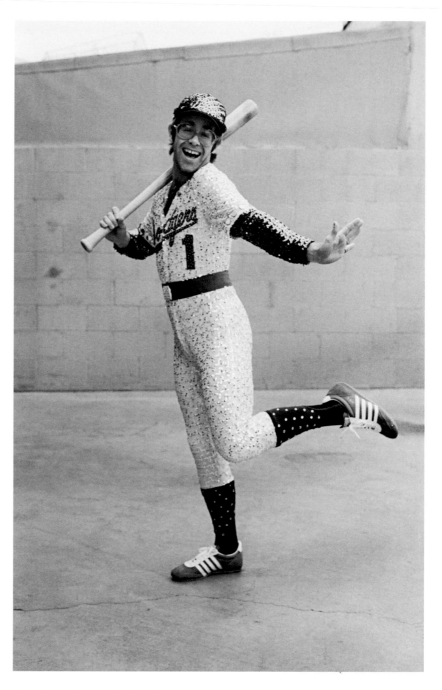

Opposite and above: "The famed
designer Bob Mackie designed many
of Elton's more outlandish stage
costumes. This is probably the most
iconic – a sequined LA Dodgers baseball
uniform, complete with his name and the
number one emblazoned on the back."

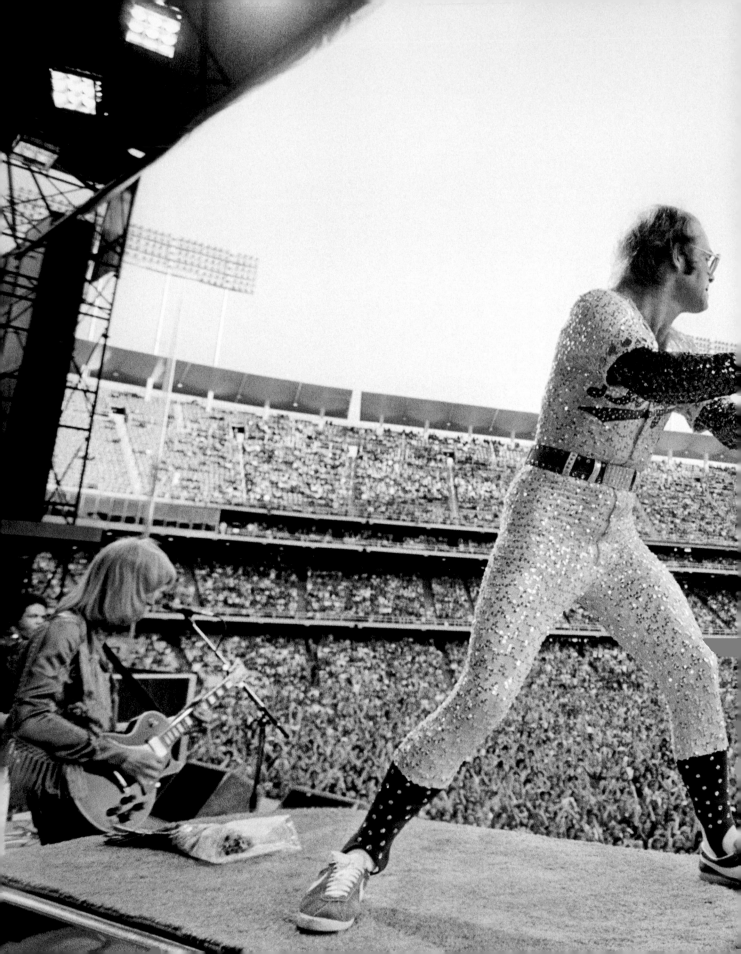

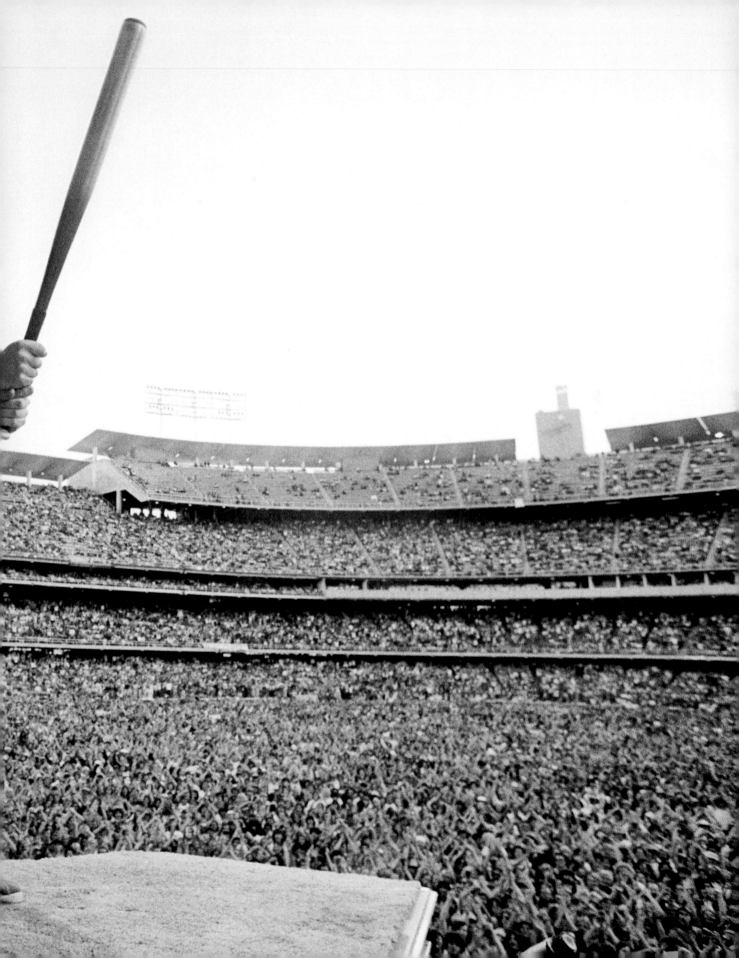

Previous pages, below and opposite:
"I took a lot of images of just Elton with the bat, but I also love the band's reaction in these."

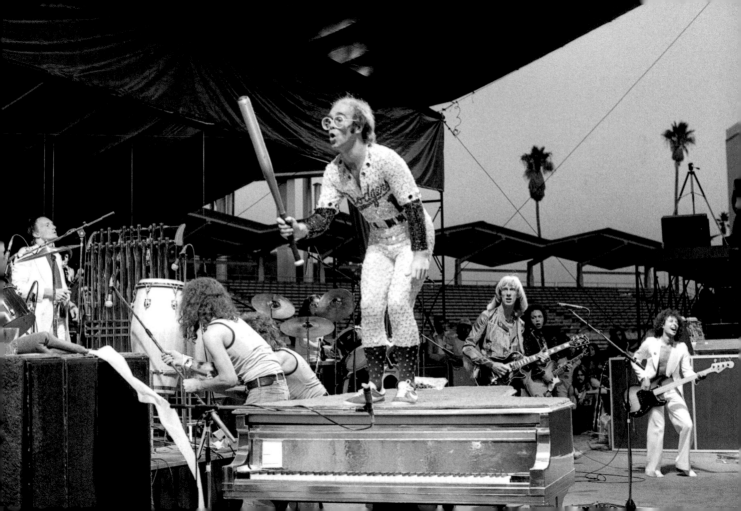

Below: The song 'Don't Let the
Sun Go Down On Me' (1974) was perfectly
timed to be performed at sunset.

Opposite: "Davey Johnstone,
the guitarist, is such a nice bloke.
He still plays with Elton, more than
40 years on."

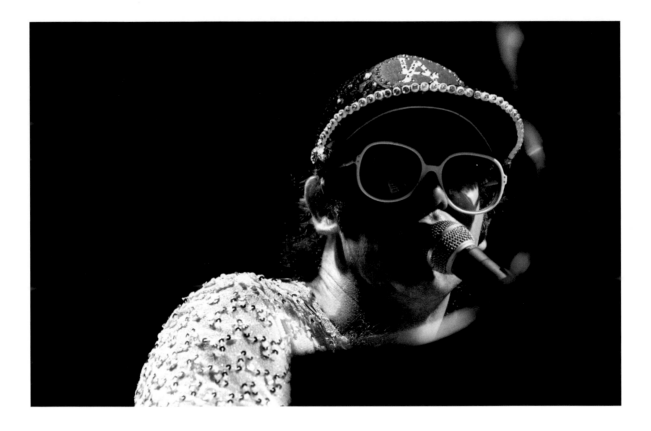

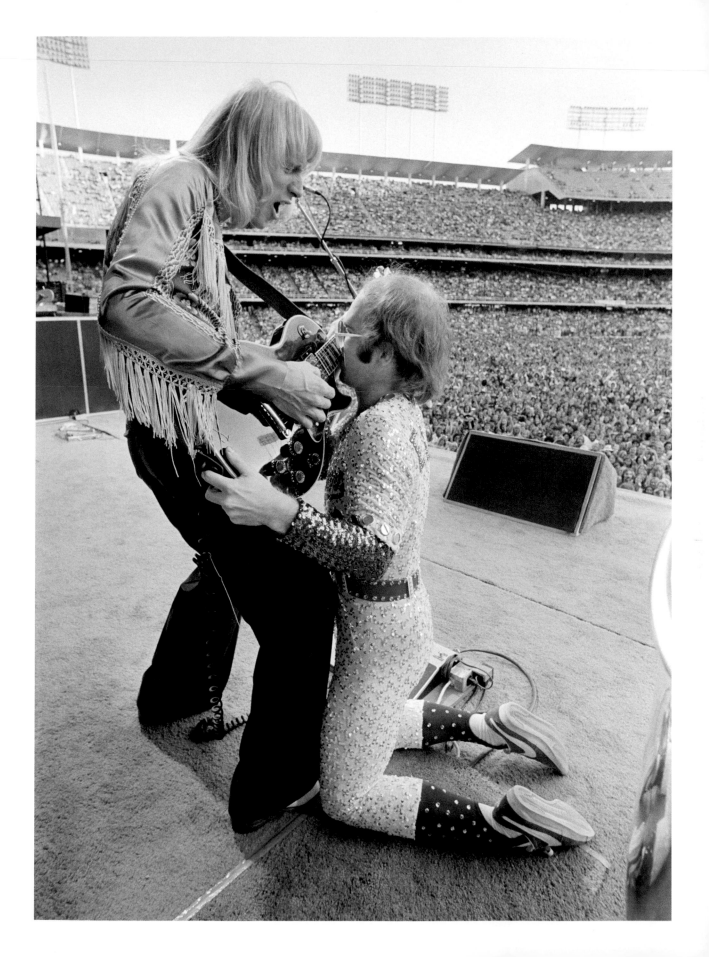

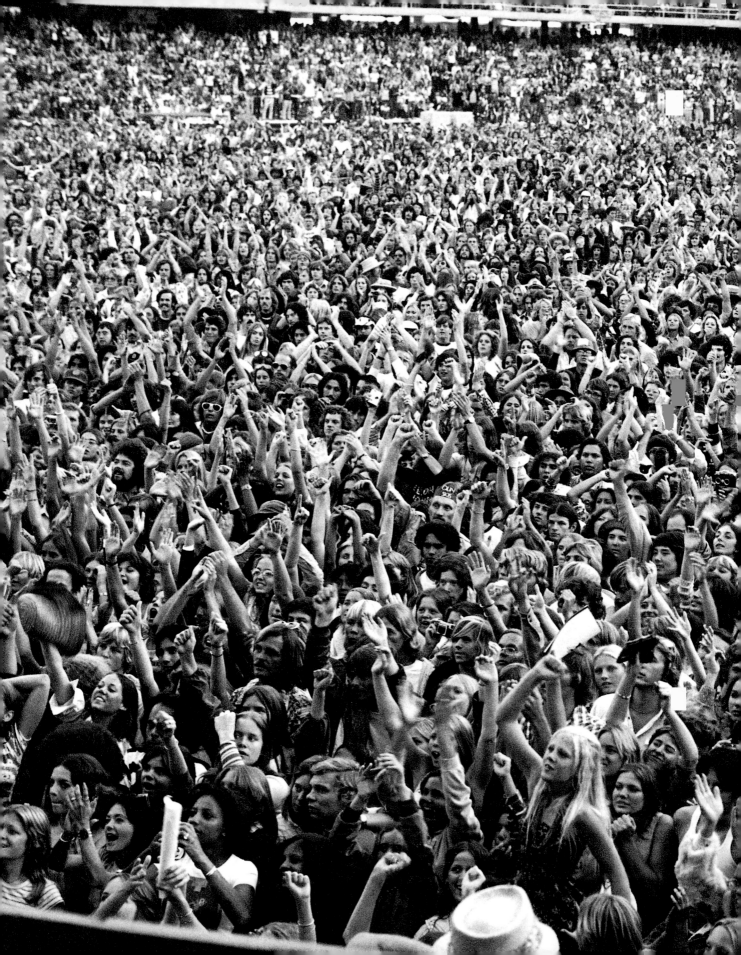

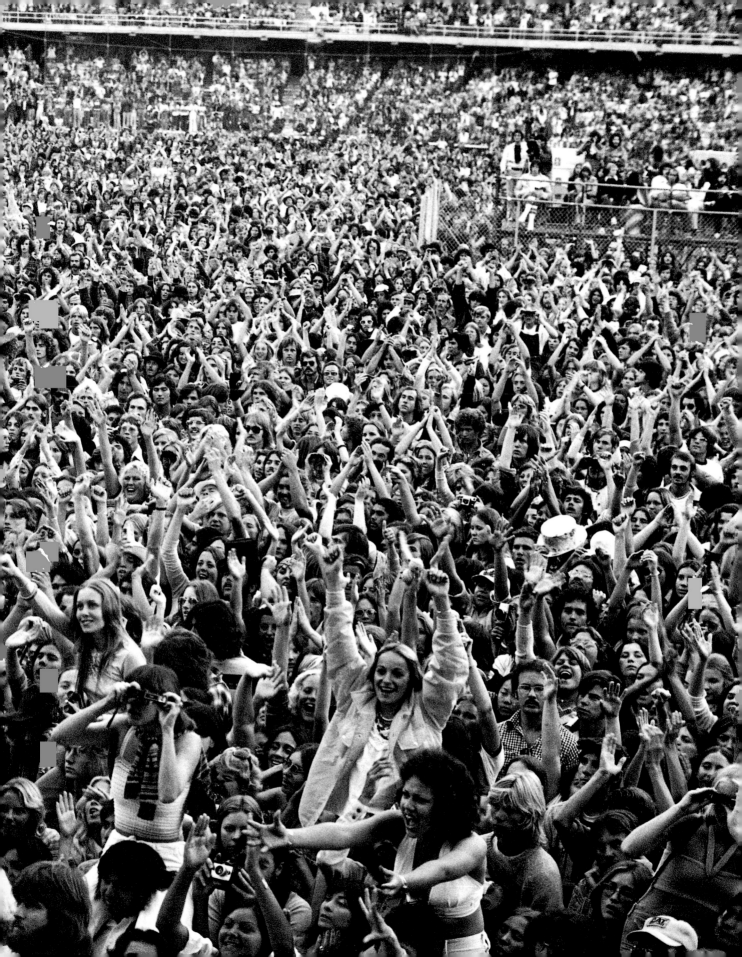

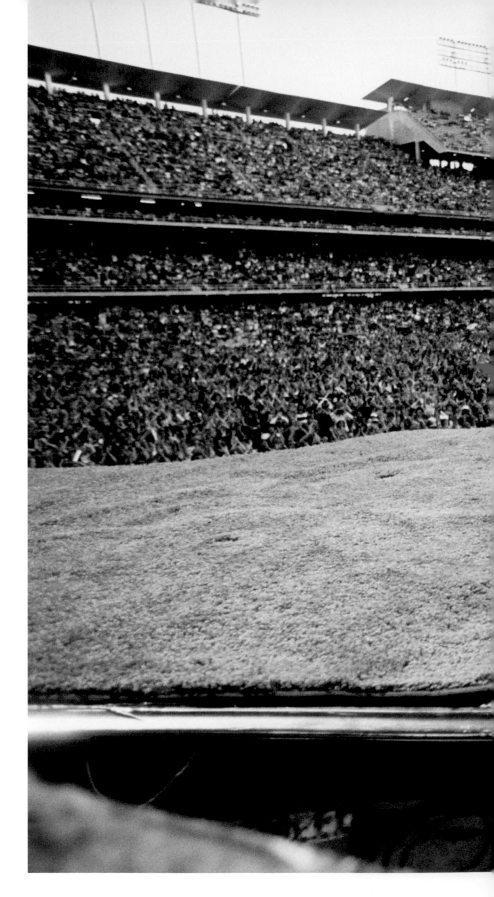

Previous pages: In two days, Elton played to more than 110,000 fans.

Right and overleaf: "I had a few cameras around my neck and would try to switch between black and white (my preferred format) and colour. This method had worked for me in the past, notably at a David Bowie show that I had shot the year before this. The colour film makes Elton's uniform and piano come alive, because they were so vivid."

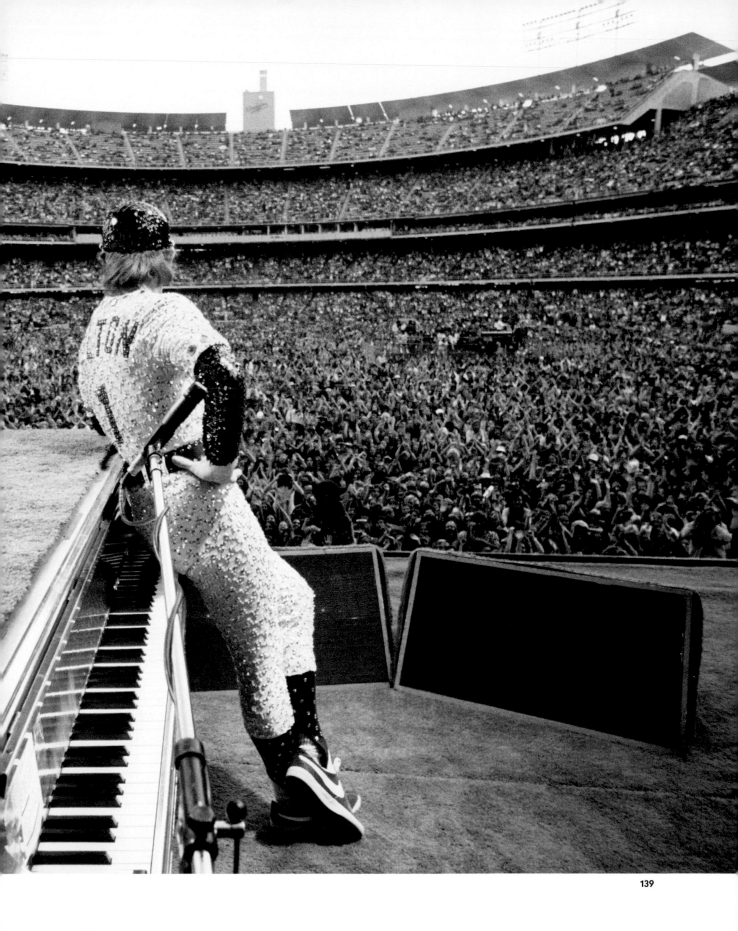

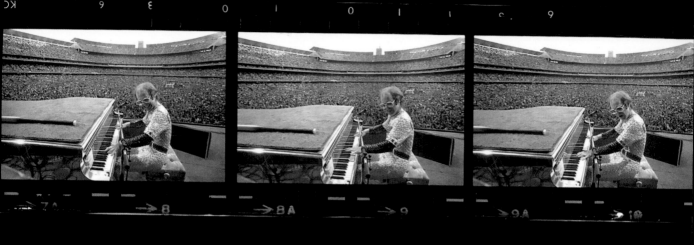
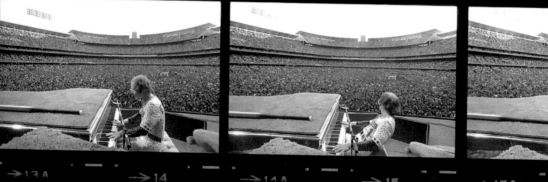
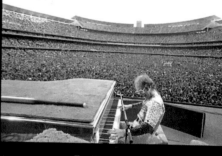
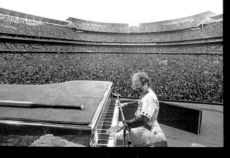
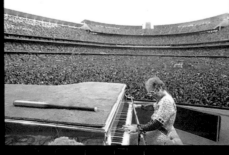
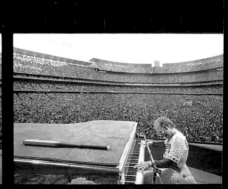

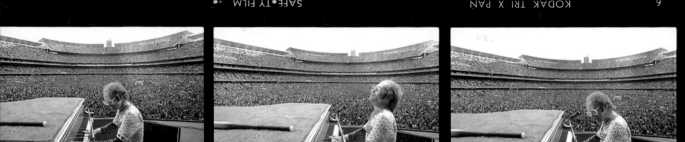

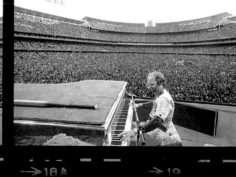

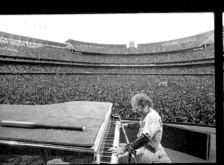
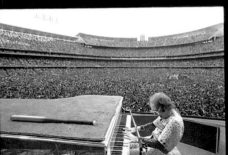
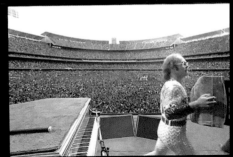

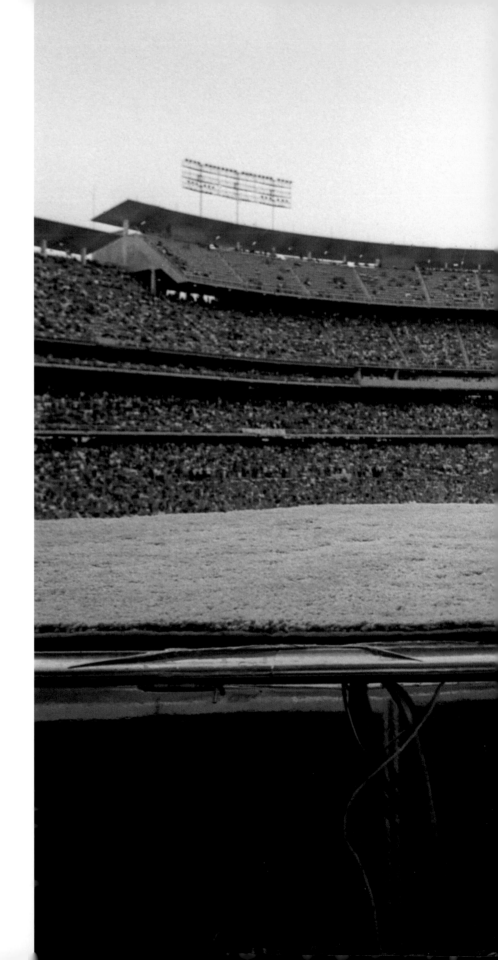

Right: "We always called this 'Elton howling' and it is one of my most requested prints."

142

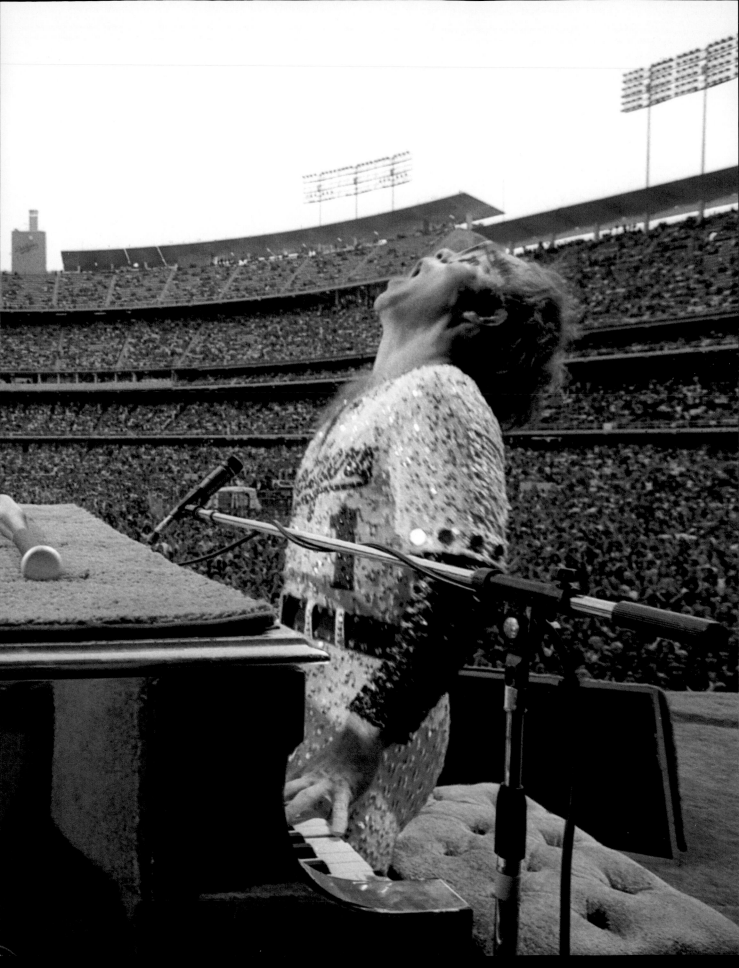

Right: "I didn't know about any of the personal problems Elton was dealing with at the time. You would never have known Elton wasn't anything but happy. He was number one worldwide – best albums, awards, biggest concerts – I only captured the joy."

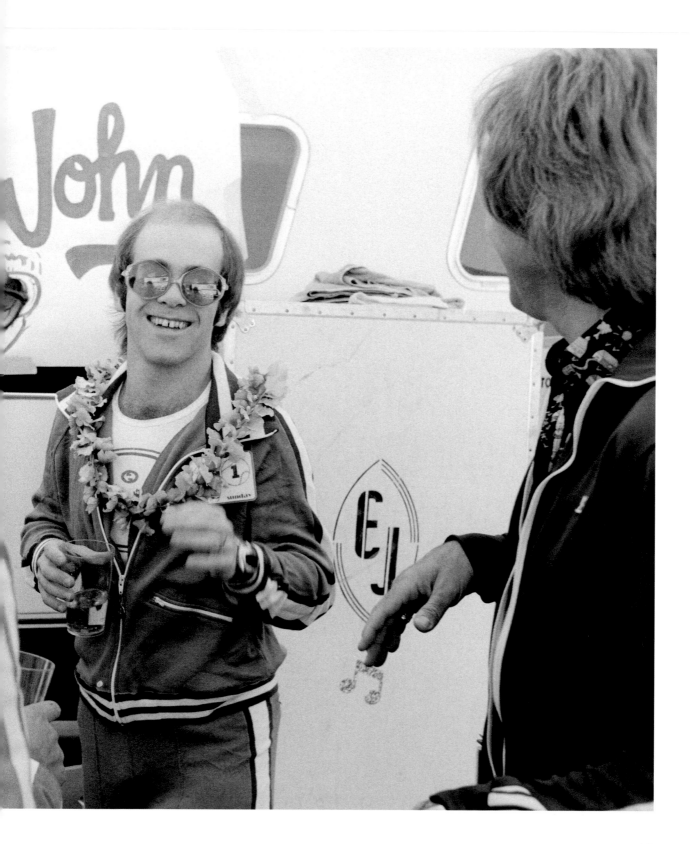

Below: "Elton has the most extraordinary and sometimes eclectic taste in what he buys."

Opposite: "He didn't just shop for himself, mind you. I remember the Cartier stop was to pick up gifts for people he worked with. Like I've said, he's a very generous guy!"

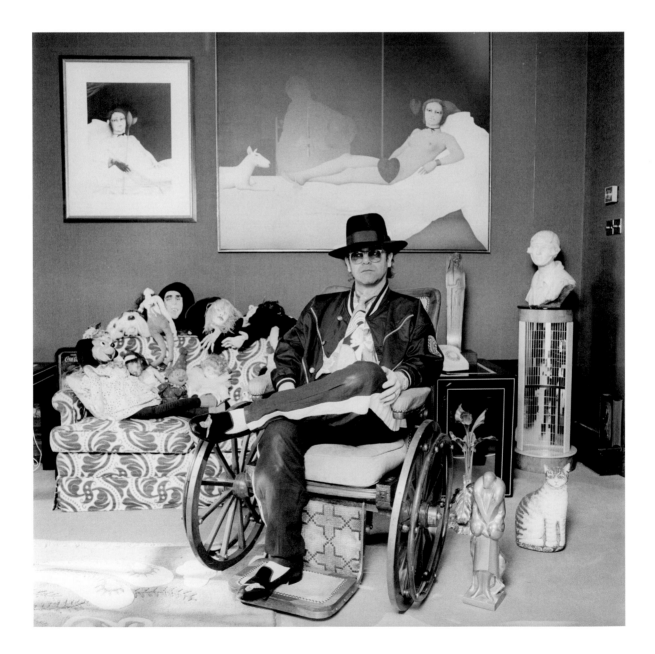

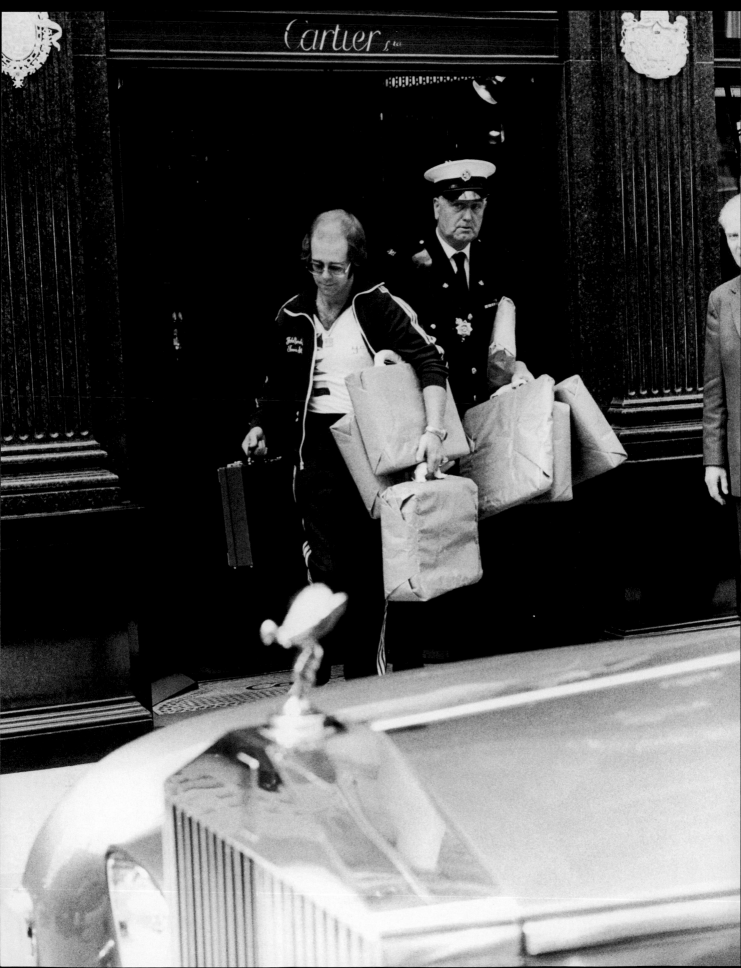

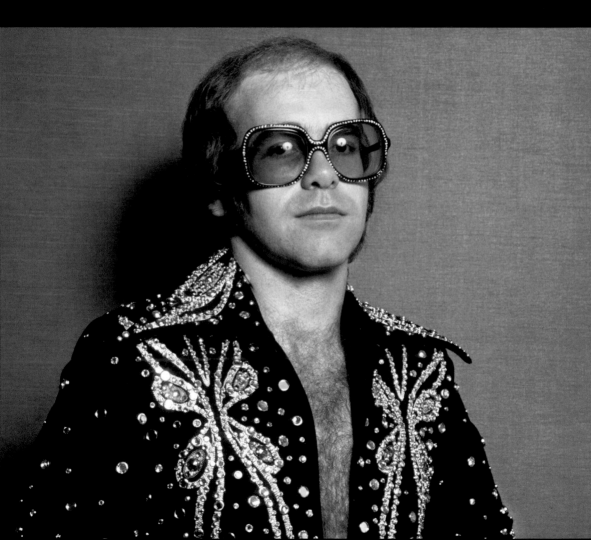

a year, and touring, so there was a real hunger for portraits. We'd do several different outfits in one sitting, but time was always tight. Here he has on a new Bob Mackie creation, known as the 'butterfly suit'."

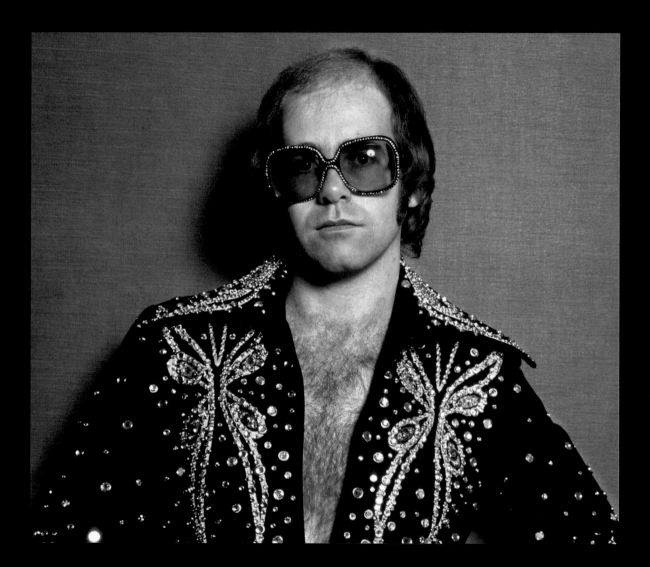

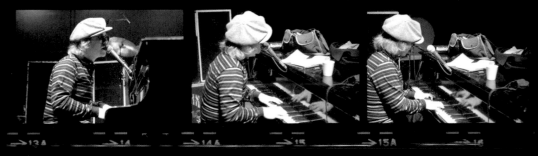
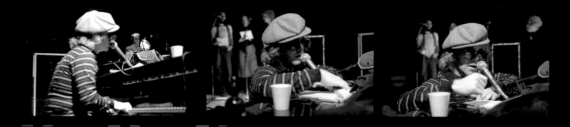

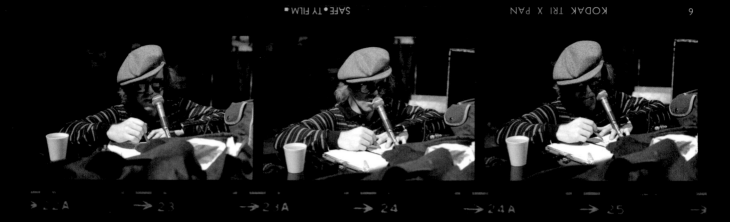

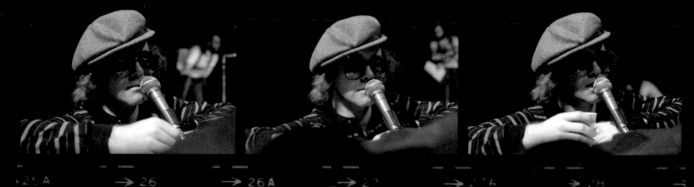

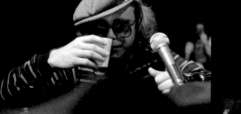

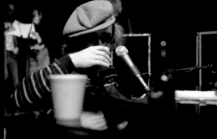

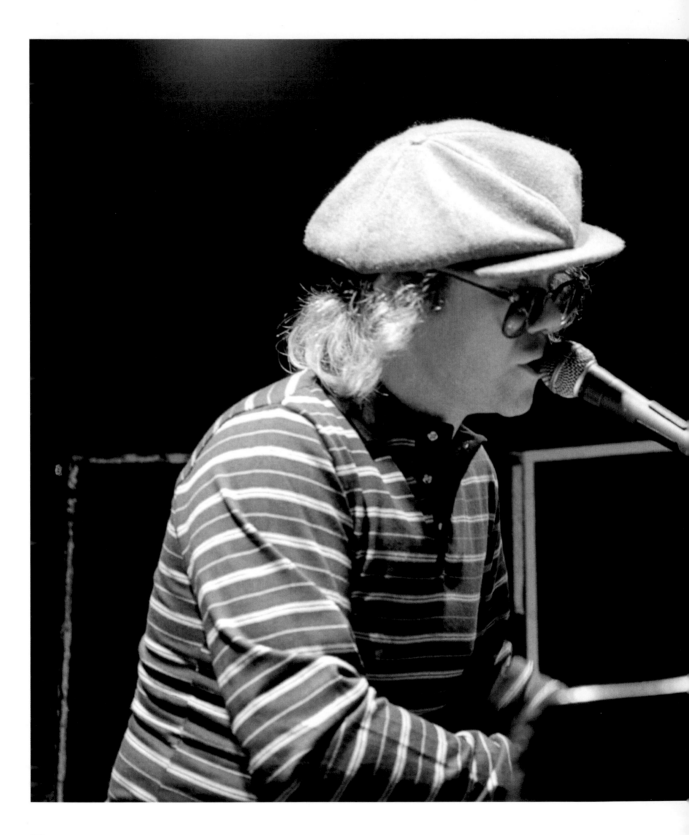

Previous pages and left: "I think this was during a sound check at the Troubadour club in Los Angeles, around the time of the Dodger Stadium concerts in 1975. Elton wanted to return to the place where it had all begun, in many ways, a performance he did in 1970 at the renowned venue. I wish I had been there that night in 1970."

Below and opposite: Elton John with
Kiki Dee. In 1976 they released the
classic duet 'Don't Go Breaking My
Heart', which was number one in the
UK and America.

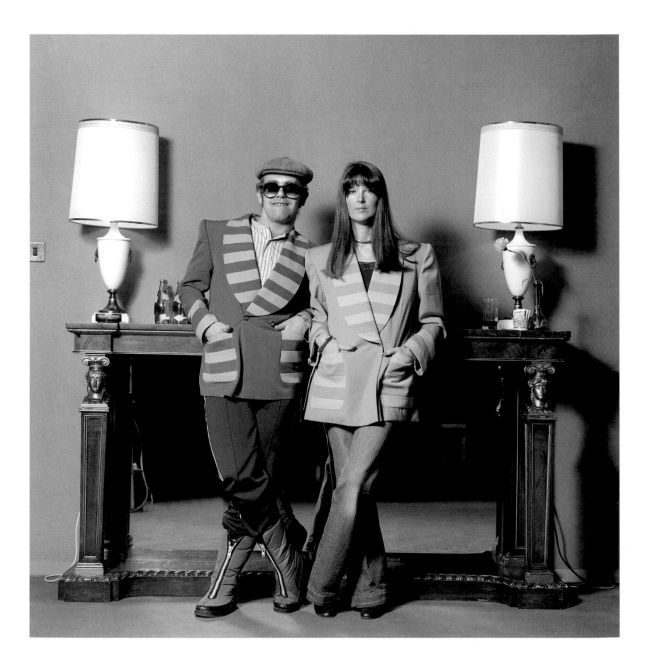

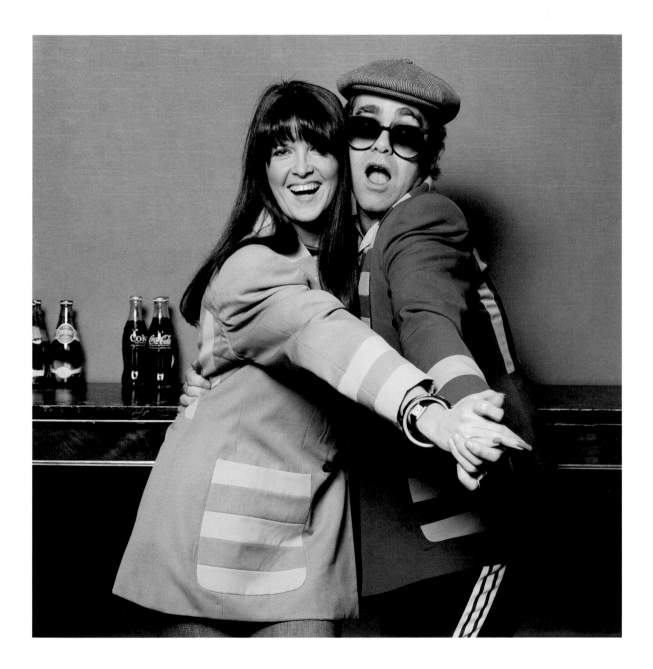

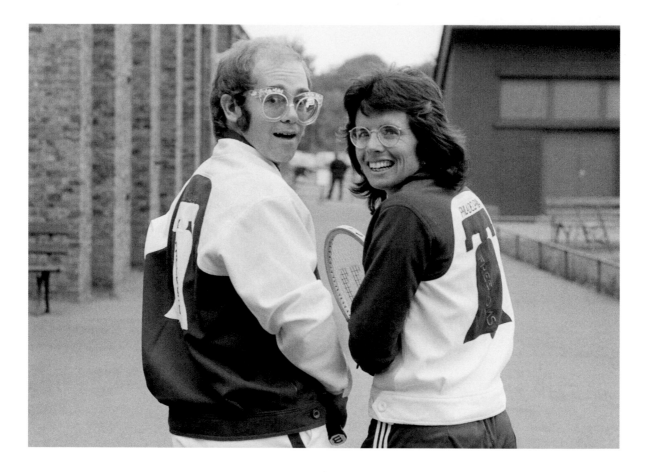

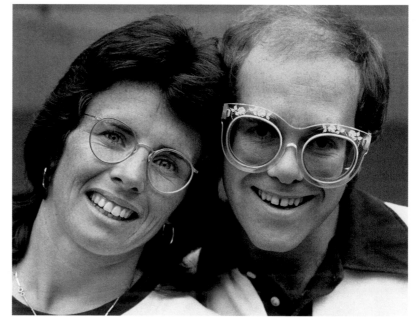

This page and opposite: "Elton loves to watch and play tennis, and Billie Jean King loves music – so there was an instant mutual respect between them. They really are like brother and sister, those two."

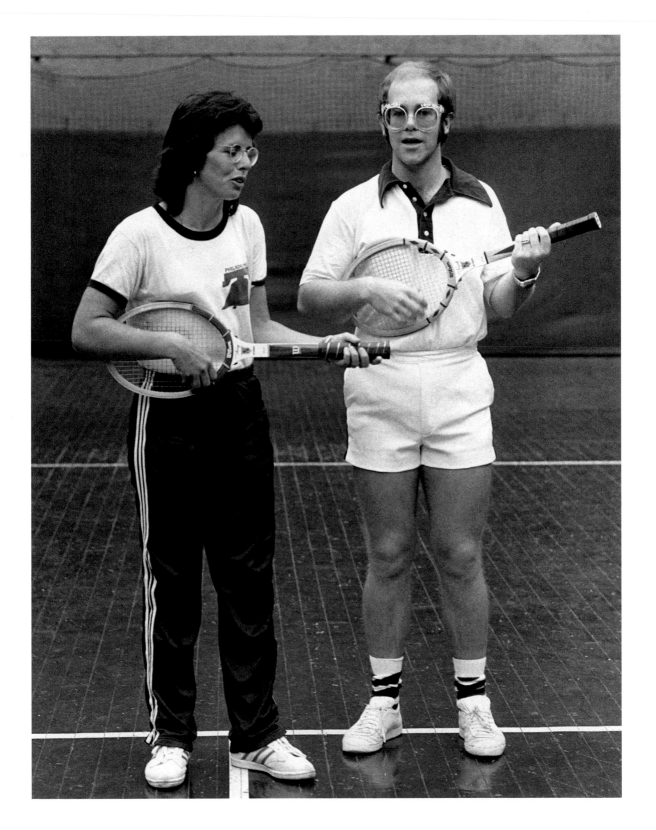

Below and opposite: "How far Elton has come from those early days, and in such a short amount of time. Everything grew – his record sales, his career and his collections. Taking photos at one of his homes got much easier as the years went on because he had so many props on hand."

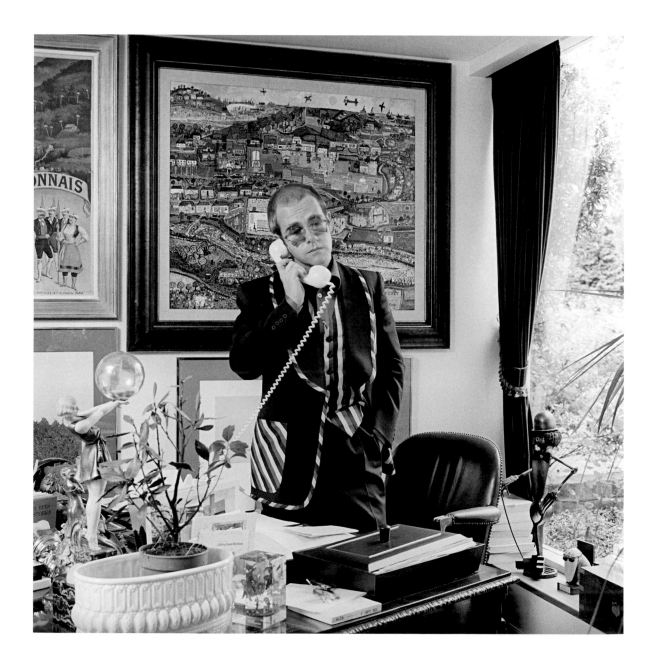

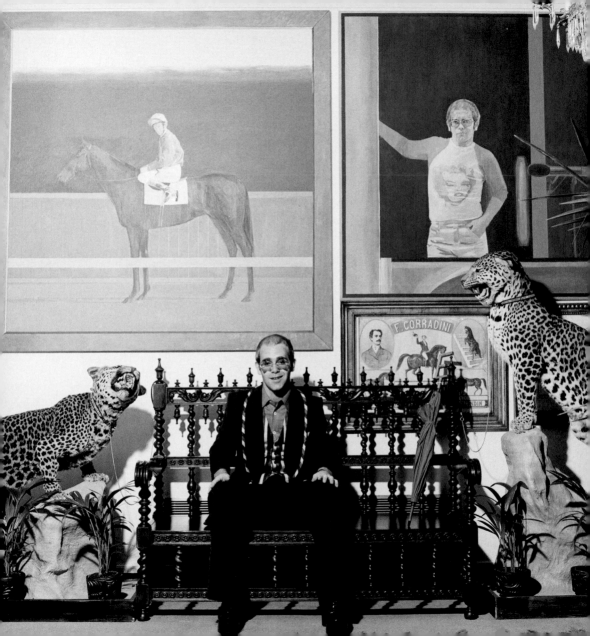

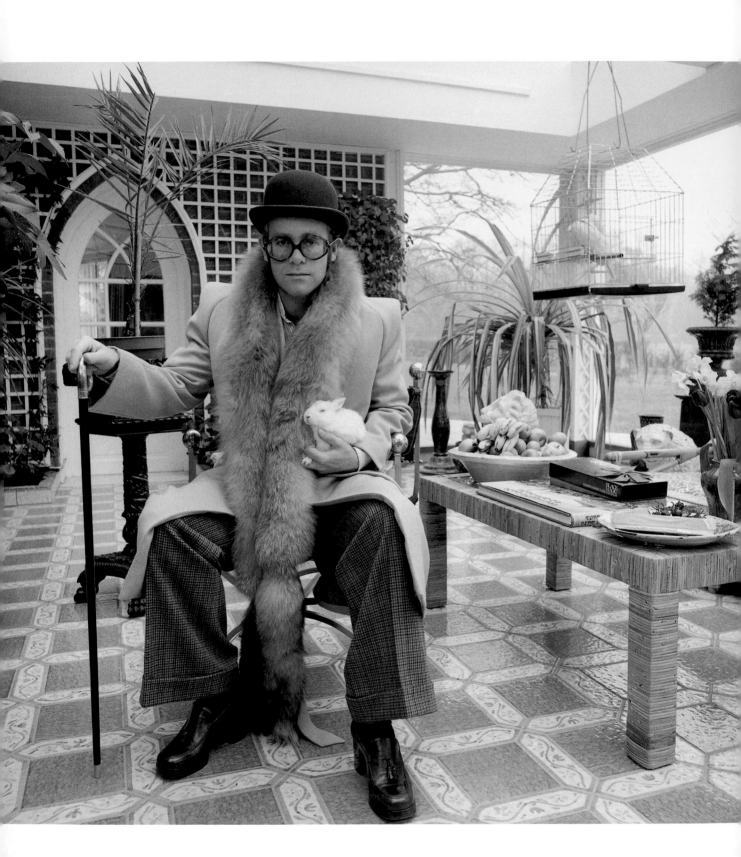

**Opposite and below: Portraits of
Elton John at home in the mid 1970s.**

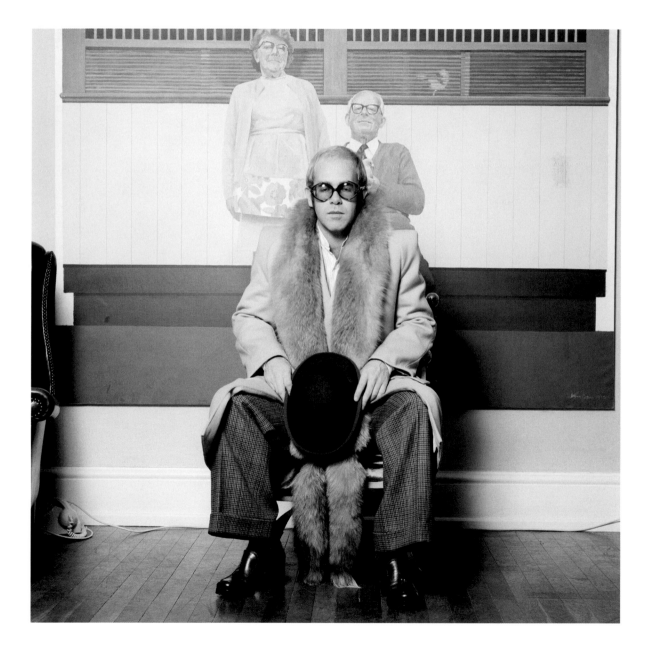

Below and opposite: "All these photos do make me laugh now. I was working with David Bowie and Led Zeppelin around the same time, but no one had more style than Elton."

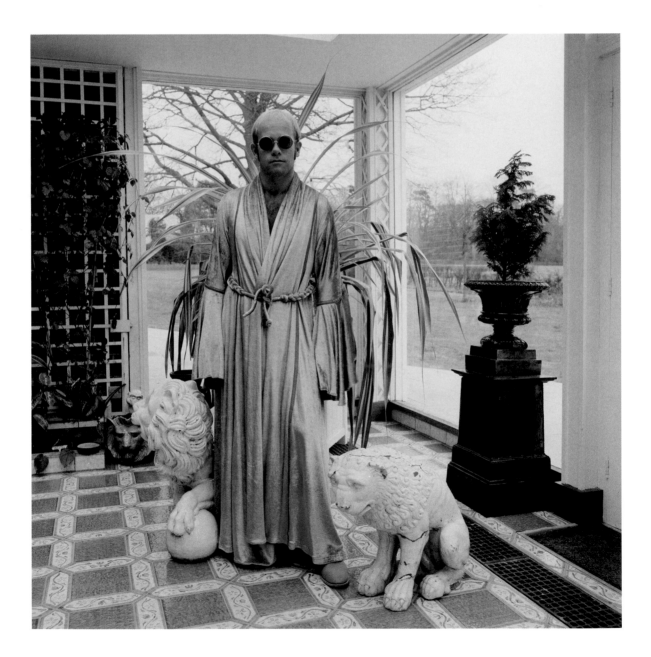

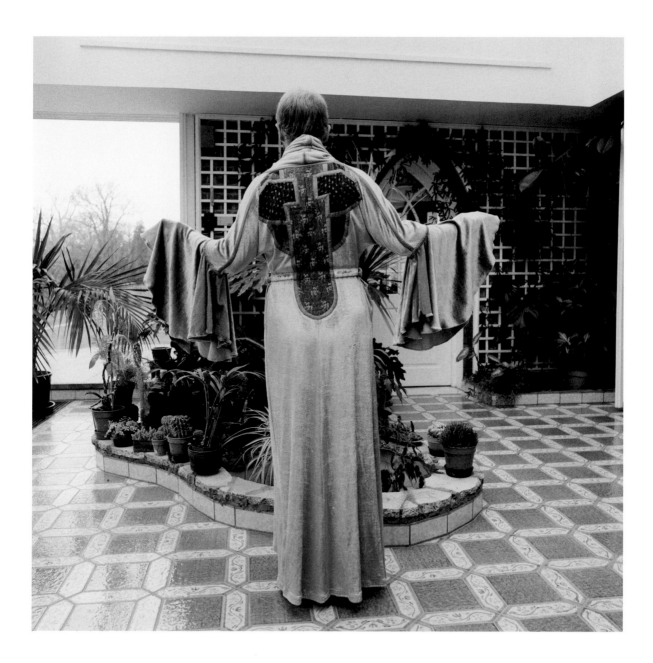

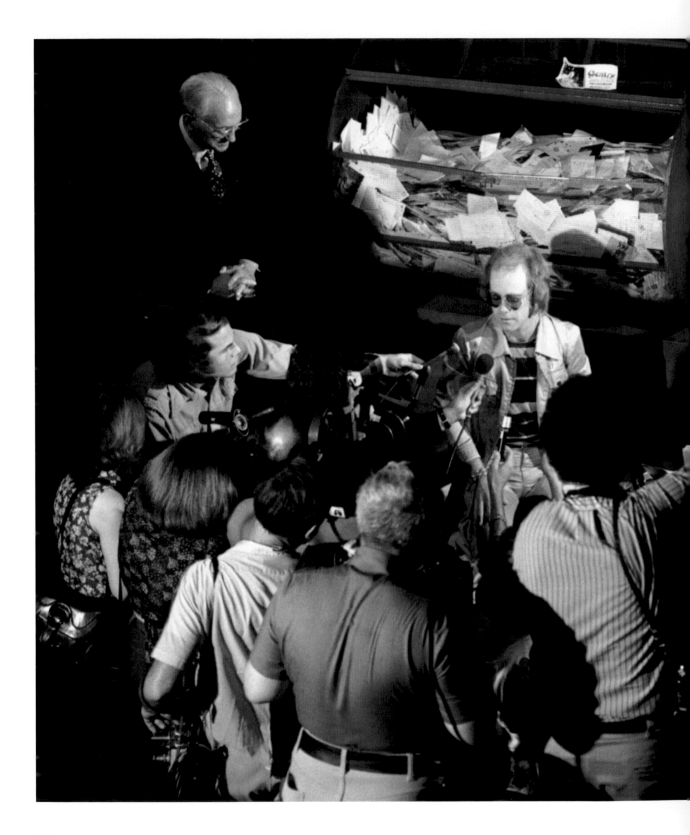

Left: "People forget about everything that went with being a big recording star. There were songs to write, albums to record and concerts to play, but I was amazed at how many other things Elton was involved in – especially when it came to the press."

"Just when I thought, well, he's done everything – suddenly I got a call asking if I was free to come over to Madame Tussauds."

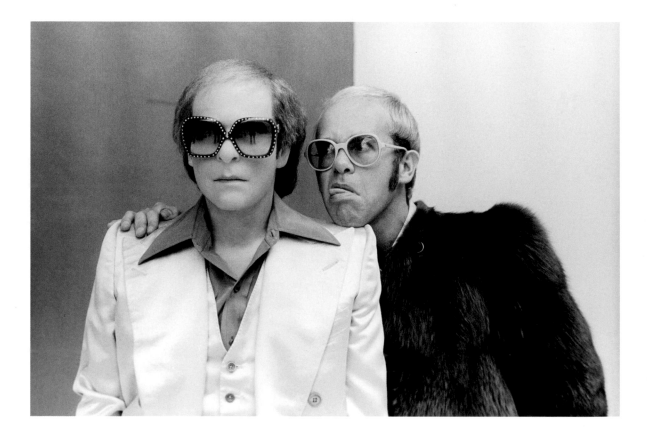

Above and opposite: In 1976 Elton John became the first rock figure to have a likeness at Madame Tussauds since The Beatles were first immortalized in wax in 1964.

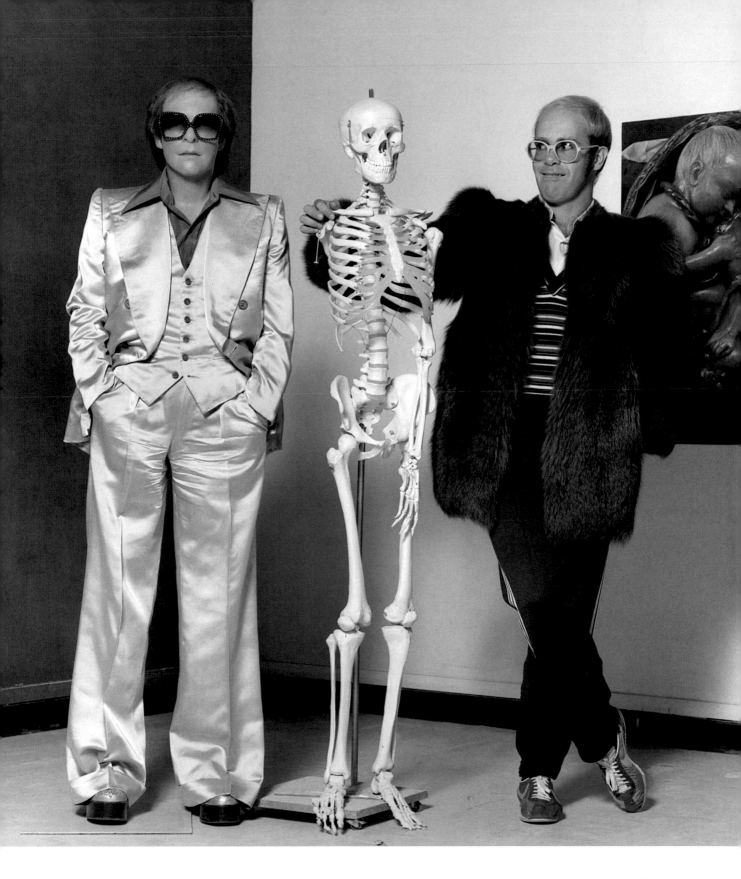

Right: "This might have been shot in Elton's manager's office, in the mid 1970s. I thought the composition was great."

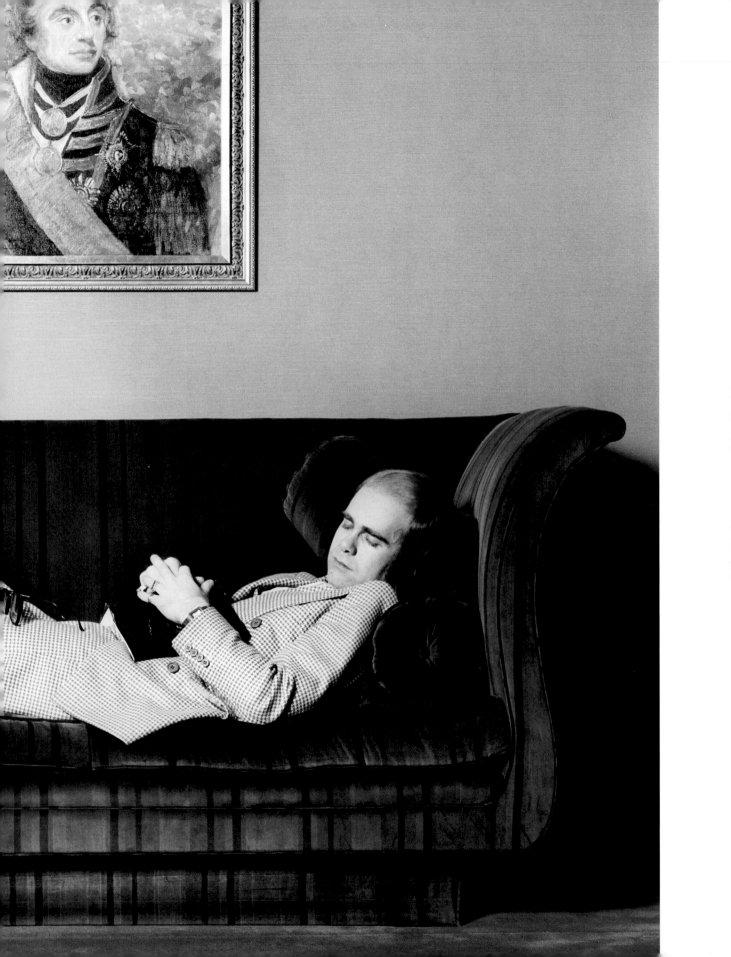

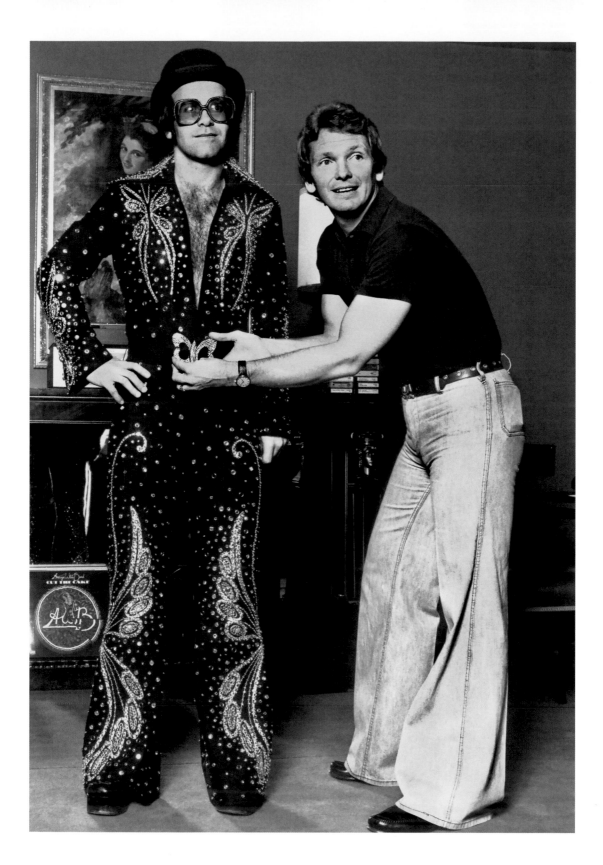

Opposite: "This is the famed Bob Mackie, doing a fitting with Elton. Mackie designed so many of Elton's most iconic outfits for the stage, and he also worked with Cher, Bette Midler, Liza Minnelli and many other performers.

His creations really helped define Elton's visual, especially when it came to live performances. For me, this was gold. I can't imagine those Dodger Stadium images without the sequined uniform."

Below: "I read that Elton still collects glasses. I bet by now he must have thousands."

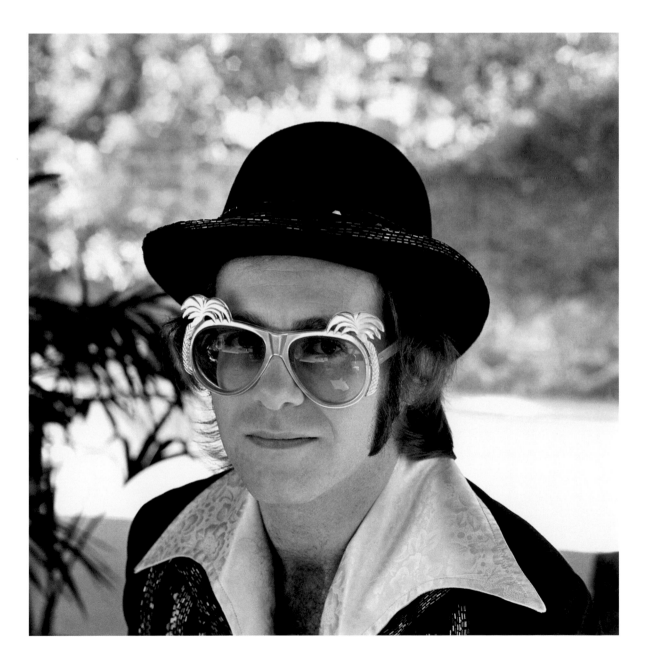

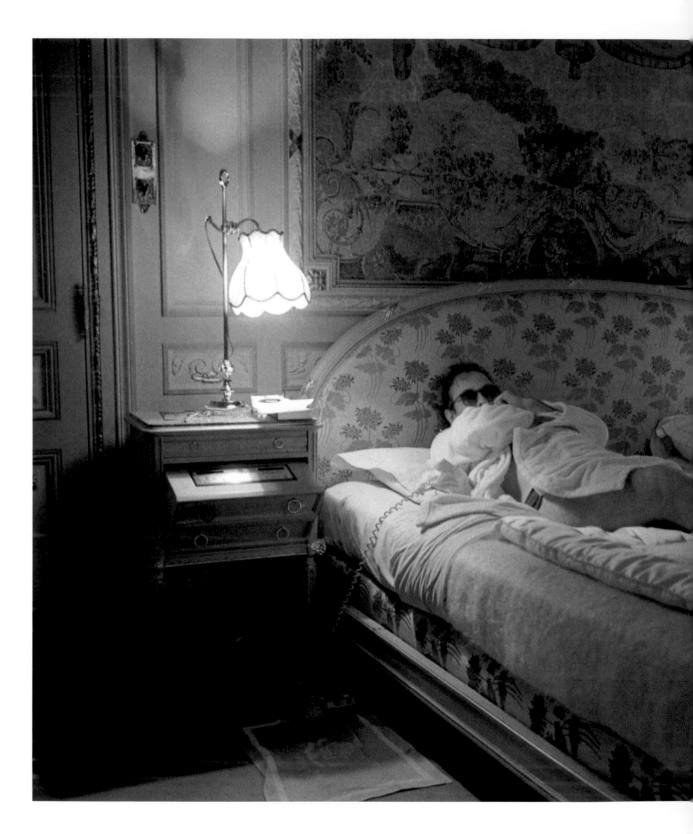

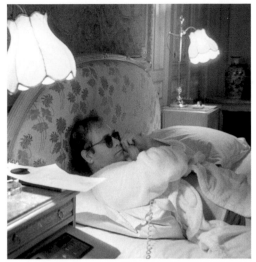

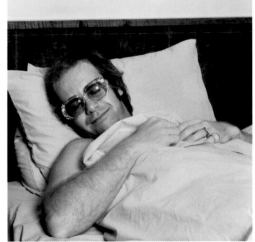

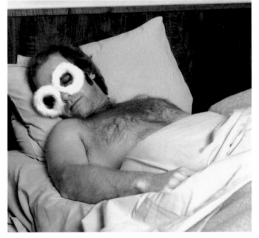

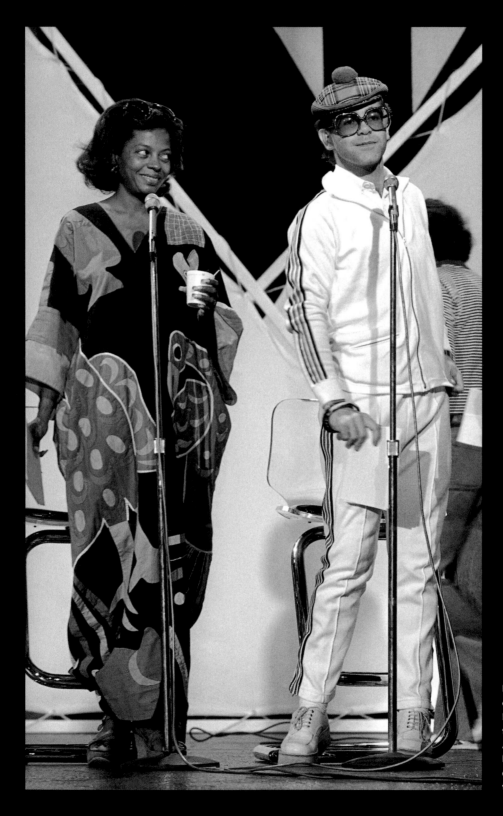

Previous pages, left and opposite: Elton John and Diana Ross hosted the first annual Rock Music Awards in 1975. Held in Los Angeles, the new awards show only lasted three years.

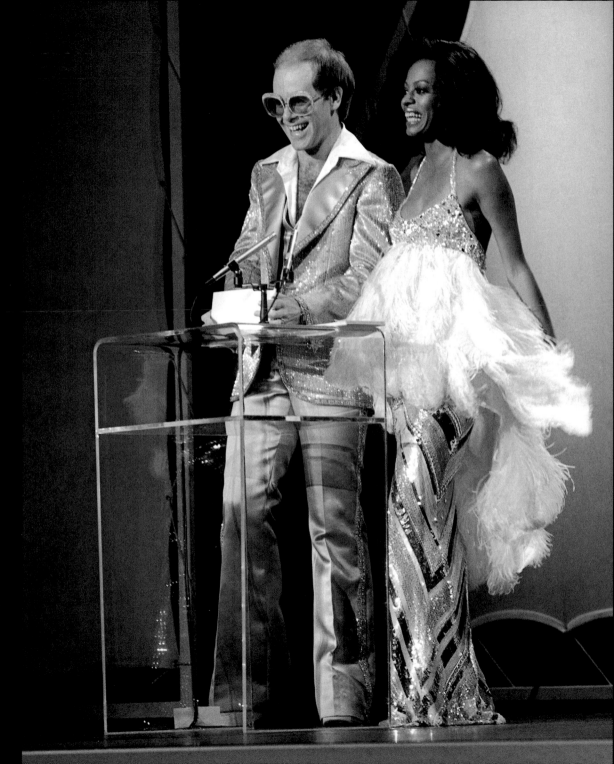

Right: Elton John greets Ella Fitzgerald onstage at the Rock Music Awards in Los Angeles, 1975.

Below: Cher presents Elton with the Outstanding Rock Personality of the Year Award while Diana Ross looks on.

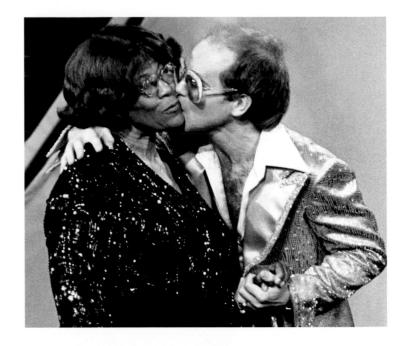

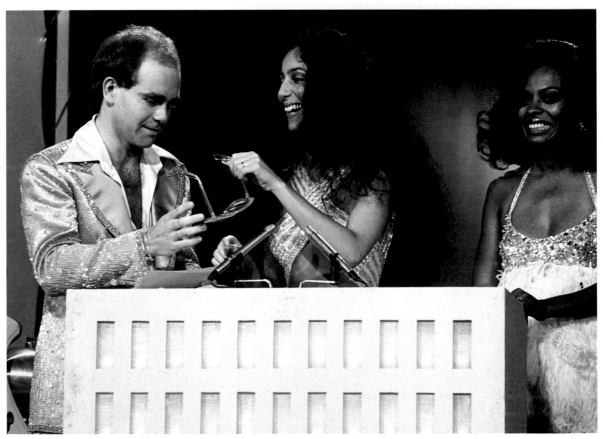

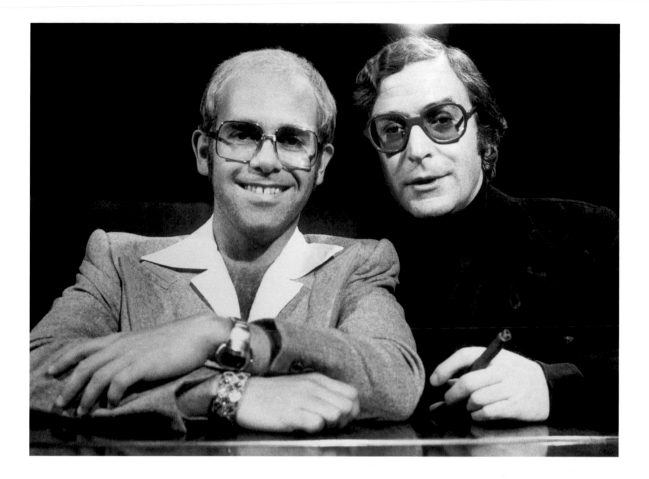

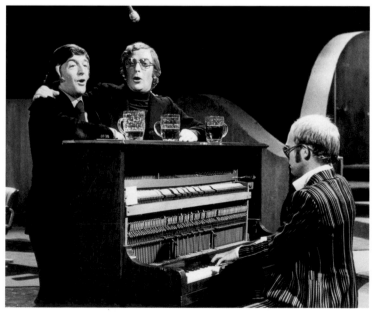

Above: Elton John with Michael Caine, appearing on the *Parkinson* television show, hosted by Michael Parkinson, 1976.

Right: Elton leads the two Michaels and the audience in a singalong.

Right: "Believe it or not, this was a chance meeting outside a restaurant in Mayfair." From left to right: Harry Nilsson, Ringo Starr, Elton John, Paul McCartney, Linda McCartney.

Below: Elton and Ringo Starr, backstage after the Wembley concert, 1975.

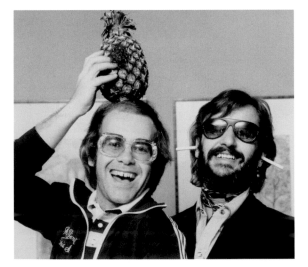

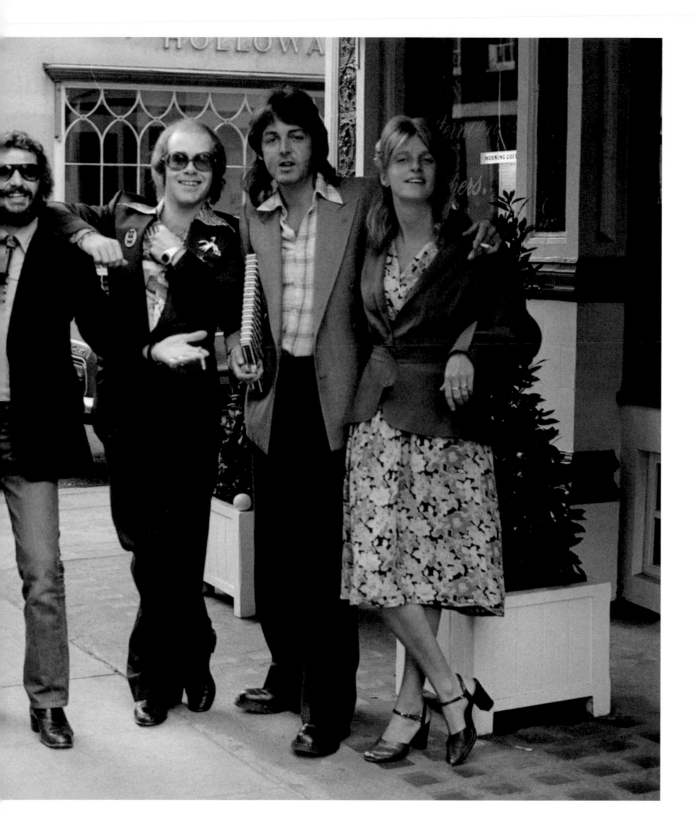

"He was a born Watford supporter."

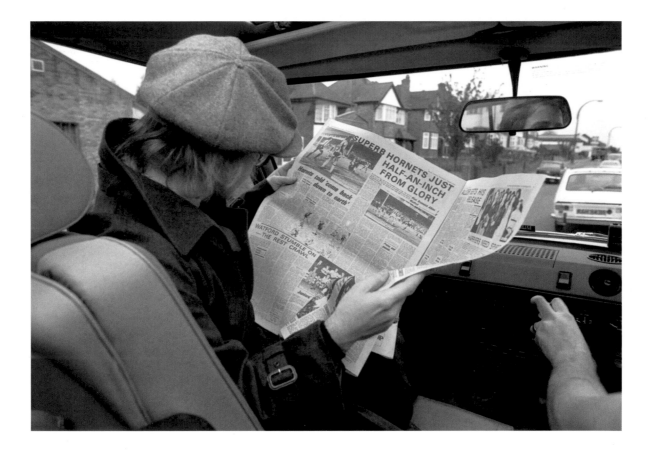

Above: Elton John became Chairman of
Watford Football Club in 1976.

Opposite, above: Elton speaking to
Graham Taylor, whom he hired to
manage Watford in June 1977.

Opposite, below: Elton with player
Luther Blissett (left).

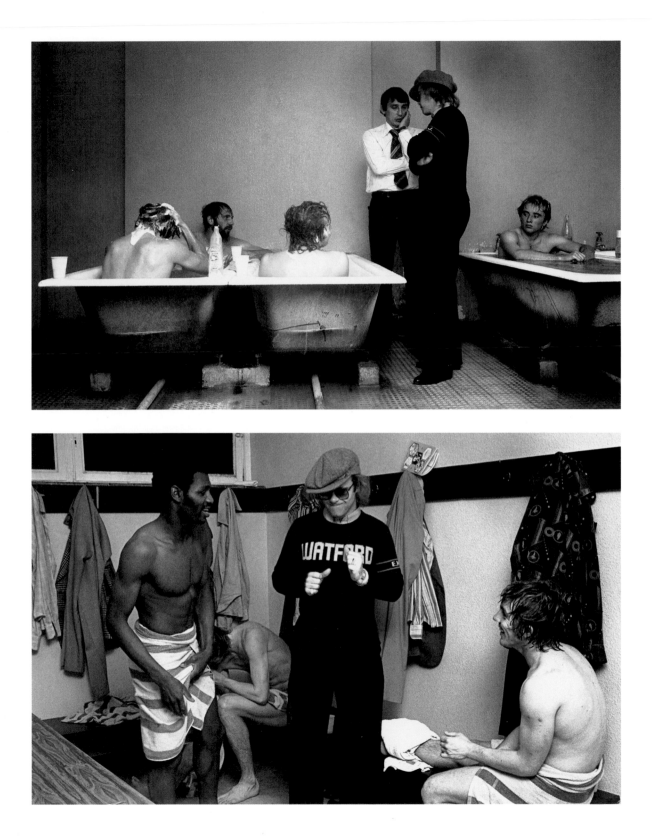

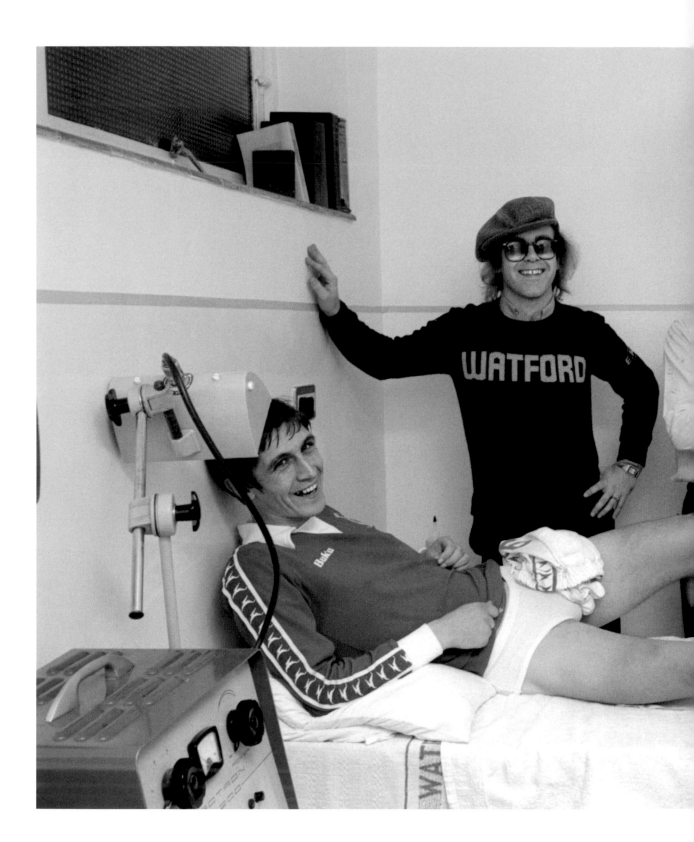

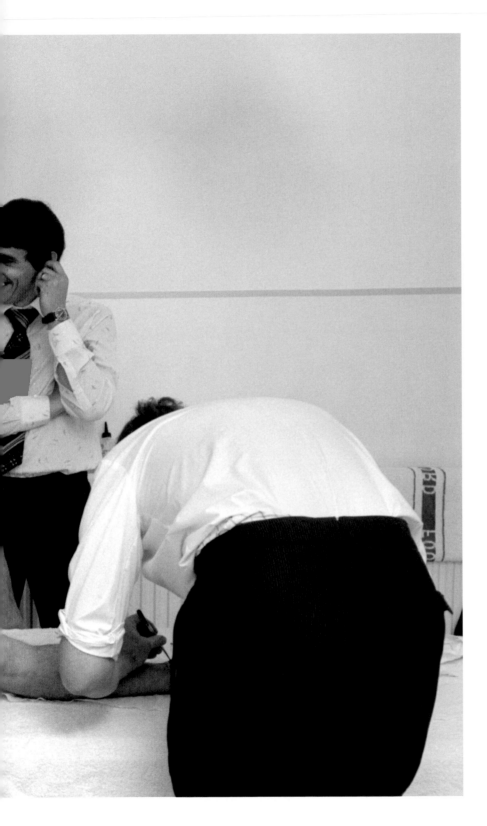

Left: Graham Taylor, pictured here with Elton at Watford FC, led the team from the Fourth Division to the First Division in just five years. Taylor managed Watford until 1987.

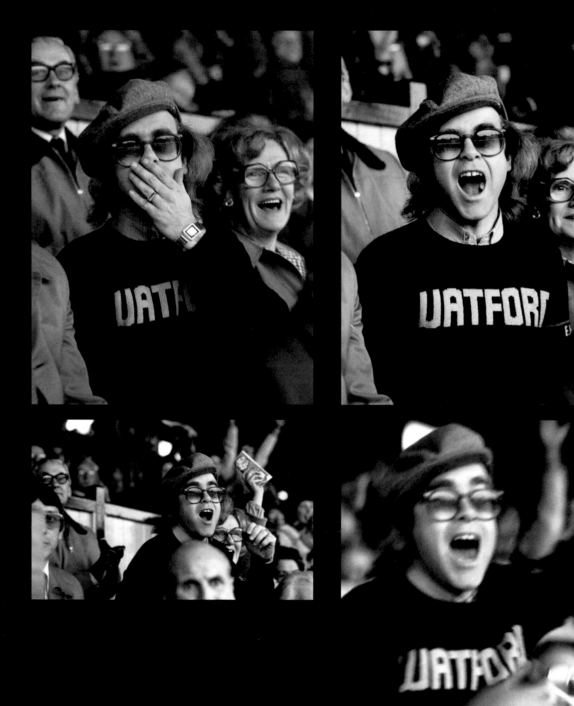

Above and opposite: "He loved it! Elton was not only an enthusiastic Watford FC fan and supporter, but he also did a good job as Chairman – helped by Taylor, of course, but he hired him."

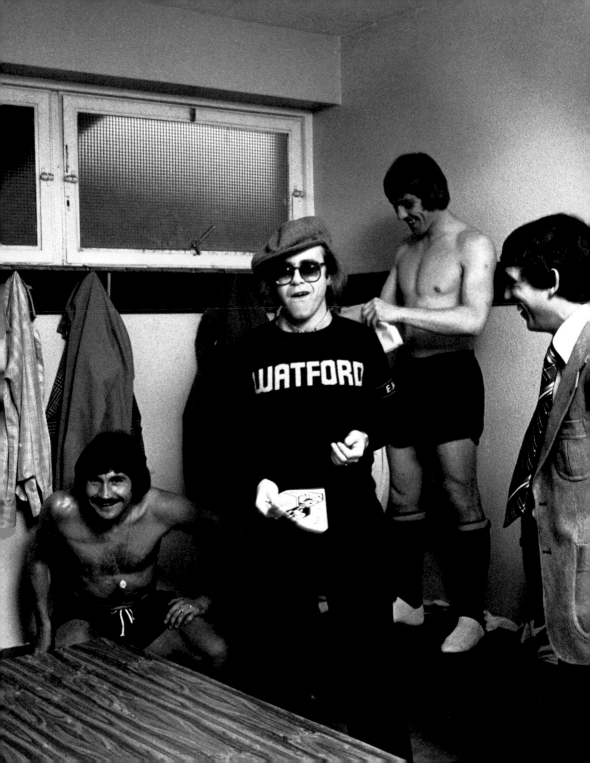

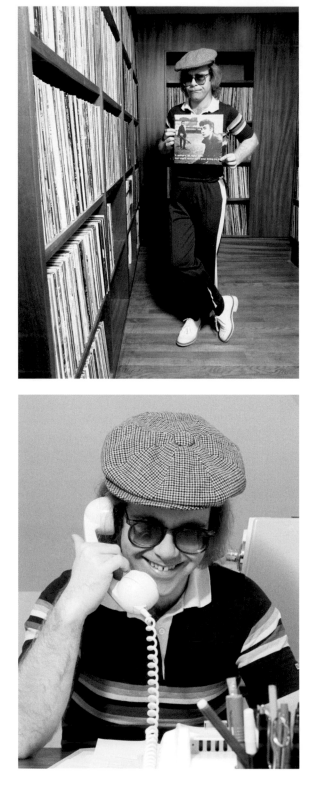

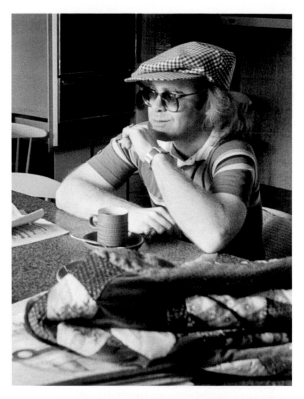

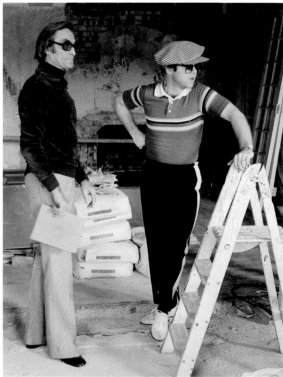

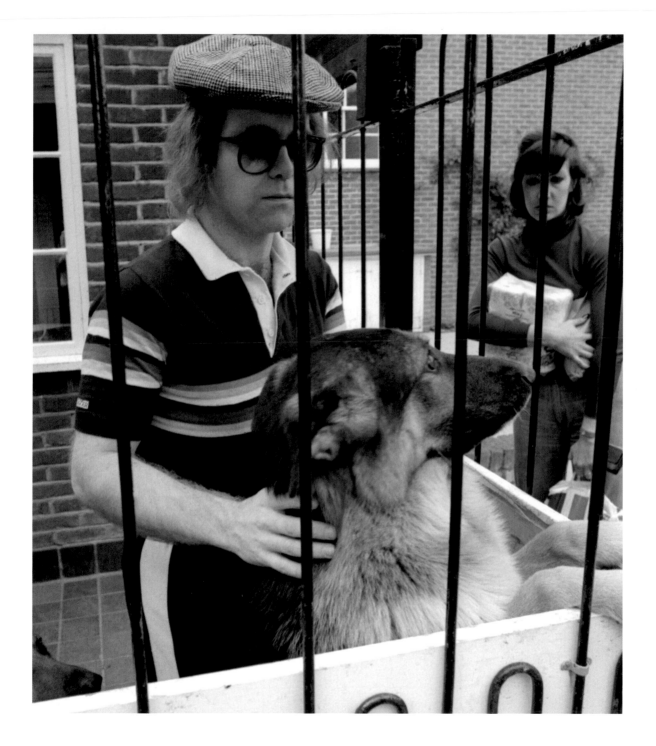

Opposite, top left: "Elton's record collection was immense – no surprise. One of the rooms of his house was practically floor-to-ceiling records."

Above: At home in Windsor, joined by one of his dogs.

Right: "I met Elton's mother, Sheila, on several occasions – she was there when he played Dodger Stadium in 1975, too."

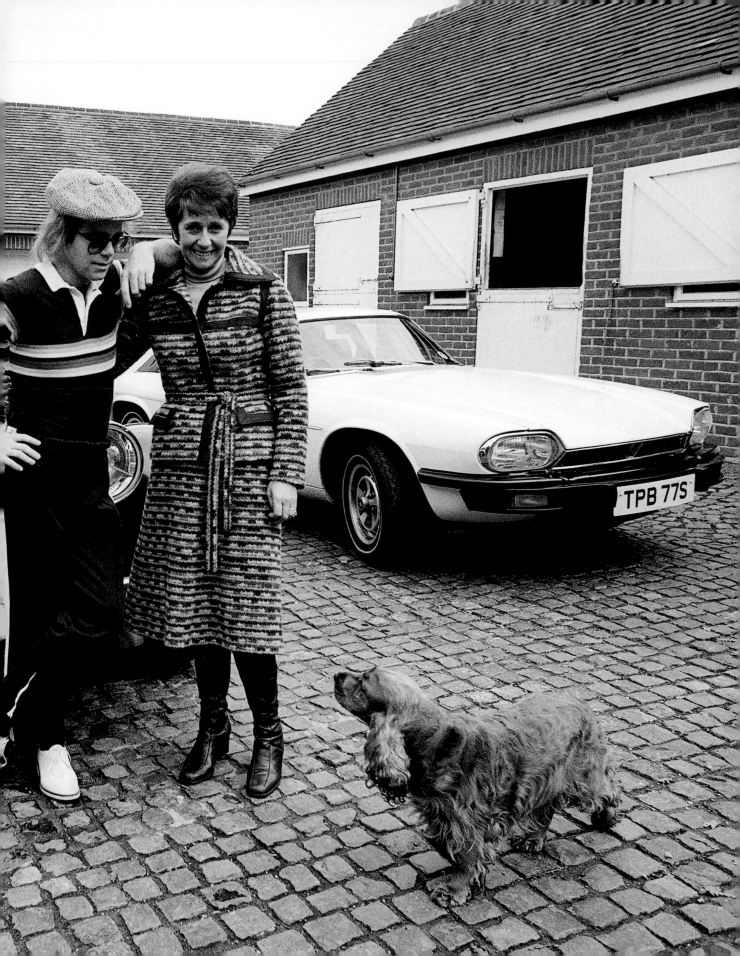

Below and opposite: "Elton was very close to his grandmother, who I remember as being very sweet. I read a story once, about how he started playing his grandmother's piano when he was just three or four years old."

Following pages: "And, of course, he also loved his cars. He didn't collect them – too big, I suppose, but he had some beautiful ones parked outside his house in Windsor."

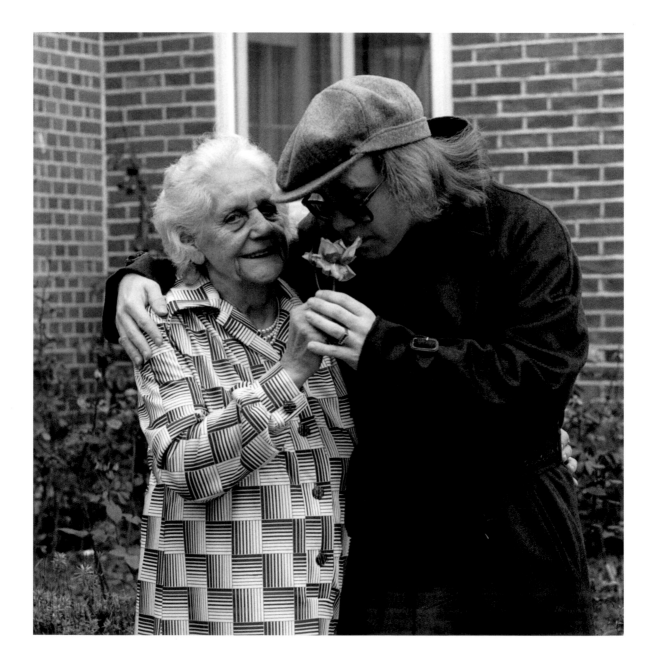

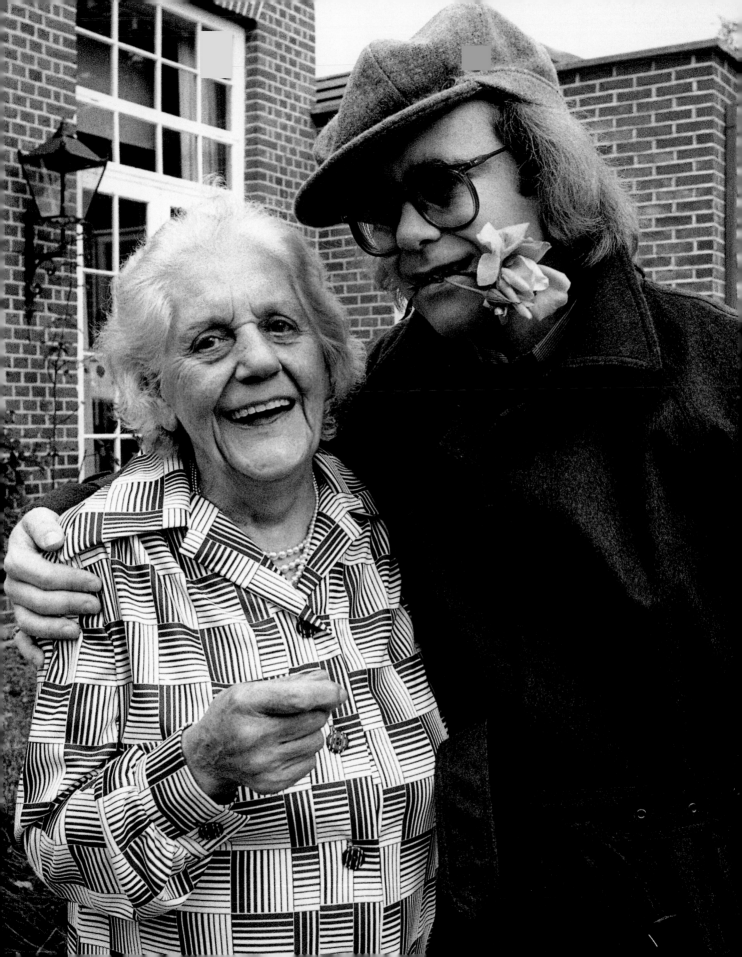

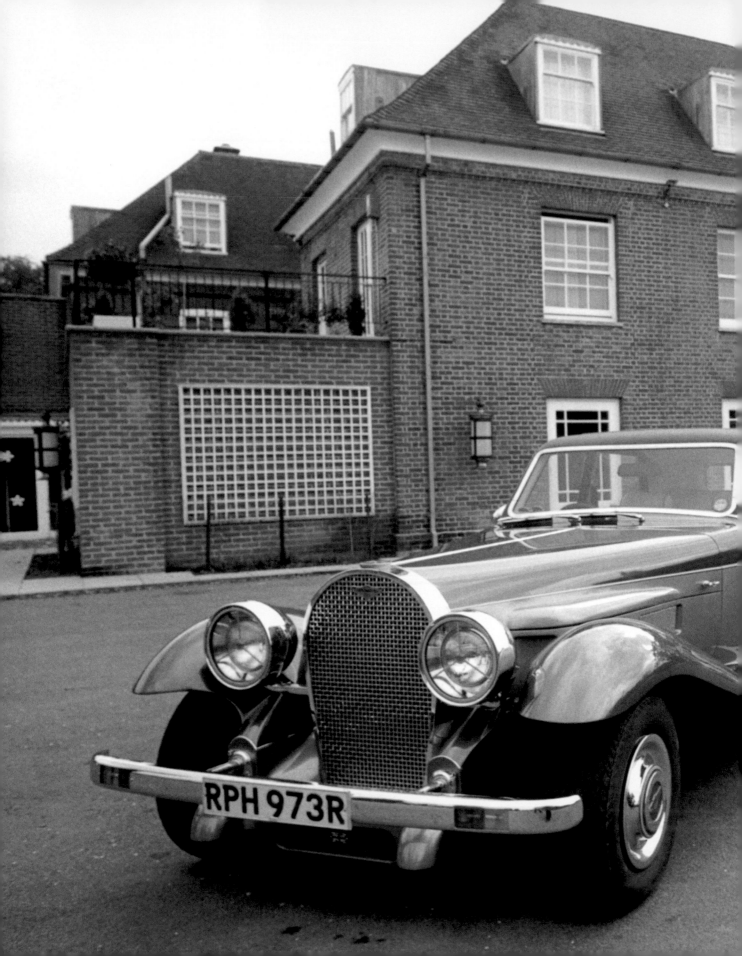

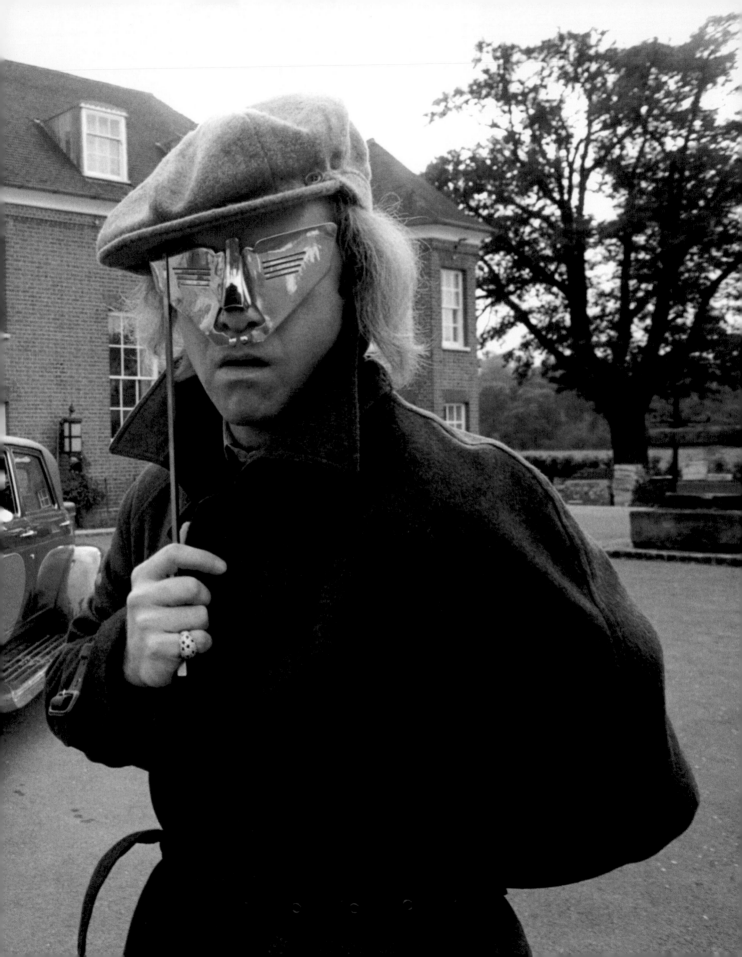

The Muppet Show was a phenomenon and most major stars would make a guest appearance. I had a good time coming along, it was interesting to see first-hand how they made everything work."

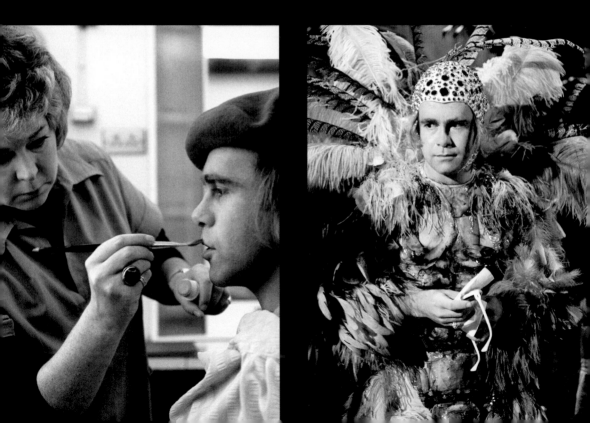

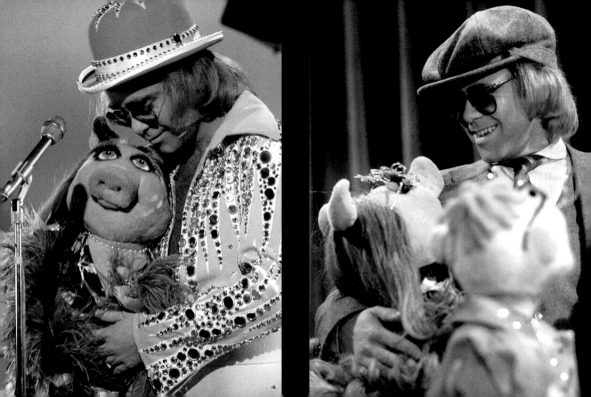

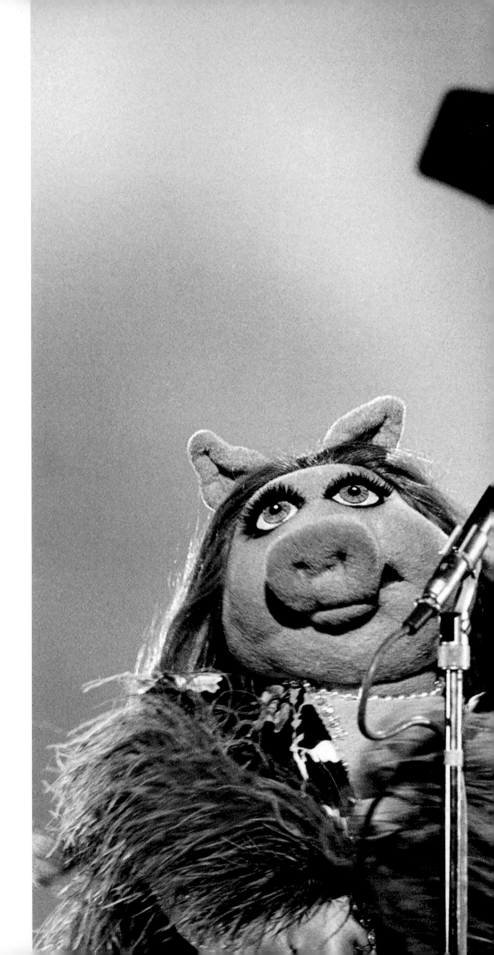

Right: Miss Piggy sang the number-one hit 'Don't Go Breaking My Heart' (1976) with Elton, at one point saying, "Eat your heart out, Kiki Dee."

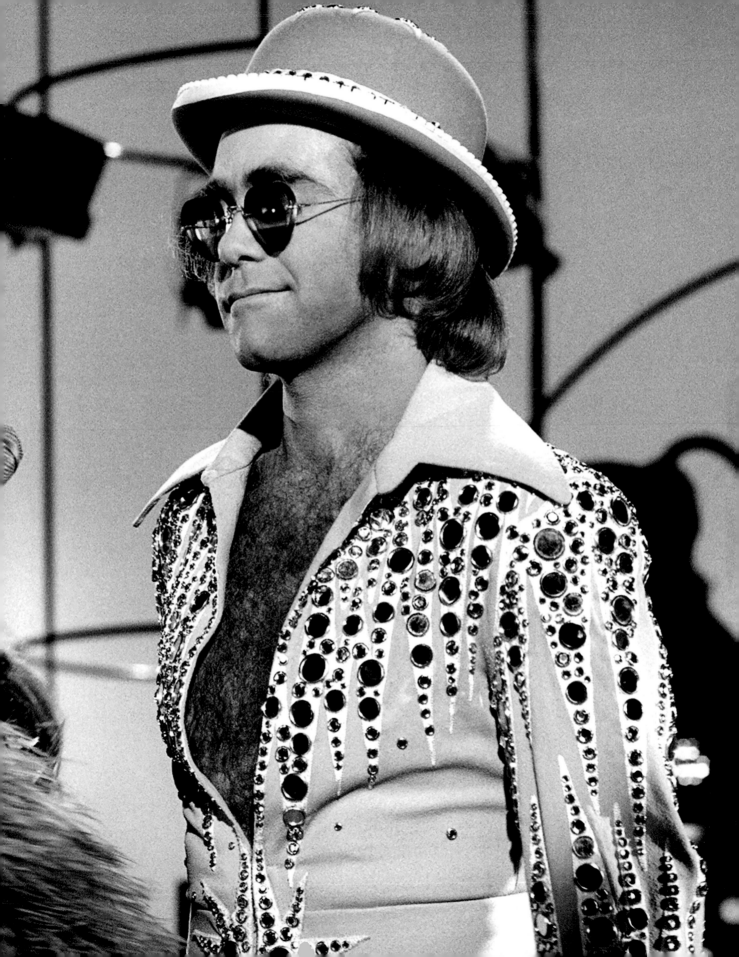

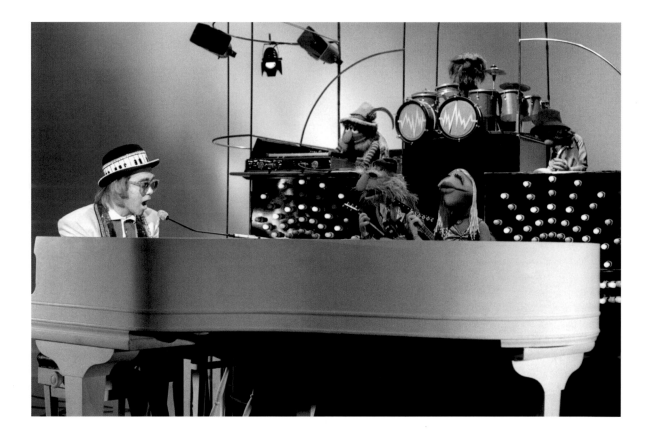

Above: "Elton performs 'Goodbye Yellow
Brick Road' (1973) with the Muppet band.
The piano and his suit were both
a golden yellow."

Opposite: Backstage, reading the paper,
which included news about himself.

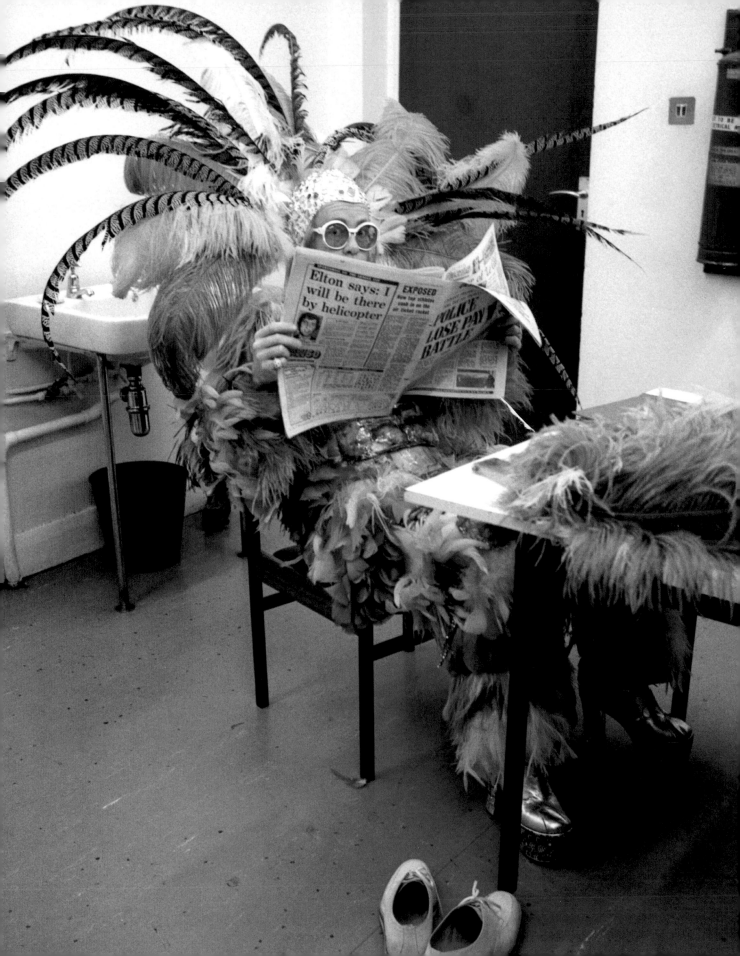

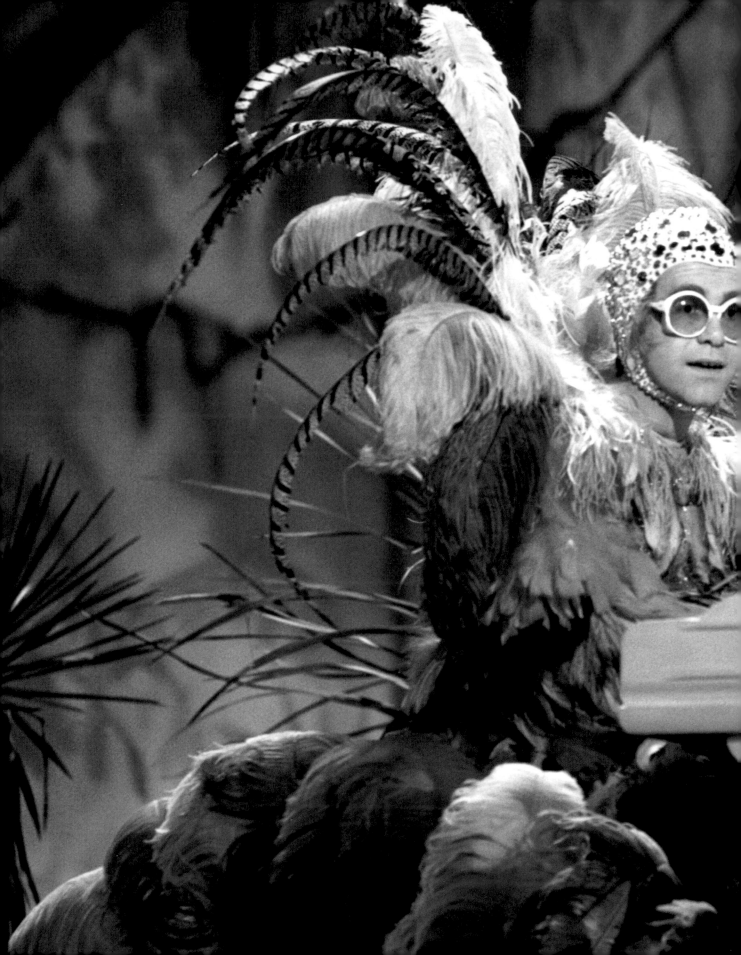

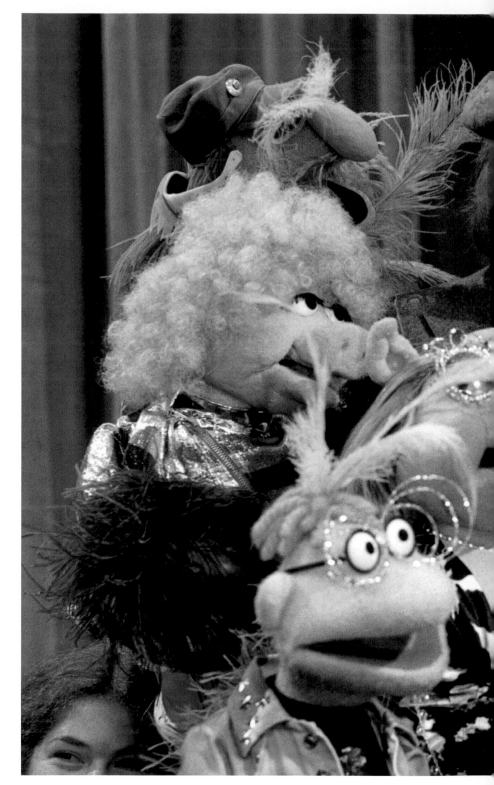

Previous pages: "Here's where colour might have helped: 'Crocodile Rock' (1973) was the first number that aired on the show, and Elton's costume had a vivid, multi-coloured design."

Right: "Here, Elton appears in a pretty modest suit, surrounded by the muppets, dressed up as him. Even the muppets thought his outfits were out-there."

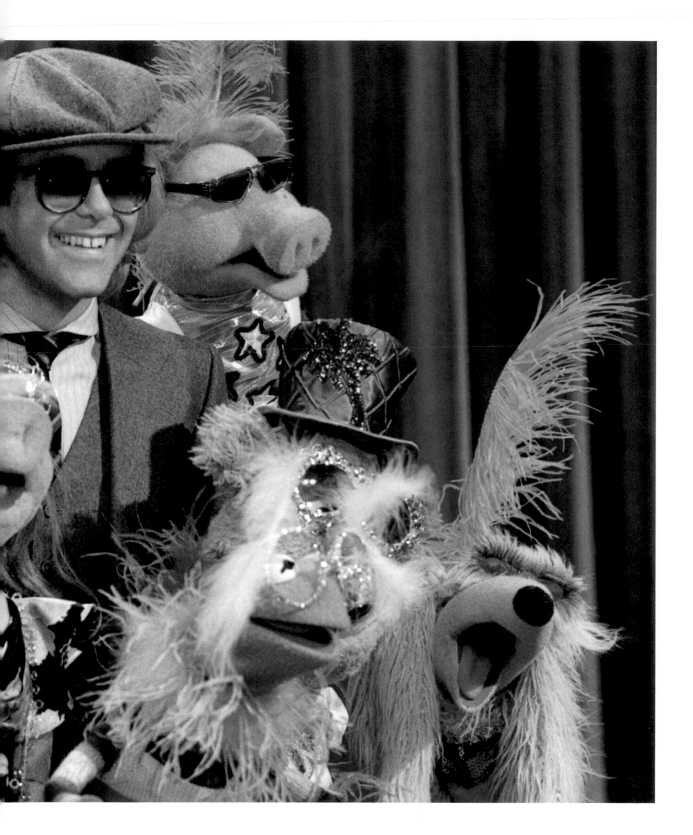

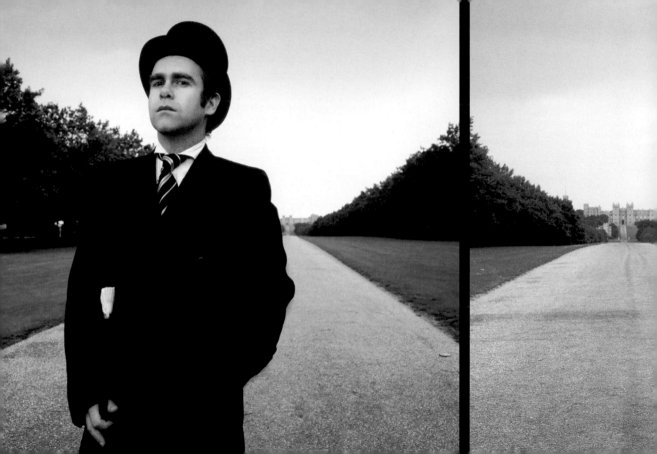

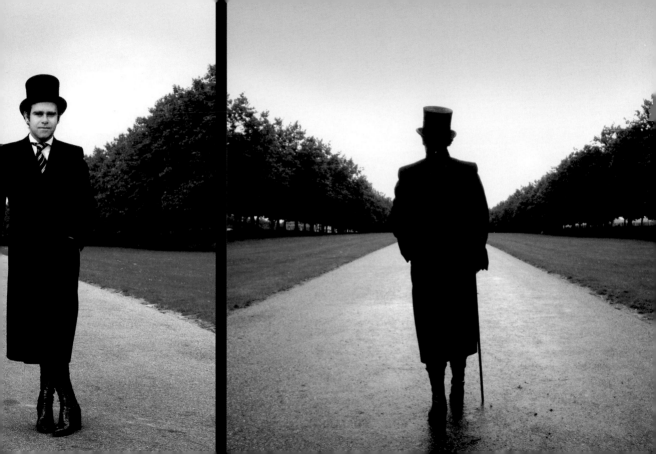

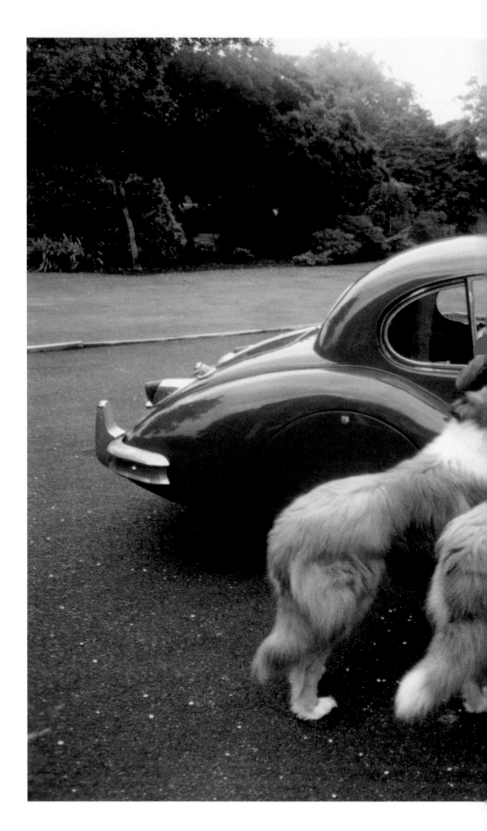

Right: "One of the images from this shoot was used on the inside of the gatefold album sleeve of *A Single Man* in 1978."

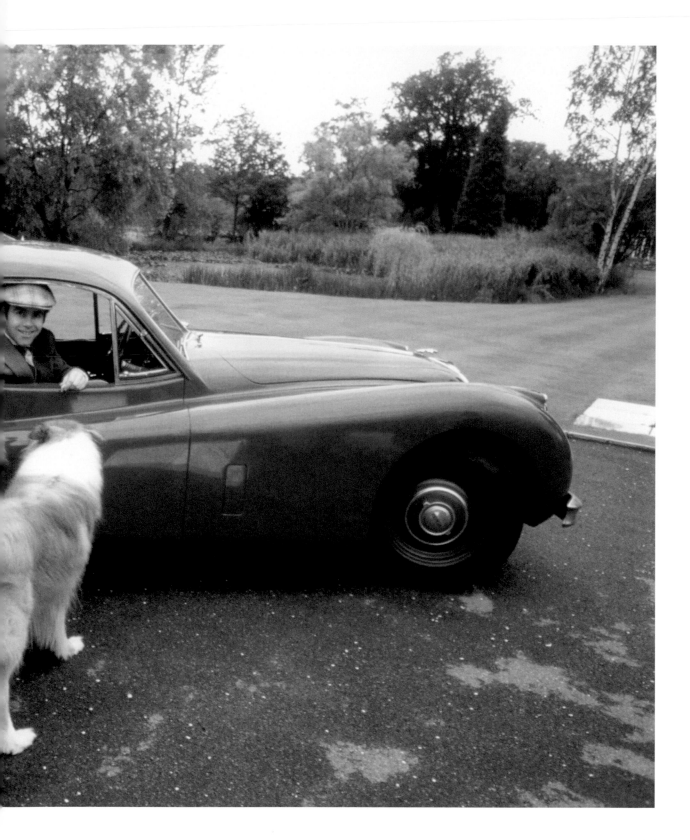

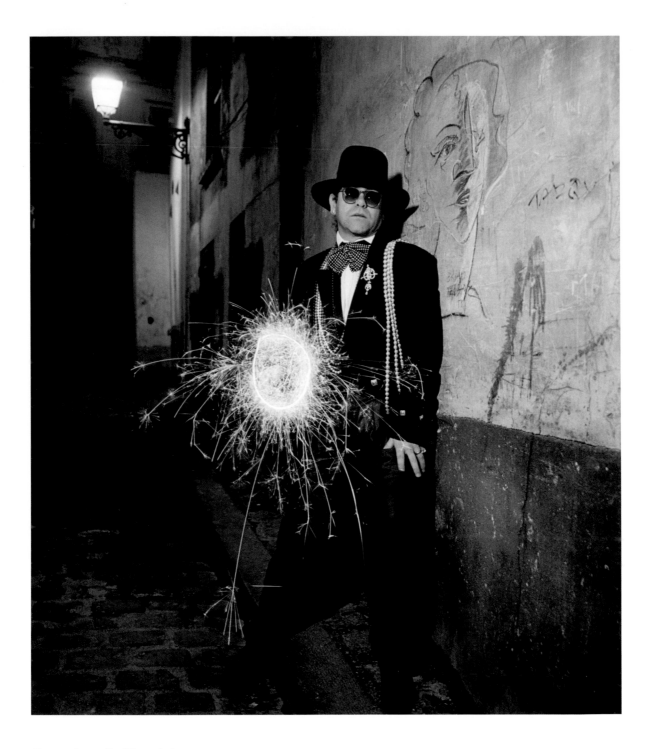

Above and opposite: "These shots were taken in Paris, at night, around 1980."

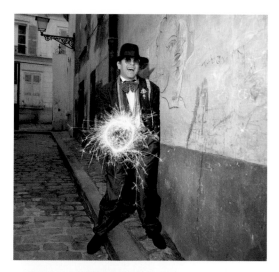
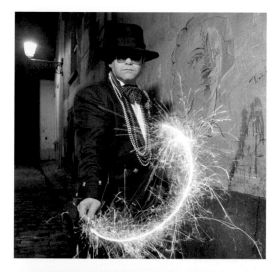
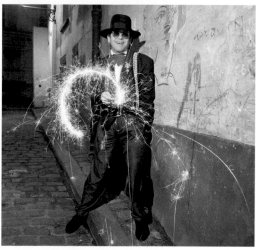
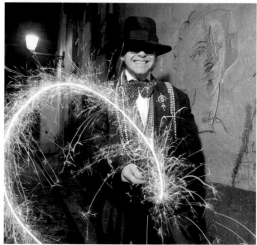
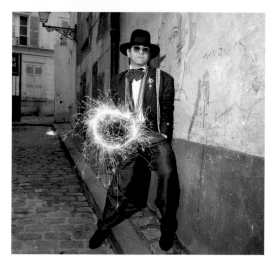
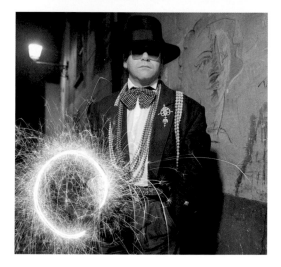

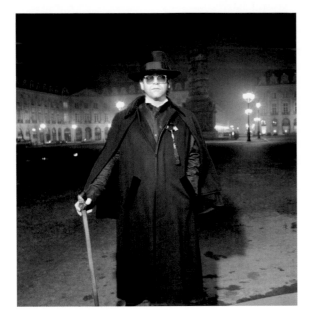

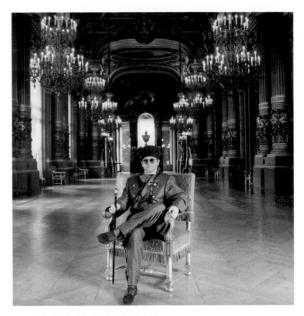

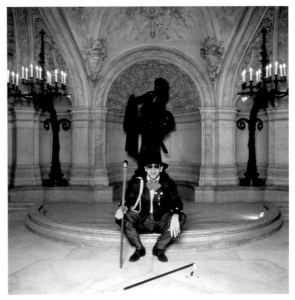

This page and opposite: "We went to several locations in Paris for these shots, including the Palais Garnier opera house."

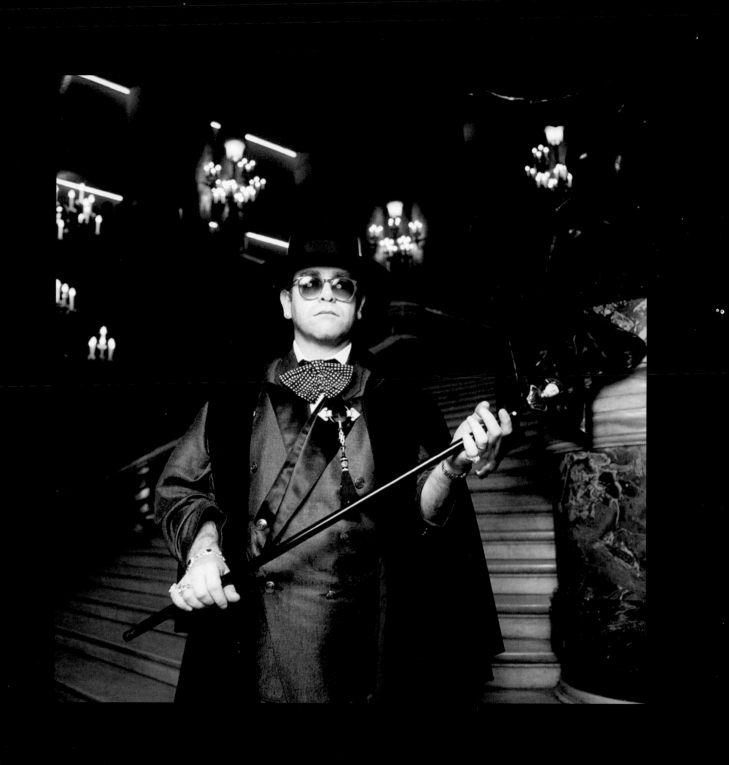

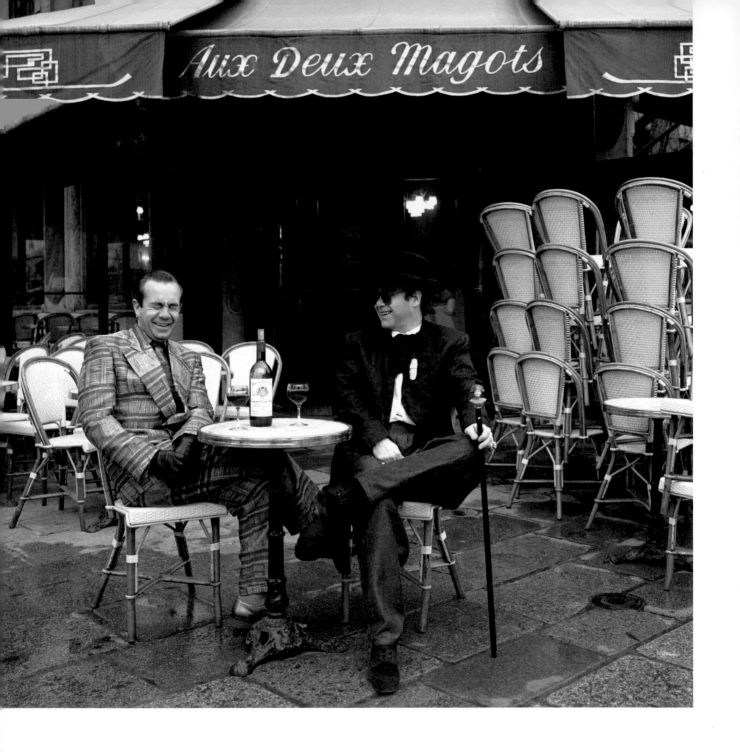

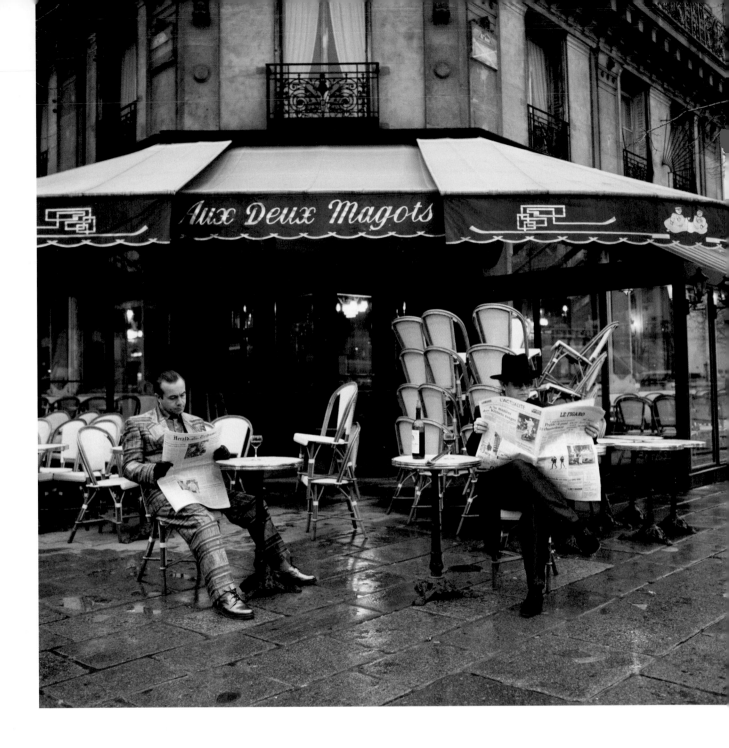

Opposite and above: "When we finished shooting [the sparkler images, see pages 214–15], it was just getting light. As we were heading back to the hotel, we turned the corner of place Saint-Germain-des-Prés and I thought it was a great setting. The restaurant was amenable – they were just starting to set up for the morning rush. So I sat Bernie [Taupin] and Elton down and took a series of shots. I don't remember if we had to pay for the wine."

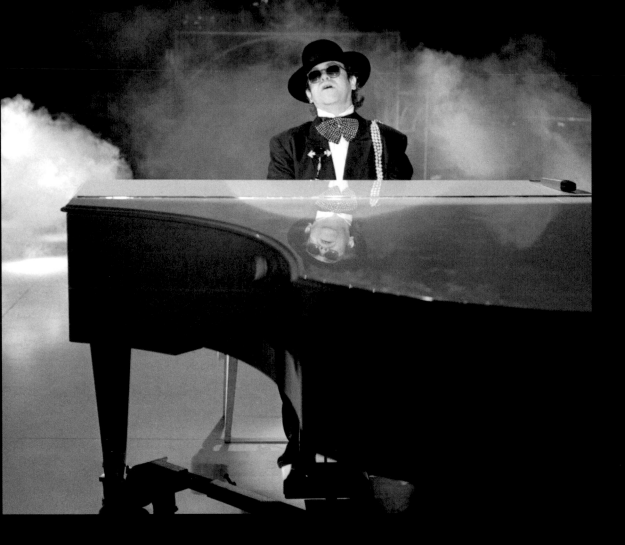

Above, opposite and overleaf: Elton
John was inducted into the Madison
Square Garden Hall of Fame in 1977,
being the first non-athlete to be
honoured. Terry O'Neill would later work
with Elton onstage for the last time at
the famed venue in October 2000.

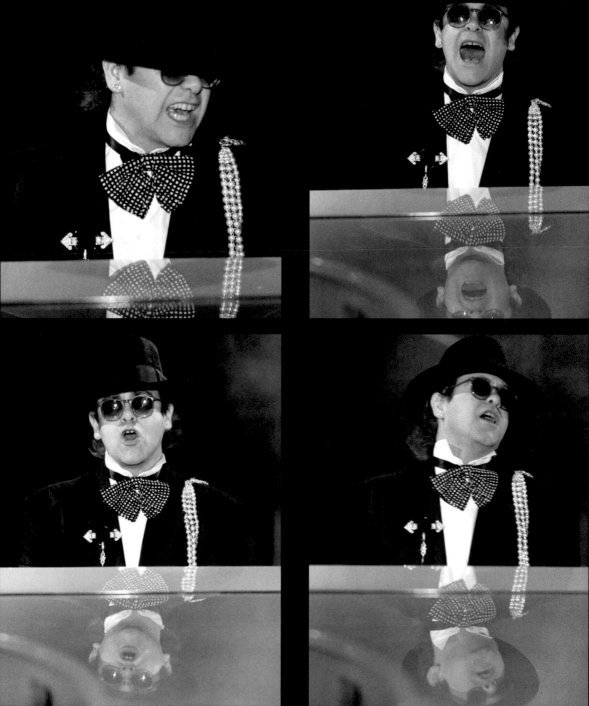

"Elton's trademark straw hat!"

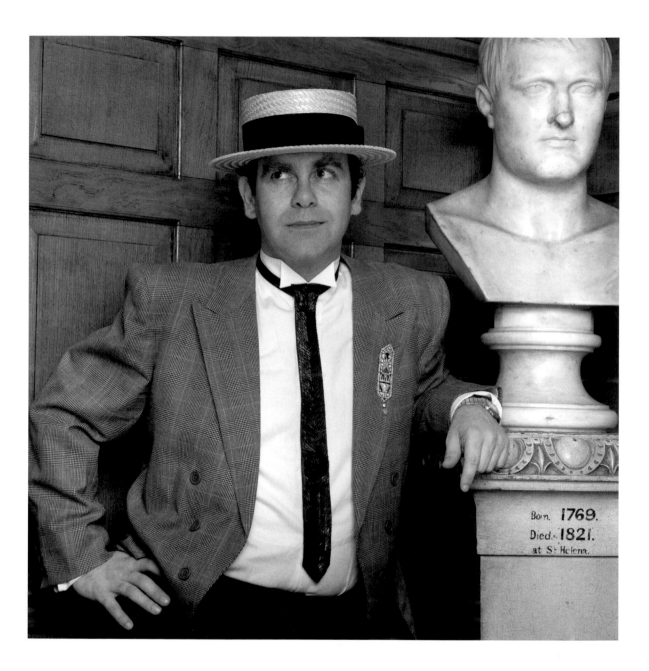

Born. 1769.
Died. 1821.
at St. Helena.

Opposite and below: "I was asked to do a series of portraits for the Sotheby's catalogue for the sale of Elton's memorabilia in 1988. We had the idea that the photos were going to be very similar, all framed a certain way, but that Elton would change clothes between shots. With so many wardrobe options, I was also trying to make it simpler for everyone involved. I think it worked really well, especially in context with the catalogue. We wanted to be serious, amongst the razzle-dazzle."

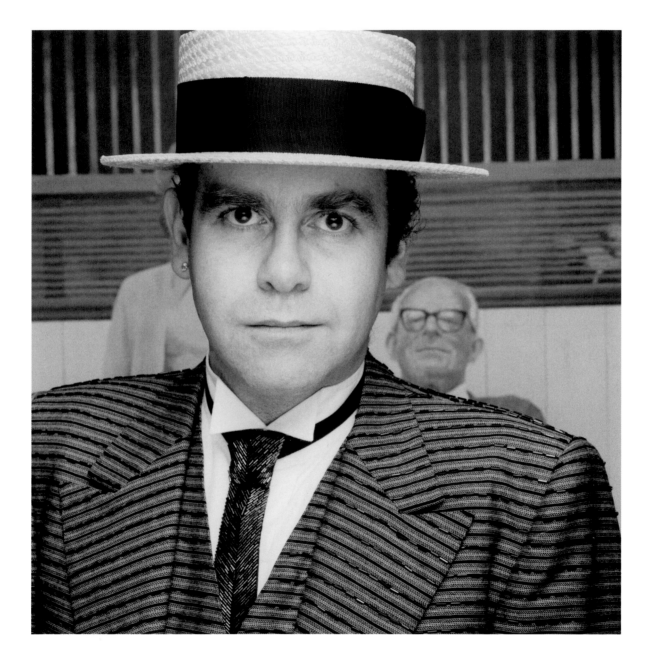

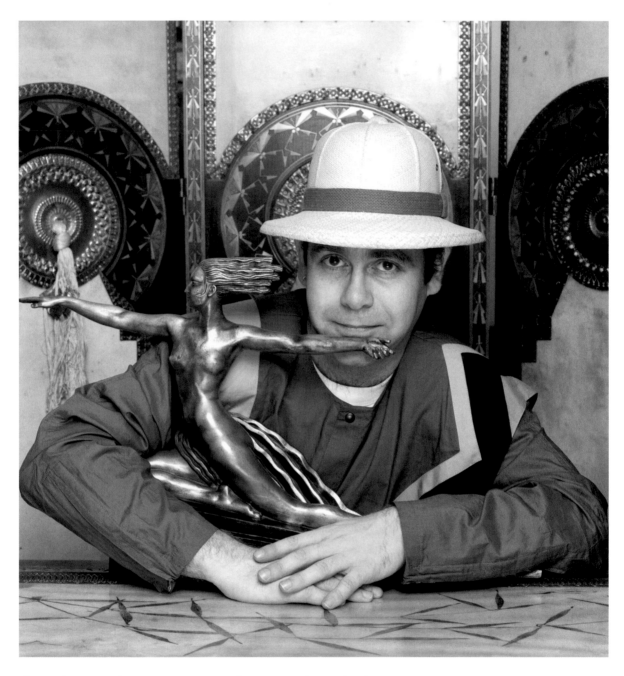

Above and opposite: "Elton put up for auction nearly 2,000 items, I remember. Not only his costumes and various accessories he wore throughout the first ten or so years, but also some of his collected artworks.

He has great taste in art and antiques – Tate Modern even held an exhibition of his personal photography collection in 2016, including works by Man Ray, André Kertész, Dorothea Lange – he developed a keen eye."

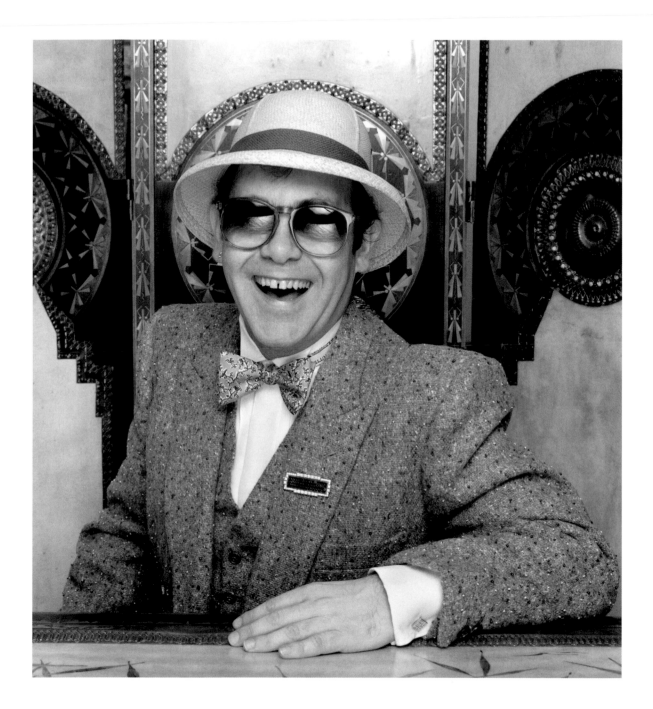

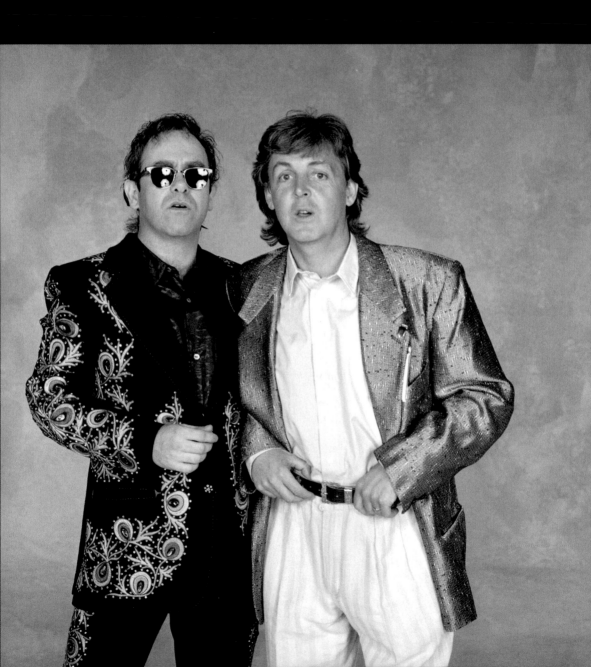

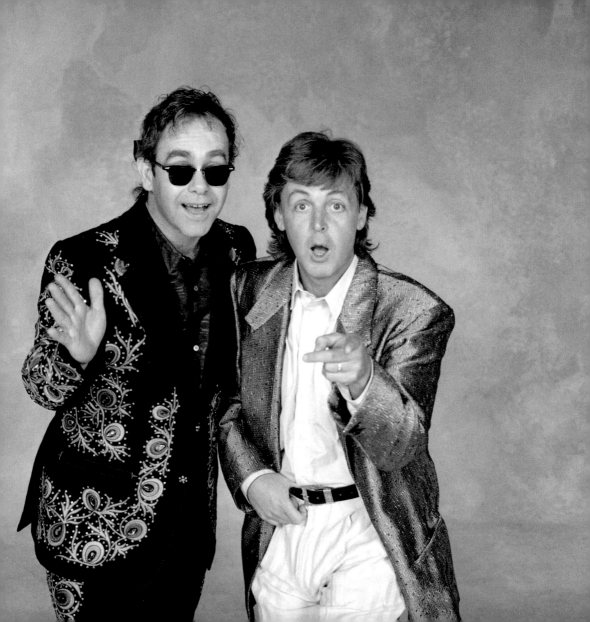

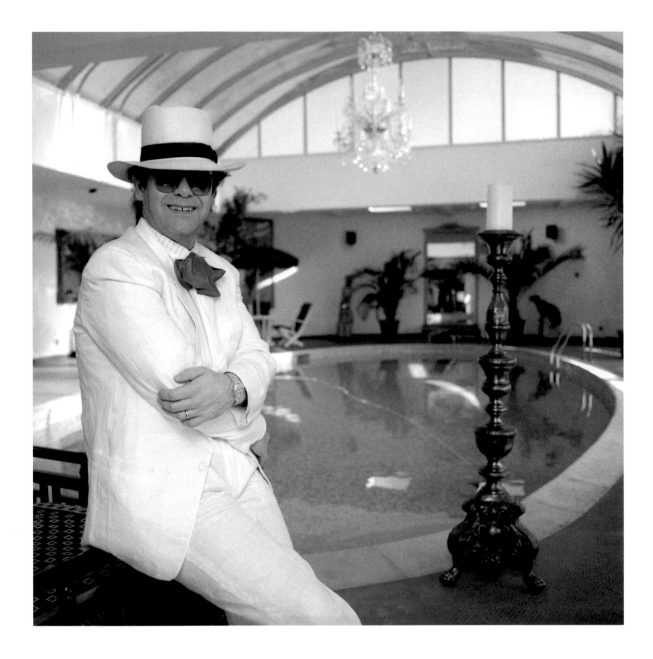

Above and opposite: Elton at home.

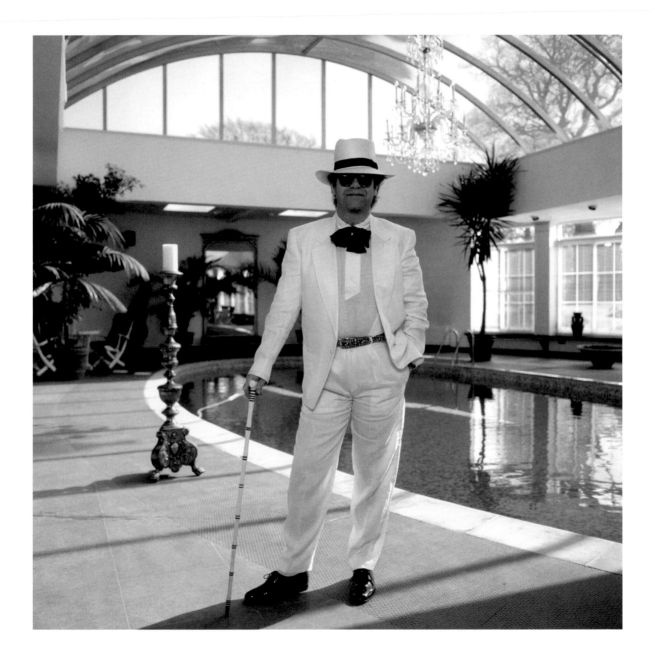

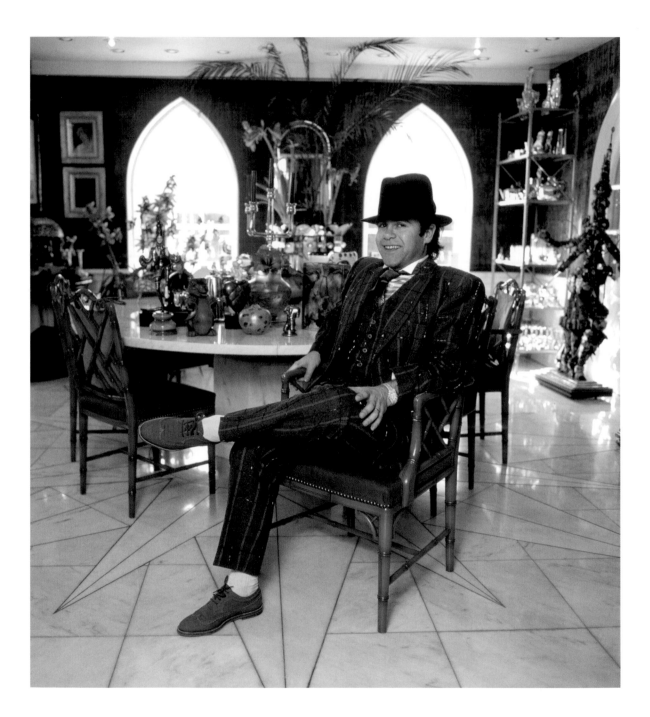

Below: "This was backstage at a charity event, most likely a Prince's Trust performance. Many of the great stars – including Elton John, here with Eric Clapton – would gladly take part."

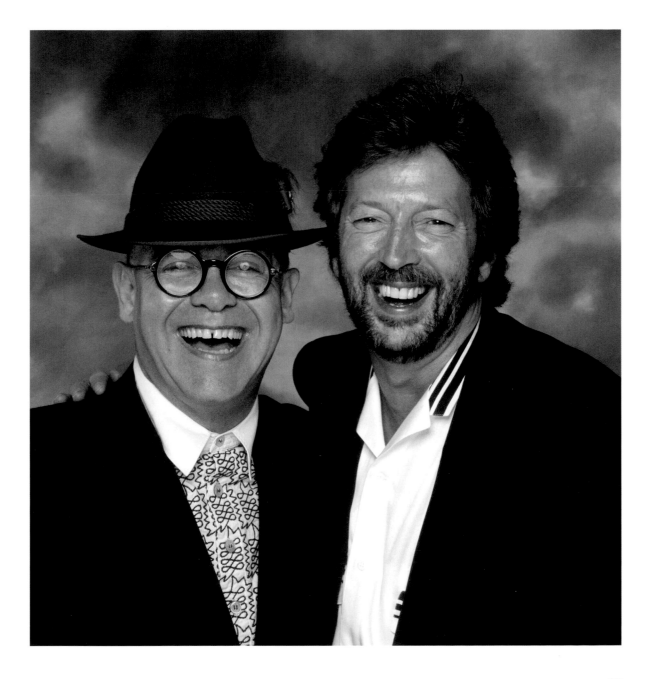

Below and opposite: "In September 1988, Elton held an auction of his costumes and accessories at Sotheby's, and I was asked to take a series of photos. The cover of the catalogue, a box-set containing four volumes, featured a silhouette of the portrait I did for *A Single Man* (1978)."

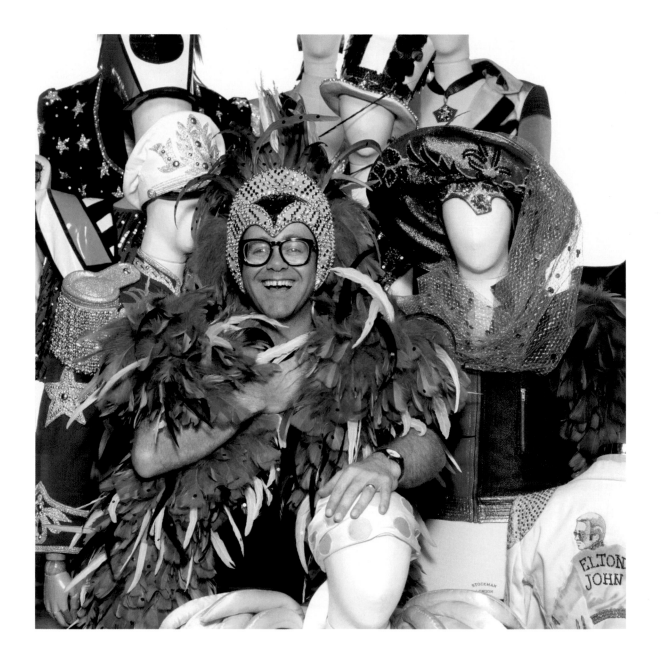

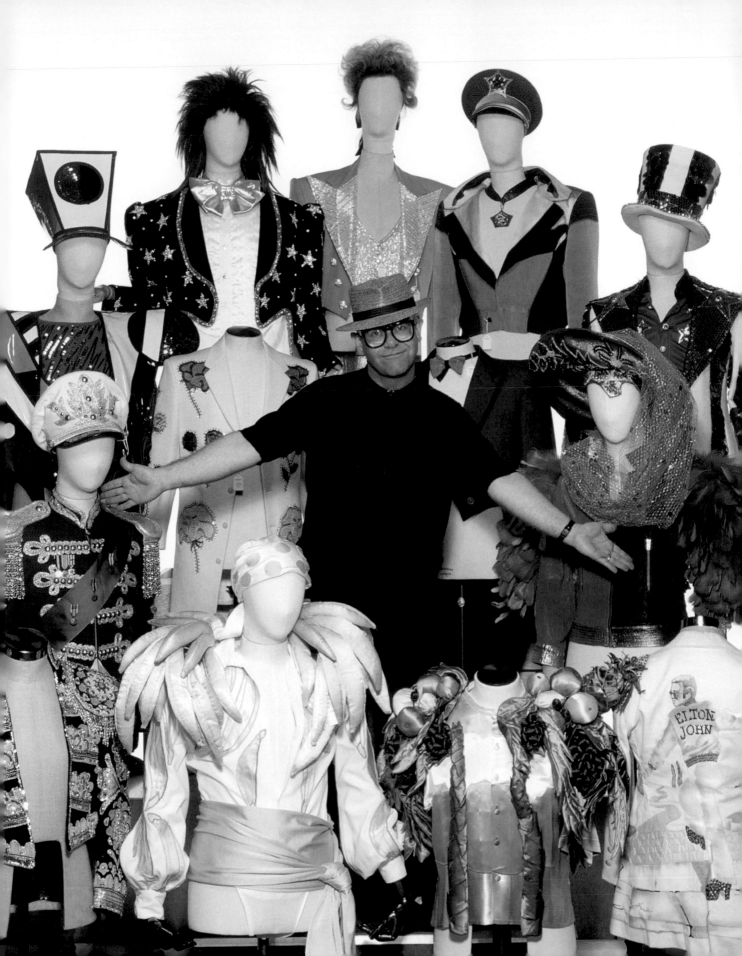

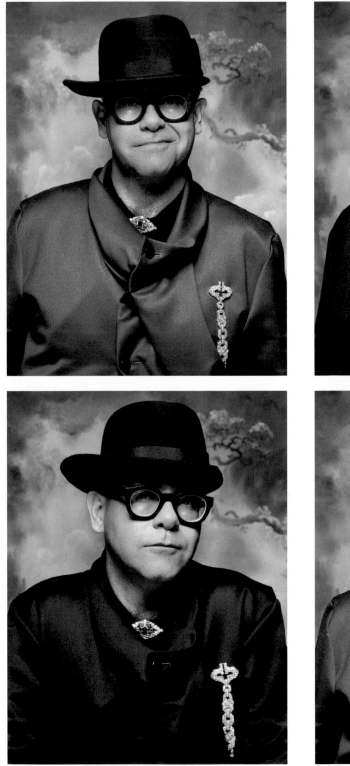
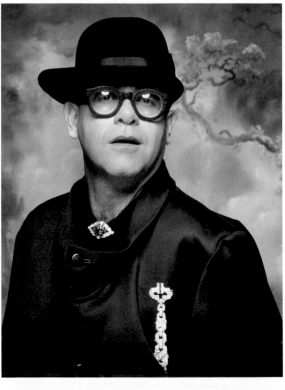
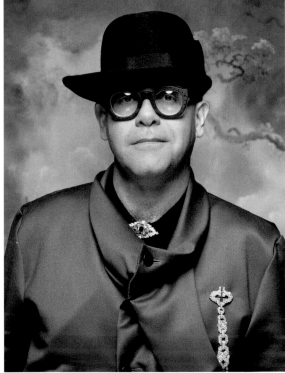

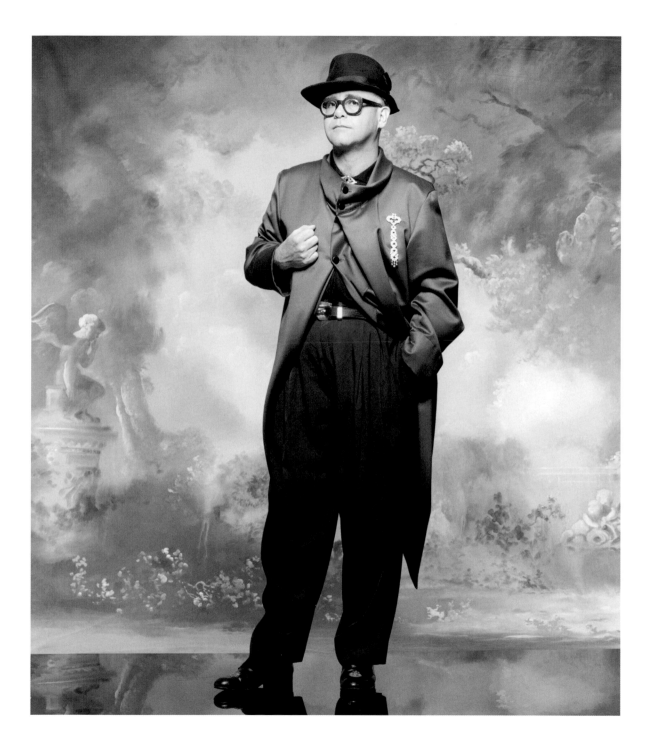

Opposite and above: "I was working
more and more in a studio by this point.
Can you blame me? I was getting older,
too – I have a good ten years on Elton.

Studio work, for me, was often easier to
manage when you had so many different
changes [in outfits] to get through."

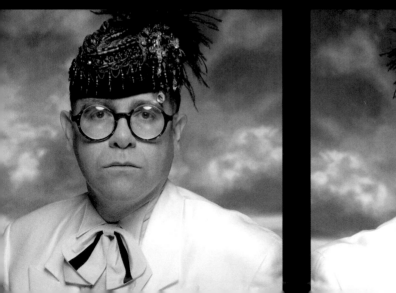
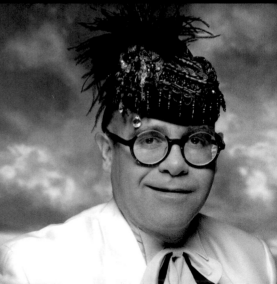

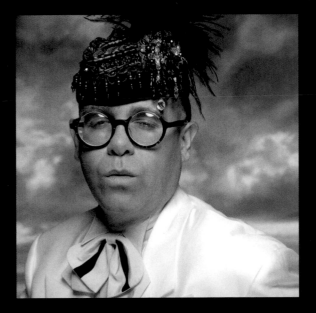
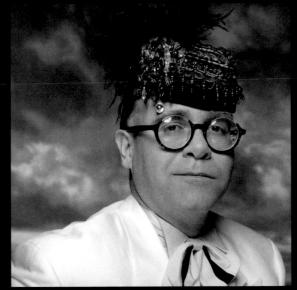

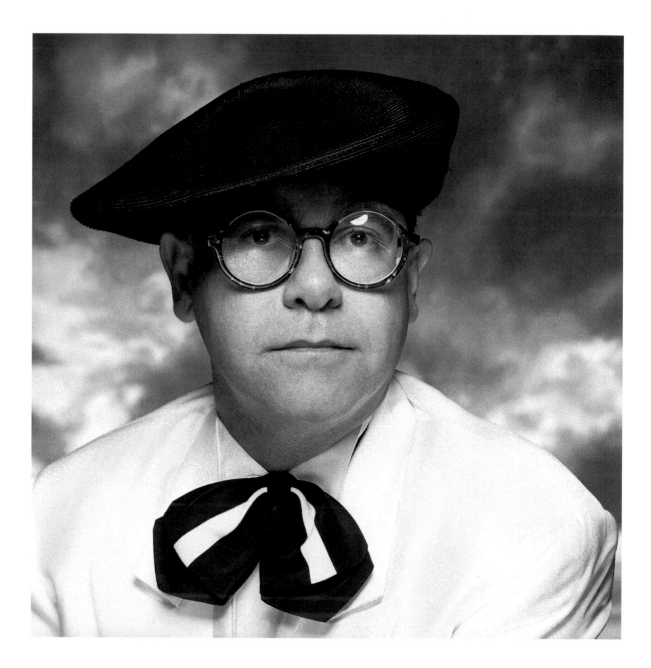

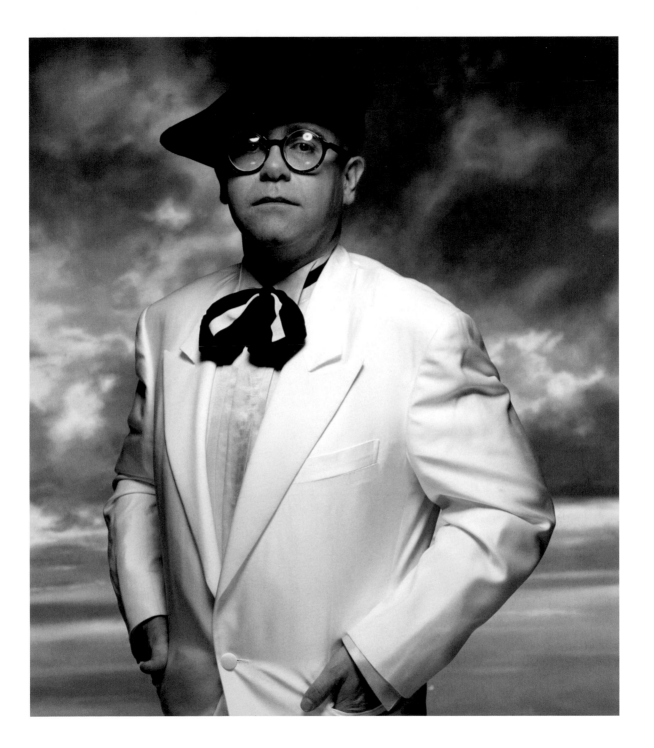

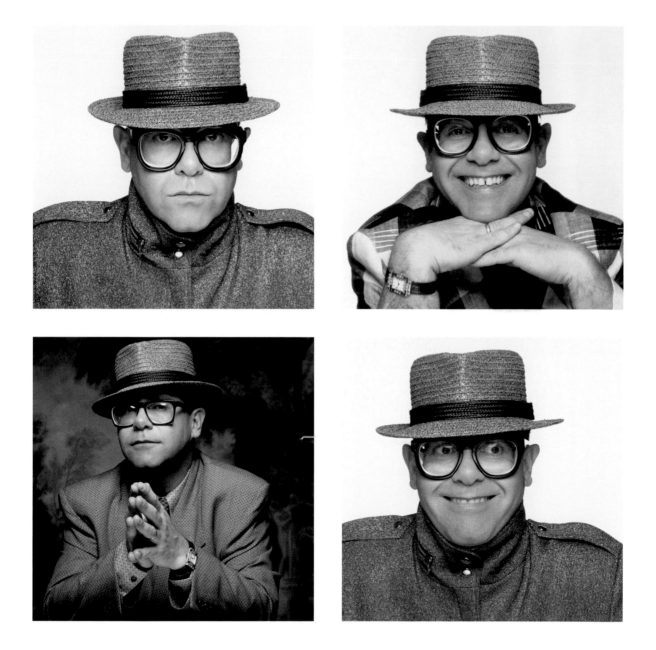

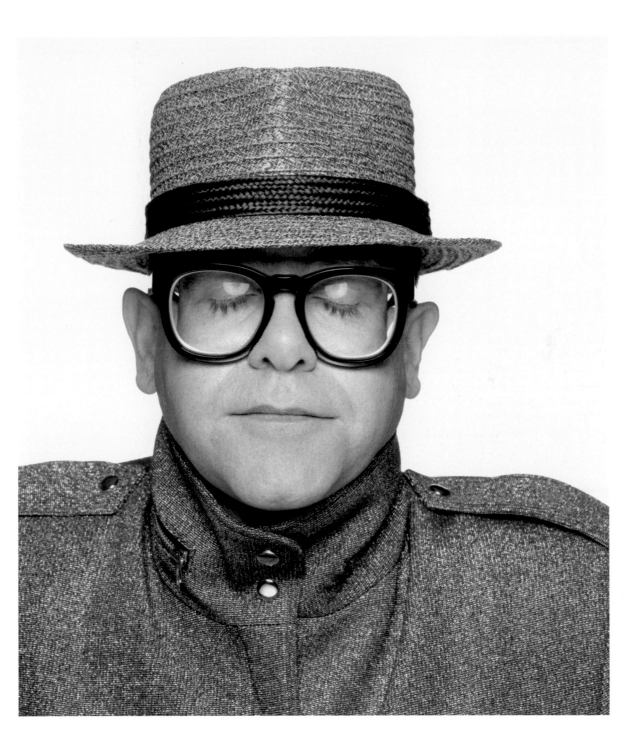

Opposite, above and overleaf: "These were part of the session for Sotheby's. I'm sure the 'eyes closed' shot was an accident – a simple click of the camera. I think it's pretty great and it has become one of my favourite portraits."

"When we started working together in 1972, I did have to direct him. And now, just look at him – absolutely loving it."

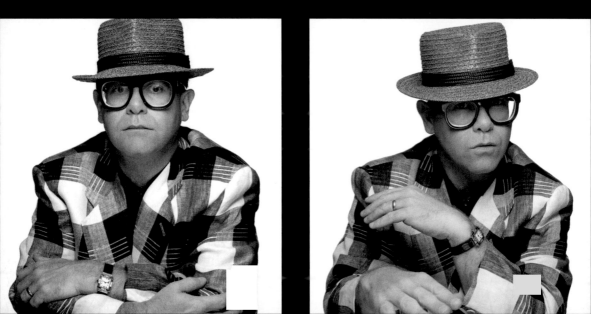

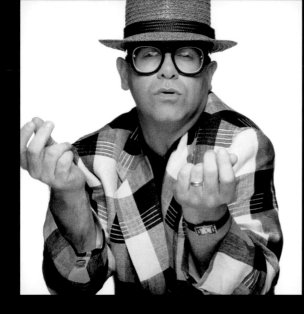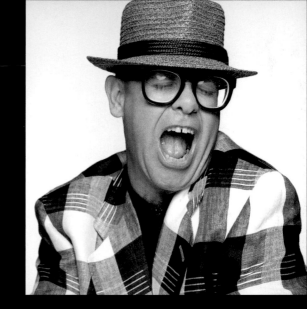

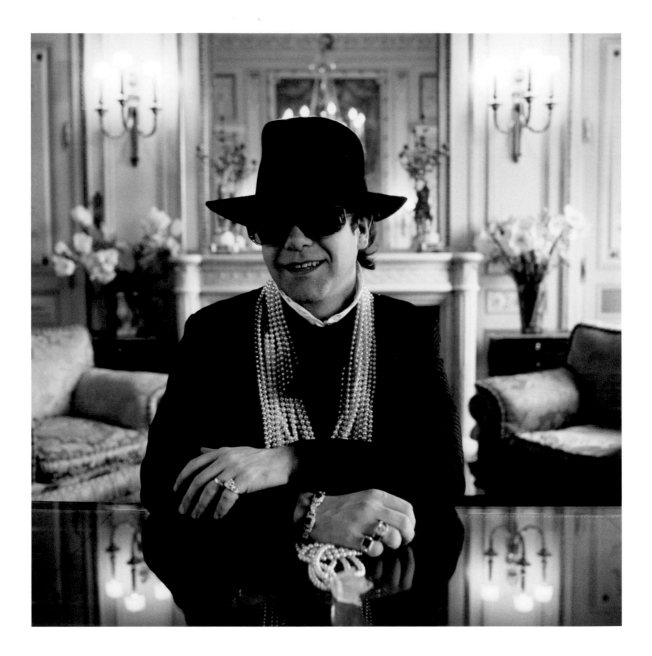

Above and opposite: "These were taken
in Paris. We had the idea of doing a series
of portraits in which the only thing
that would change would be Elton's
costumes. Every time, it was a complete
change – right down to the shoes, which
you can't even see in the pictures."

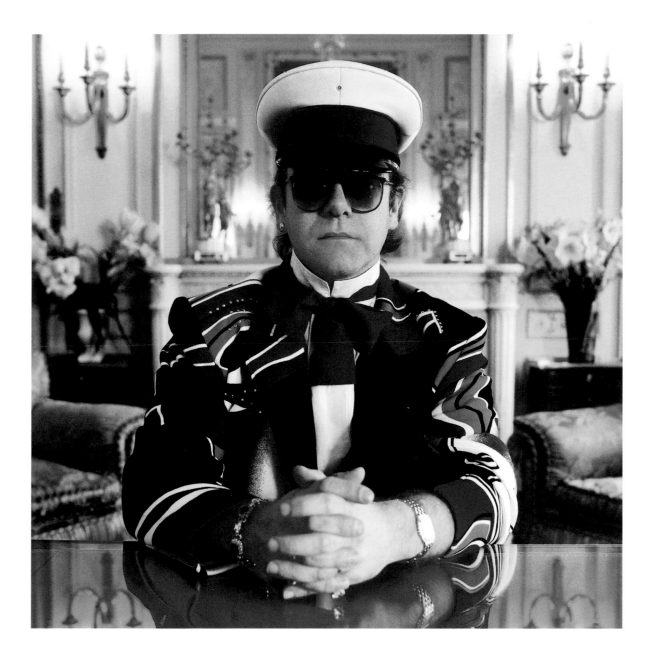

"One quick change after the next and, each time, a different Elton appeared."

Below: Elton with Ringo Starr, backstage
at a Prince's Trust concert, Wembley, 1987.

Opposite: Portrait of Elton for the "Face
to Face" tour, 1994.

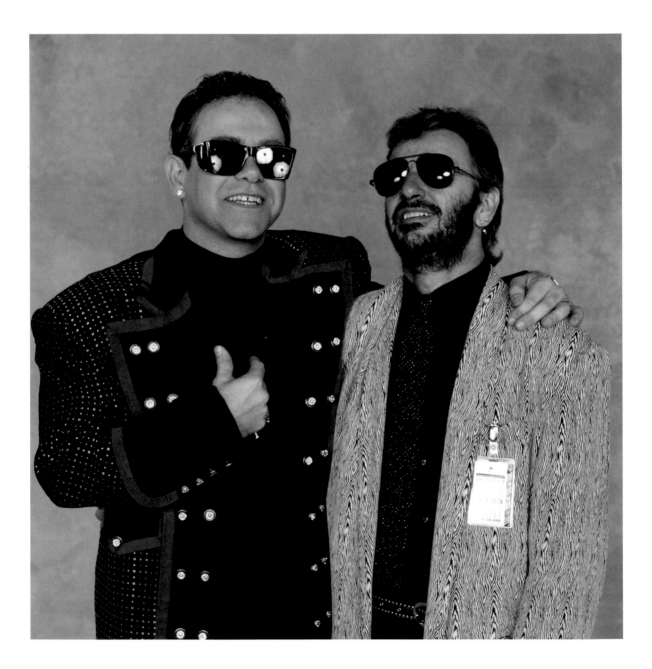

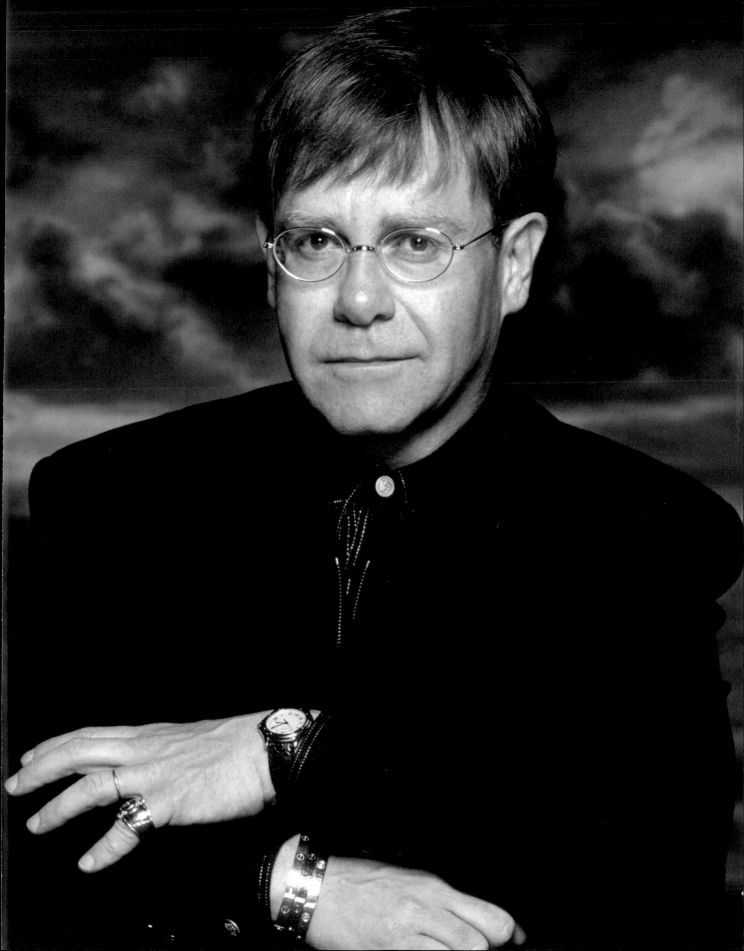

Below: Elton John and his band in a promotional photo for the "Face to Face" tour with Billy Joel, 1994. Clockwise from top left: Guy Babylon, Bob Birch, Ray Cooper, Charlie Morgan, Elton John, Davey Johnstone.

Opposite: Promotional photo of Elton John and Billy Joel for the "Face to Face" tour, 1994.

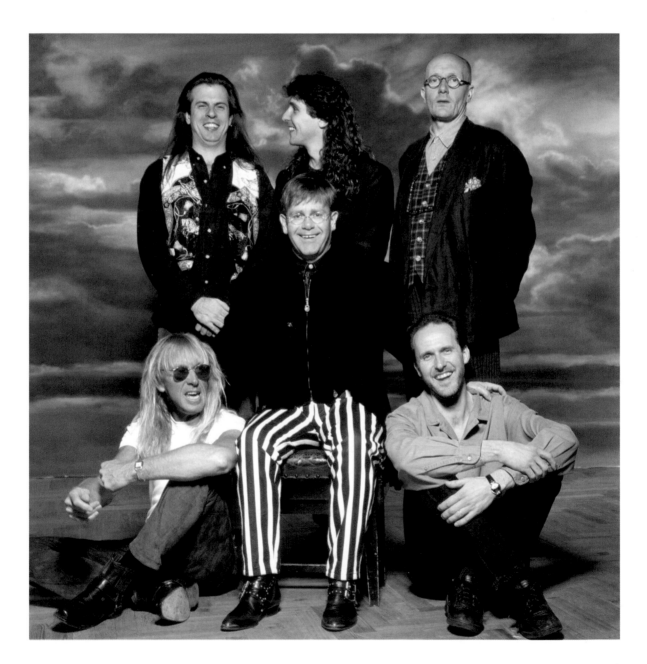

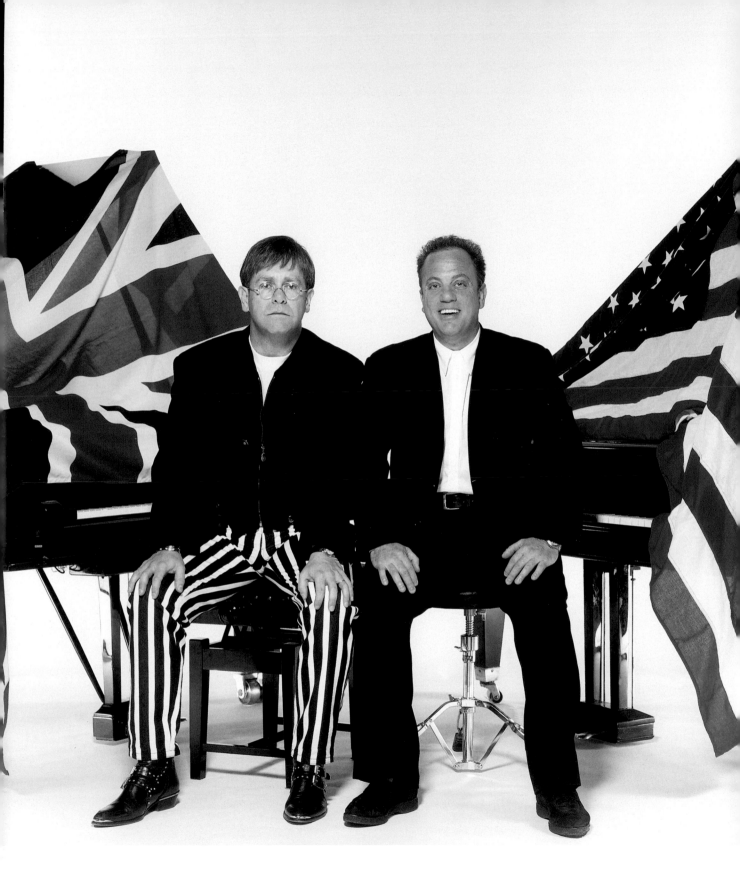

Right: "I was asked by the *Sunday Times Magazine* to work with Elton one last time. I was pretty much retired at this point. There was no one left, really, that I wanted to work with, to be honest. But you can't say no to Elton."

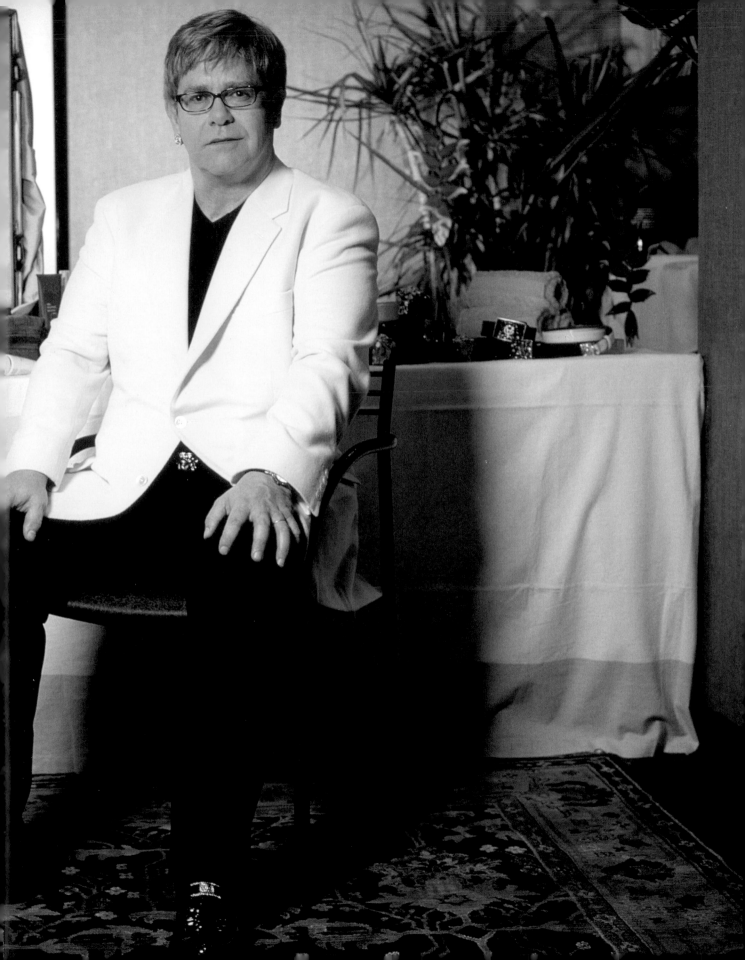

Below, opposite and following pages:
Elton John in concert at Madison Square
Garden, New York, 2010. "We had a great
collaboration and it was a joy to work
with Elton for all those years, it really
was. And to think that it all started when
I heard him on the radio and thought
I should give him a call."

"He's a genius – arguably the best piano player of the past 100 years, maybe even more."

Right: "A great farewell to the audience – I should have suggested he try the piano handstand!"

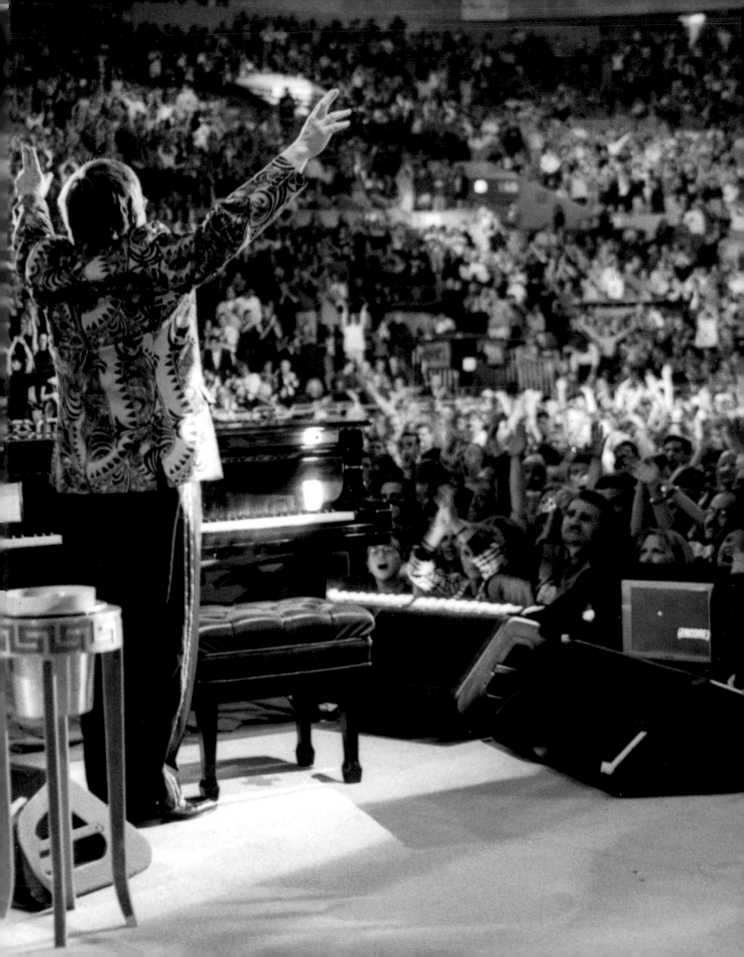

Benjamin McMahon

TERRY O'NEILL

Terry O'Neill is one of the most important photographers of his generation, taking iconic portraits of artists from The Beatles to The Rolling Stones, Elizabeth Taylor to Audrey Hepburn. He has worked with such icons as Michael Caine, Brigitte Bardot, Sean Connery, Terence Stamp, Ava Gardner, Paul Newman, Robert Redford, Raquel Welch, Roger Moore, Amy Winehouse, Nelson Mandela and hundreds of others. Frank Sinatra, whom O'Neill worked with for several decades, considered him a friend and O'Neill had a close working relationship with David Bowie, including photographing the iconic "Jumping Dog" image used for the promotion of *Diamond Dogs*. O'Neill's photograph of Faye Dunaway sitting by the pool the morning after winning the Academy Award in 1977 is widely considered to be the most iconic image of Hollywood. His work is included in permanent collections in museums, galleries and private collections worldwide.